MT 748

Donated to

**Visual Art Degree
Sherkin Island**

GLASS

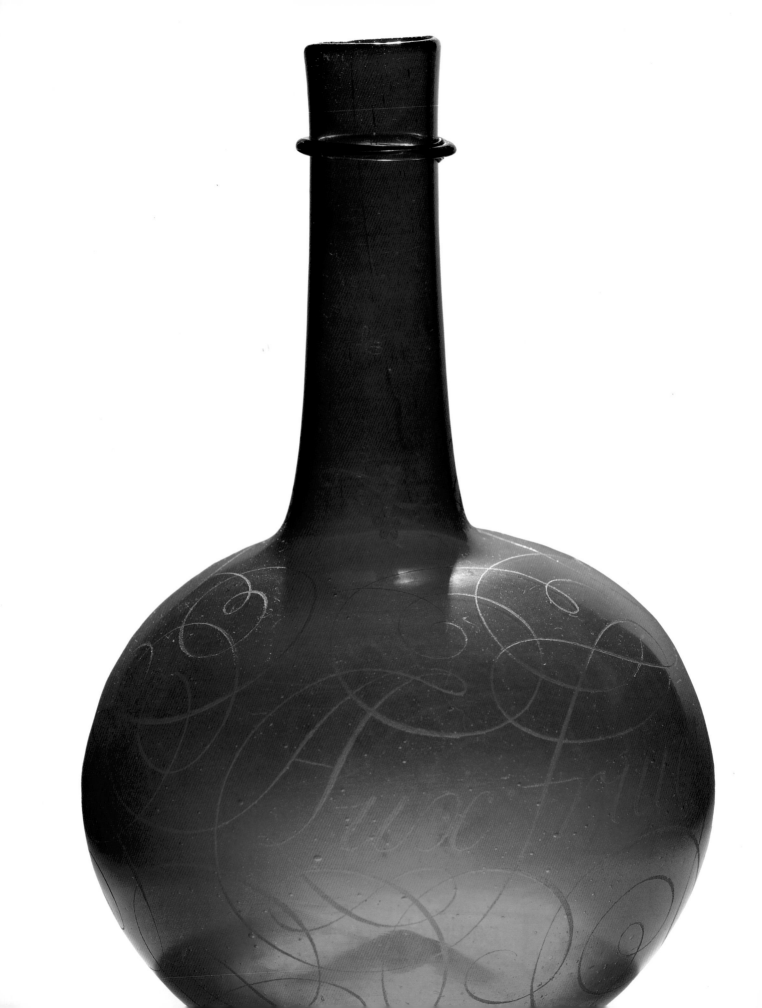

GLASS

Edited by Reino Liefkes

V&A Publications

To the memory of Daniel McGrath, a wonderful friend and colleague, who was responsible for the object photography specially taken for this book

First published by V&A Publications, 1997
Reprinted 2000

V&A Publications
160 Brompton Road, London SW3 1HW

Reino Liefkes asserts his moral right to be identified as the author of this book

Designed by Bernard Higton

ISBN 1851771980

A catalogue record for this book is available from the British Library

Printed in Hong Kong by South Sea International

CONTRIBUTORS

Judith Crouch, Assistant Curator, V&A
Robin Hildyard, Assistant Curator, V&A
Rose Kerr, Chief Curator, V&A
Reino Liefkes, Deputy Curator, V&A
Jennifer Opie, Deputy Curator, V&A
Susan Stronge, Assistant Curator, V&A
Veronica Tatton-Brown, Assistant Keeper, British Museum
Oliver Watson, Chief Curator, V&A
Hilary Young, Assistant Curator, V&A

Cover Illustrations
Front: *Standing cup and cover, Italy, late 15th century*
Back: *Scent bottle by David Taylor, Britain, 1980.*

Frontispiece.
Bottle for serving wine. Diamond-point engraved by Bastiaan Boers, schoolmaster of Warmond, the Netherlands. Signed and dated 20th May 1699.

CONTENTS

Note: For full list of contibutors, see opposite.

ACKNOWLEDGEMENTS

We are grateful to:

Carol Andrews from the Egyptian Department, and Ian Freestone and Colleen Stapleton from the Department of Scientific Research, both of the British Museum, London; Roger Dodsworth of the Broadfield House Glass Museum, Kingswinford; Wendy Evans, London; William Gudenrath of Corning, New York State; Detlef Heikamp, Florence; John Michell & Son, London; John P. Smith, London; Marianne Tazlari, Förderkreis Wertheimer Glasmuseum, Wertheim; and Eleanor Townsend, Stephen Jackson, Melanie Nunzet and Fi Gunn of the Ceramics and Glass Department at the V&A.

We would also like to thank Mary Butler, Miranda Harrison and Helen Castle of V&A Publications for commissioning and editing this volume.

INTRODUCTION

Glass is all around us today, but is none the less a remarkable product. There are unique possibilities in shaping it while hot and fluid; it can be blown, moulded or pulled and twisted into canes. As it cools it becomes viscous and gradually less soft, until it finally reaches a rigid state. Its fascination stems above all, however, from the fact that glass is a man-made material, with properties that are quite different from anything found in nature. It is a wonderfully transparent, bright and shiny, and fragile material, yet it is made from the most humble raw materials and is born in the roaring heat of a furnace. It seems as wonderful and secretive to us today, as it must have done to our predecessors in Egyptian, Roman, or medieval times.

Glass is made by melting a mixture of its three main components, called the 'batch', at a high temperature. The basic 'glass-forming' material is silica, found in ordinary sand, comprising some 60 to 70 per cent of the batch. An alkaline flux has to be added to lower the high melting temperature of pure sand. This can be sodium or potassium, derived from minerals or from plant ash respectively. A stabilizer, usually lime, is needed to make the glass water-resistant.

In antiquity sand contained the lime, and soda usually came from natron, a naturally occurring soda found especially in Egypt on surface deposits in dried out lakes. A major source of natron in antiquity was Wadi Natrum on the Nile Delta. In the East soda also came from saline plants found in the deserts and marshy areas. From the ninth century AD onwards, potash from the ashes of bracken and other woodland plants provided the flux for northwestern European glasshouses. (Pre-industrial glassworks are referred to as glasshouses). At different times, notably from the late seventeenth century, lead was added to the recipe to improve the quality. If nothing was added to the original soda, lime, and silica mixture, the glass was naturally bluish-green; coloured glass was initially made by adding specific metal oxides and by varying the furnace conditions. Manganese or antimony were used as decolorizing agents, already in Roman times, to make almost colourless glass akin to modern crystal glass, which also relied on the careful selection of the raw ingredients.

The 'batch' is melted in a furnace at about 1,110–1,300°C. The resulting material softens progressively as the temperature is increased, until it reaches a perfectly liquid state. At room temperature it has a solid state, but it is technically still a fluid as the molecules have a disordered arrangement rather than a rigid, crystalline structure. The ideal working temperature of glass is about 1,200°C.

The high temperature needed to melt the batch and the specific knowledge of the raw materials needed, make this part of glass-making a highly specialist procedure. It seems likely that from an early date this part of glass-making was performed in specialized workshops, located in only a few places. These would produce glass ingots, which were exported to sometimes distant glass-makers, who would remelt them and fashion the glass in their own, much smaller, furnaces.

The glass-maker can only work with his material when it is too hot to touch and so it has to be taken hot from the furnace. It can then be fashioned or blown, with or without a mould, and perhaps shaped and decorated with tools while held on his blowpipe or on a metal rod. The glass must frequently be returned to the heat of the furnace, to keep it malleable, and speed is vital. Glass-makers of all periods who practise without the use of machines deserve our awe and admiration as skilled craftsmen.

When a glass object has just been finished, it must cool down gradually to avoid internal tensions within the material, which could cause it to break. For this purpose a special annealing furnace (or 'lehr') is used, which is often a top or side compartment of the main furnace.

Glass has many applications, ranging from stained-glass windows, mirrors, glass mosaics, beads, and paste jewellery to lenses for glasses, and optical instruments, not to mention many modern technical uses such as fibre optics. This book, which is based on the collections of the Victoria and Albert Museum, in London, is mainly concerned with vessel glass and, from the twentieth century onwards, also with glass as art. It sketches a stylistic development through the ages, but it also focuses on the making of glass and its commercial significance, as well as its use and its users. Far from pretending to be exhaustive in any of these subjects, it attempts to provide a varied introduction to this fascinating material.

A Tour around the Glassworks

Since the invention of glass-blowing almost two thousand years ago, the organization of the glasshouse has hardly changed. Central to the glasshouse is the furnace. The high costs of firing and the long time it takes to melt glass to a workable temperature of about 1200°C means the furnace is fired continually, day and night. Work has to be carried out in shifts.

Glass-making is a highly skilled craft. Master glass-blowers are generally trained from an early age. Glass-workers always work together in a team of three to four men. A strict division of labour assures the maximum economic use of the available skills. Each team works on several objects at the same time. The master glass-blower only performs the critical steps that cannot be done by one of his assistants. Every movement of each team member is essential. An experienced team can produce hundreds of glasses a day. Even in our heavily industrialized and mechanized era, glass is still being made in this way all over the world.

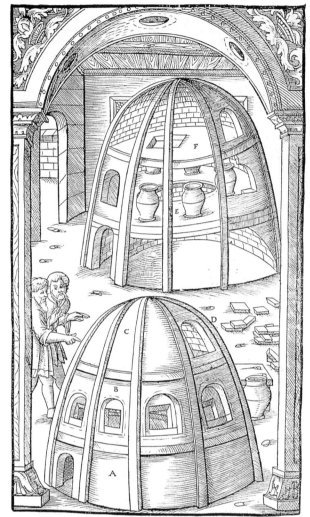

1 (right). For centuries the most common shape for a furnace was a dome, divided into three levels. This engraving shows the inside of a 16th-century furnace. The firing chamber is fuelled from below with wood or coal. In the middle section the glass is held in earthenware melting pots. The fire can reach this level through a large opening in the floor. Access to the pots is through small openings in the wall. Normally each furnace has six melting pots, or crucibles, and six corresponding work-openings, allowing several glass-blowers to work simultaneously. At the top is the annealing chamber where the finished products cool slowly, to prevent breakage.

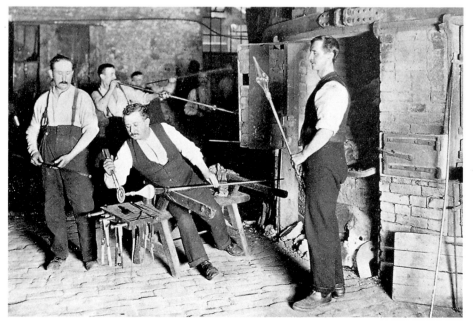

2. Each team consists of a master glass-maker and one or two assistant glass-blowers. An assistant, left, is waiting for the master to finish the foot of a goblet. In his hands is the punty-iron which will be attached to the underneath of the foot of the goblet. The top can then be detached from the blowing-iron and reheated in the furnace, in preparation for the master's finishing touch to the rim. Another glass-blower on the right, has blown the bowl of the next goblet. The glass-maker's chair, invented in the 16th century, makes it easy for the master to concentrate on his work, while the elongated supports at the sides facilitate the constant rotating of the blowpipe.

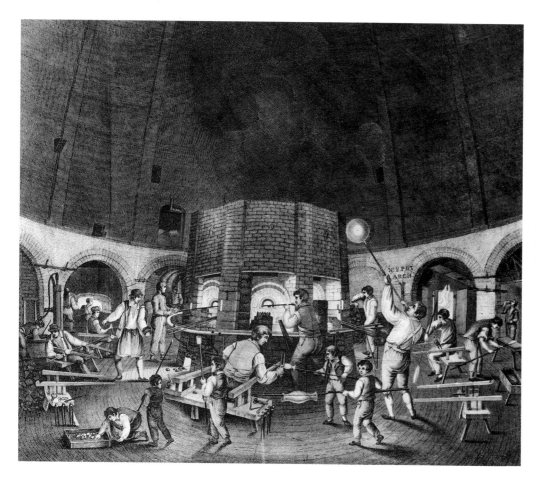

3. This late 18th-century print gives a good impression of the cramped conditions under which the glass-blowers worked. They had to stay close to the furnace because the glass would quickly cool when walking around with it. The heat meant that the glass-blowers consumed enormous quantities of beer or cold tea (back right). Traditionally, small boys were employed to perform simple tasks like carrying the finished objects to the annealing furnace, and the cleaning and preparing of tools.

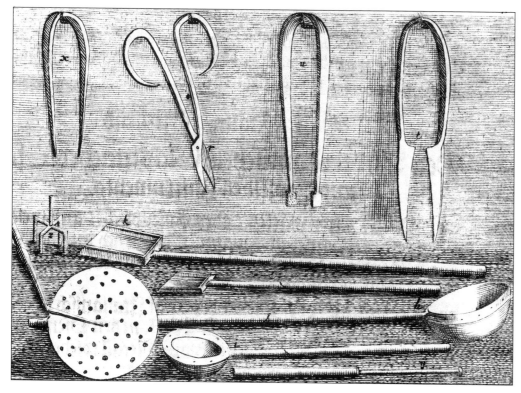

4. The tools of the glass-maker have hardly changed since Roman times. The blowing rod (bottom right) is a simple iron pipe of about four-foot long, often with a wooden handle at the end to prevent the hands from burning. Scissors (top row, second from left)) are used to cut away any excess glass. Final alterations in shape and any added decorations are shaped with the aid of shears (top right) and pincers (top left and centre) or sometimes simply a wooden stick.

THE ANCIENT WORLD

The First Glass-Makers

For the Egyptians glass was 'stone of the kind that flows', as it was for the Greeks, whose words for it signified 'transparency' or 'clarity'. Texts in the cuneiform (wedge-shaped) script of Mesopotamia (the ancient name for the land between the rivers Tigris and Euphrates) use words for glass not fully understood, but it is clear from various references that the early glass-makers were imitating precious and semiprecious stones. There is little evidence about how ancient glass production was organized, though cobalt-blue glass ingots, evidently of Egyptian origin, from the wreck of a merchant ship that sank off the coast at Ulu Burun in southwestern Turkey towards 1300 BC, confirm that glass itself was made in only a few places. With the exception of the Pharaohs, discussed below, it is not known for whom exactly glass objects were produced. The large number of surviving Mediterranean core-formed pieces suggests that they were quite widely available, but the comparative rarity of some other classes of non-blown vessels infers that the owners must at least have been wealthy, if not of the aristocracy or ruling class.

It is from Mesopotamia that the first glass objects come, dating from about 2500 BC; these are beads and small objects formed by simple tools or cast and finished by techniques familiar to stone workers. A technological breakthrough, the discovery of the core-forming technique about 1550 BC, led to the manufacture of the first glass vessels. This was to be the foremost method used in the production of glass vessels for the following 1,500 years. Recent experiments suggest that this process involved drawing molten glass from a crucible (fire-resistant container) placed in a furnace and forming it around a core of dung and clay mixed with a little water; adding the decoration by trailing soft glass of a different colour around the body of the vessel when it was out of the furnace and combing it into patterns with a pointed

instrument; and subsequently, after reheating, forming the shoulders, neck, and rim, and applying any handles, before placing the finished vessel in an annealing furnace, and afterwards removing the rod and the core. The first vessels appear to have been produced in northern Mesopotamia.

The Egyptian glass industry was born shortly after the Mesopotamian, though it was not until the time of Amenhotep III (1390–1352 BC) that vessels were produced in any great number. In earlier times beads, scarabs, and some statuettes were made very occasionally of Egyptian blue, a man-made material akin to glass. More commonly they were made of faïence, which consisted of a sandy core covered by a glaze, the composition of which is the same as that of Egyptian glass; some glass was used in jewellery in the eighteenth and seventeenth centuries BC at Tell el-Daba in the Nile Delta occupied by Asiatics, and a few glass beads date from about 1550 BC. However, new Mesopotamian glass-workers, brought back to Egypt after successful campaigns conducted by Thutmose III (1479–1425 BC) in Syria and up to the Mesopotamian borders, were probably responsible for establishing the glass industry. Most core-formed Egyptian vessels were designed to hold cosmetics and toilet materials and, like those of Mesopotamia, generally copy the shapes of vases already known in other materials (fig. 9). Thus, there are unguent jars with broad necks, hemispherical bodies, and tall trumpet-shaped feet, and ovoid jars and lentoid flasks probably for scented oil. Particularly popular are tubes for kohl (eye paint) in the shape of palm columns.

Another technique, apparently also originating in northern Mesopotamia, was that of forming vessels of mosaic glass. The first examples of the fifteenth century

5 (opposite). *Original or copy? Probably a masterpiece of Roman mosaic glass-making, this bowl was long thought to be a 19th-century copy.*

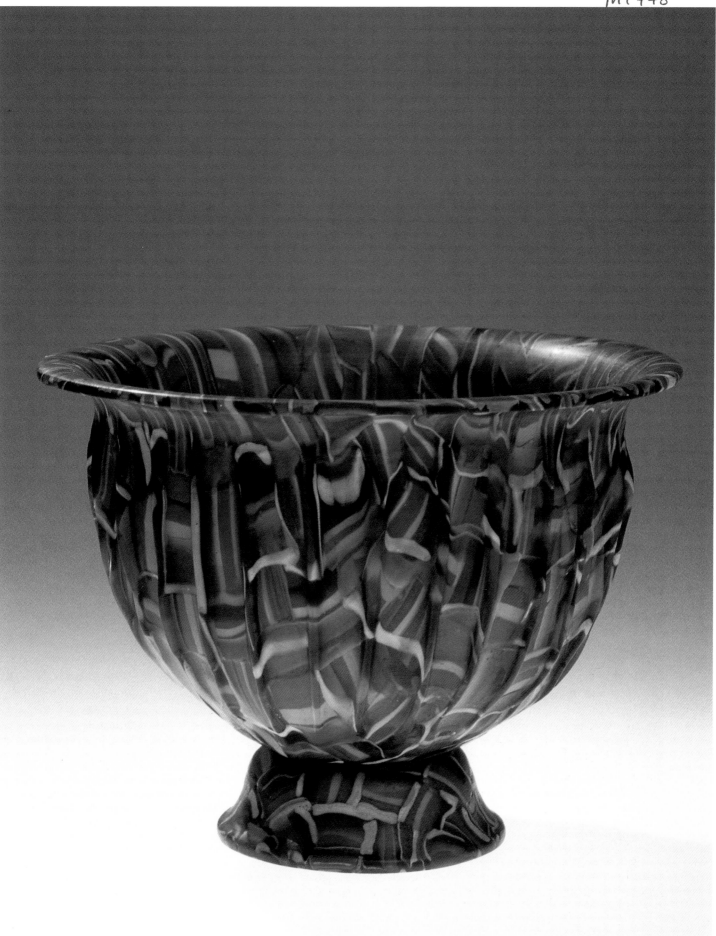

Glass of the Pharaohs

The tomb of Thutmose III (1479–1425 BC), the pharaoh credited with the introduction of Asiatic workers to found the Egyptian glass industry, contained the earliest glass vessel with enamel decoration. Of foreign inspiration, if not manufacture, it nonetheless established a tradition for the use of luxurious glass by the formidable Egyptian pharaohs. It was for them and their court that the splendid core-formed vessels for perfume, eye paint (kohl), cosmetics, and scented oils, the inlays originally set in other materials, and jewellery were made in glasshouses associated with their palaces. The quantity of fragments found at the palace of Amenhotep III (1390–1352 BC) at Malkata on the Theban West Bank of the Nile suggests that this was the site of an important glasshouse, and glass was certainly being manufactured at Amarna, the new capital of Egypt established by Amenhotep III's son Akhenaten (1352–1336 BC). This would have supplemented the imported supplies that we read about in diplomatic correspondence also from Amarna. At this time too Egypt seems to have been exporting glass, at least to Mycenaean Greece. The magnificent jewellery in the tomb of Tutankhamun (1336–1327 BC), in fact, mostly consists of precious metal settings for inlays predominantly of glass and illustrates how glass was used to replace inlays of semiprecious stones such as lapis lazuli, turquoise, and jasper.

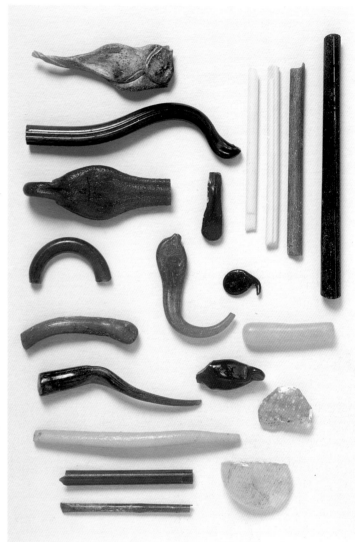

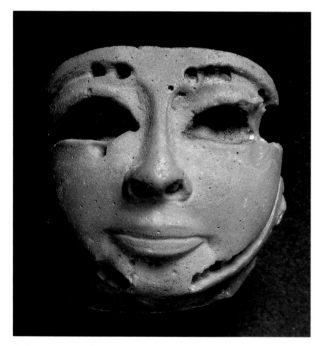

6. Statuettes and inlays were made of colours familiar to glass-makers, who were unable to follow the usual Egyptian conventions of flesh colours, reddish-brown for men and yellow for women. This head is part of a composite statuette, most likely of Amenhotep III. It was probably mould-pressed, the rest of the statue being made of stone, wood or ivory with a faience headdress and some other details gilded.

7. The glass manufacturing waste illustrated here comes from the palace of Akhenaten at Amarna. The discovery, alongside the glass debris, of furnace remains and, more especially, of a pan of frit (ingredients ready to melt), suggest that glass was actually being made, as well as worked, in these glasshouses at this time.

8 (right). Akhenaten himself is shown on this painted limestone stele (carved stone slab) of which half is preserved. Originally from Amarna, it is almost certainly from a private house. Akhenaten, in typical slouched Amarna pose, is seated on a lion-footed throne beneath the rays of Aten (a form of the sun god promoted by Akhenaten to be the supreme god) and before him would have been his wife, Nefertiti, who is mentioned in the text.

9. A core-formed footed unguent jar of opaque blue glass with three transparent blue handles, and a single orange trail around the rim and another around the edge of the foot. The neck and body are decorated with opaque white marvered (smoothed) trails combed into a feather pattern on the neck and festoons on the body, each pattern outlined at top and bottom with an opaque orange marvered trail. This fine vessel was made in the time of Amenhotep III (1390–1352 BC), perhaps for the pharaoh himself. Core-formed vessels are never very large; the actual size of this piece is only about 6.5 cm.

24431

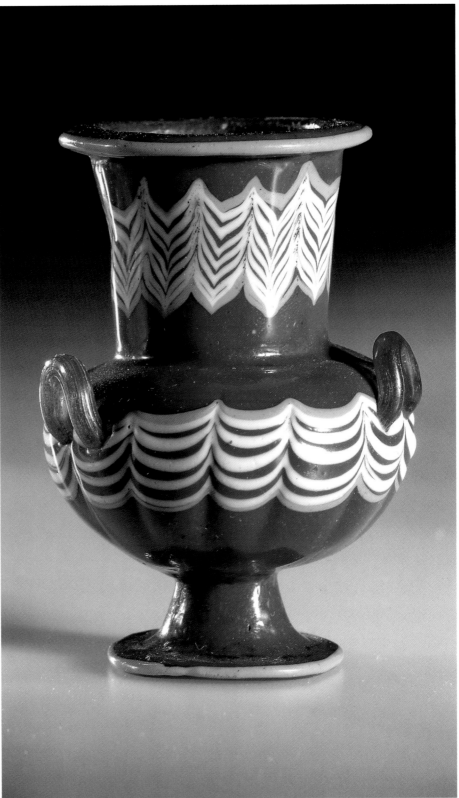

BC were made of monochrome pieces of opaque glass fused together and then shaped around a core or, for open shapes, slumped over a form. The latter process evidently involved 'draping' a fused disc of hot glass over a ceramic form (mould) in the required shape, and introducing the whole into a furnace or kiln, which allowed the glass to soften and fall downwards over the form. In the fourteenth century BC slices of multicoloured mosaic canes were used, anticipating the practice of Hellenistic and Roman glass-makers.

Glass-makers of this time in both Mesopotamia and Egypt also produced a great variety of objects including beads, pendants, ornaments, amulets, furniture inlays and figurines of deities, demons and animals, as well as, occasionally, small-scale sculpture. These may be of one colour and cast in open or closed moulds; others are polychrome and made of mosaic or core-formed glass. Simple beads and some more elaborate pendants were formed by wrapping molten glass around a wire or rod coated with a separating agent. Flat-backed amulets, jewellery settings, and inlays were cast in open moulds or mould-pressed, as were other objects such as plaques showing a nude female figure often identified as the Phoenician goddess Astarte (fig. 10). Mould-pressing involved pressing a mould on to soft glass that had been poured on to a flat surface.

Mesopotamian glass vessels and objects have been found all over the Middle and Near East from Persia (modern Iran) in the east to Syria and Palestine on the Mediterranean coast, and in Mycenaean Greece and Late Bronze Age Cyprus. Egyptian core-formed vessels travelled, too, to Syria, Palestine, Greece and Cyprus. A group of core-formed vessels found on Levantine (Syrian, Palestinian and Cypriot) sites differ from those of the Egyptians and seem to have been produced locally: diplomatic correspondence speaks of glass being exported to Egypt by kings of Tyre (in modern Lebanon) and neighbouring cities. There is some evidence too that glass

10. *A Mesopotamian figurine often identified as the Phoenician goddess Astarte. It was probably formed by pressing a mould on to soft glass.*

objects were being produced at this time in Mycenaean Greece. Exclusive to that area are bright blue ornaments, often in the form of spirals (representing locks of hair) or rosettes, cast in steatite (soft stone) moulds and made of glass evidently of Egyptian origin.

By 1200 BC Mesopotamian and Egyptian glass-makers had mastered all the techniques used by the glass industry before the invention of blowing. From 1200 BC to 900 BC very little vessel glass is found in the East, though beads were still manufactured, particularly in Syria, and glass technology was evidently introduced to Italy in the tenth or perhaps the eleventh century BC when beads were made in the Po Delta. In Egypt there was a hiatus in the glass industry from the end of the New Kingdom (*c.*1070 BC) until the 26th dynasty (*c.* 664–525 BC).

The Revival of the Glass Industry

Following this hiatus, glass manufacture was resumed on a large scale for inlays, which were set in ivory furniture panels and receptacles. These have been found in large numbers in the Assyrian palace at Nimrud (modern Iraq) and at Arslan Tash (Syria) and Samaria (modern Israel). Most are said to date from the eighth century BC, but they were first made in the ninth. It is tempting to see Phoenician glass-workers (from modern Lebanon) as responsible for these inlays, but we cannot be certain. About 750 BC glass vessels began to be produced by this revived industry. Many were of clear monochrome glass, usually in natural greens, or yellowish and greenish colourless, and only rarely in deliberately coloured glass such as blue, purple or aquamarine. For simple open shapes like bowls, used as drinking vessels, the glass was slumped over a form. More elaborate vessels such as jugs were perhaps formed around a friable and removable core, with handles and feet added as required at a later stage. Perfume flasks were evidently core-formed or made by a related technique around a metal rod coated with mould-release material (pulverised previously fired clay mixed with water). Phoenician glass-workers may have been responsible for all these vessels, which are often found in places with Phoenician associations. However, the

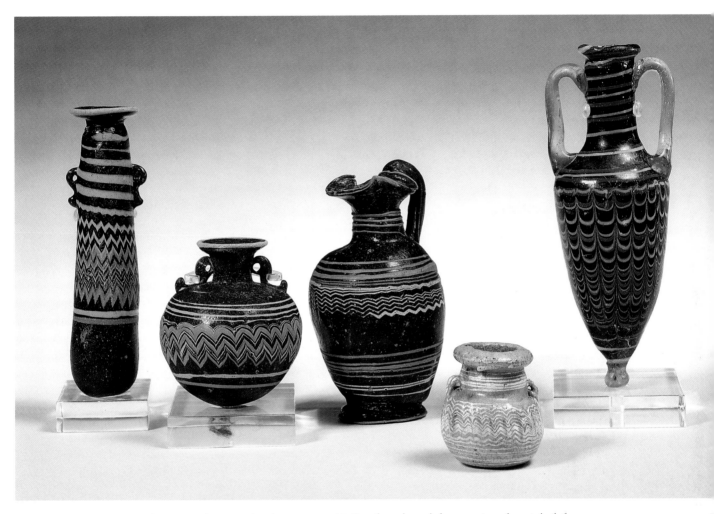

11. *Core-formed vessels for cosmetics and scented oils from Mediterranean workshops operating between 550 and 50 BC, together with an earlier Mesopotamian example (front).*

drinking bowls occur in large numbers in the Assyrian homeland (modern Iraq), appearing only rarely beyond its boundaries.

The tradition of polychrome core-formed glass was revived in Mesopotamian workshops at about the same time, in the mid-eighth century BC. Bottles and jars (fig. 11) are formed of dull translucent glass decorated with thread decoration limited to opaque white and yellow, very occasionally both are found together. Prominent among this group of rather dull core-formed vessels are *alabastra* (cosmetic flasks). Of particular importance is a group of at least five examples of the seventh century from the island of Rhodes that seem to have inspired the establishment of a prolific industry originally centred there. Although core-formed glass was produced in many other centres in western Asia and the eastern Mediterranean, and in central and northern Italy, by far the most numerous and widespread core-formed glass

vessels were these products of Mediterranean workshops, which were active between about 525 and 50 BC (fig. 11). Designed to contain cosmetics and scented oils, their shapes copy Greek vases of pottery and metal and are varied to follow contemporary fashions. The most common body colour is translucent blue and decoration usually consists of opaque orange, yellow, white, or turquoise trails that are combed into zigzag, festoon, or feather patterns. They travelled to every major site in the Mediterranean and also reached Egypt, the Black Sea, the Balkans and Gaul (modern France), perhaps initially traded by Phoenicians. There is no firm evidence for the location of the glasshouses, but it is possible that the vessels were first made on the island of Rhodes (inspired

by the Mesopotamian imports) and perhaps also in glasshouses further to the east, then in southern Italy and Macedonia, and finally in Syria, Palestine, and Cyprus.

Non-blown Traditions in the Hellenistic and Roman Periods

The Hellenistic period is the name given to the years between the death of Alexander the Great – king of Macedon and leader of the Greeks, who had ruled over the whole of western Asia and Egypt, as well as Macedonia and Greece – in 323 BC and the firm establishment of the Roman Empire in 30 BC. At this time, the glass industry was to flourish as never before in an era marked by the diffusion of a basically Greek (Hellenic) culture. Core-formed cosmetic containers continued to be made, but complete dinner services of monochrome glass were also introduced. A series of bowls, some of which may date from the late fourth or early third century BC, is made of sandwich-gold glass, where gold leaf is sandwiched between two colourless layers to form intricate designs. Mosaic glass was again widely used, notably for fused and slumped hemispherical bowls made of polychrome canes with spiral or star patterns, often interspersed with monochrome and occasional sandwich-

gold glass segments. Some were made of a type of mosaic glass invented at this time and known as 'network' or 'lacework'; canes of spirally twisted threads of different colours are laid side by side and fused together to form a disc ready for slumping, later in Venice known as *vetro a retorti*. The first examples of these mosaic glass bowls were made in the second half of the third century BC, but most date from the second century. Shallow dishes with upright sides or outsplayed rims were made in the second to first century BC. The location of the glasshouses responsible for these magnificent monochrome and mosaic glass vessels remains uncertain. Examples come from Greek settlements in southern Italy and around the Black Sea, and from sites in Greece, Asia Minor, the Aegean islands, Anatolia, Syria, Mesopotamia, and Egypt. Possible candidates are Alexandria, the new capital of Egypt founded by Alexander the Great; Greek settlements in southern Italy, where much of the tableware and mosaic glass plates have been found; or Rhodes, where sandwich-gold glass bowls were evidently being made in the second half of the third century BC.

12. During the Ptolemaic period in Egypt slices of multicoloured canes were inlayed into other materials, such as wood, and set in furniture or receptacles. The long rectangular plaque is built up from many slices of the same cane. The cane section (top left) shows the head of a crocodile.

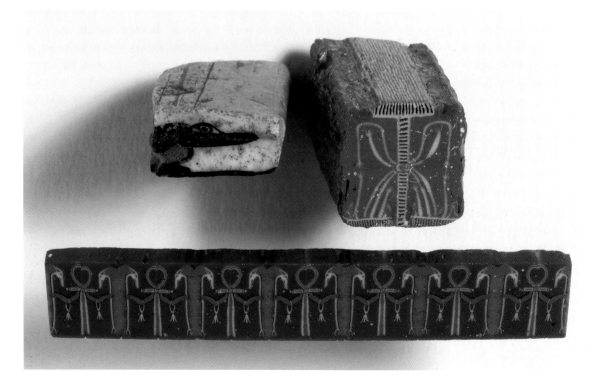

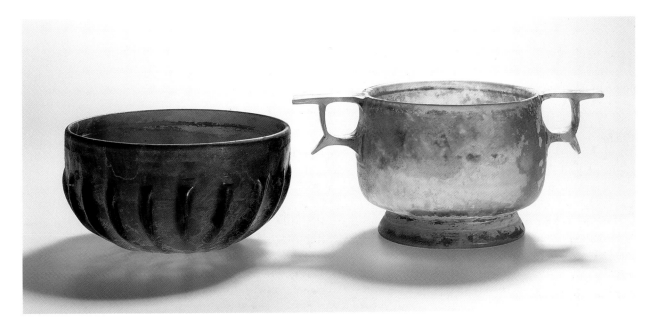

13. Two handled cup or 'skyphos' from the Late Hellenistic period and a Roman 'pillar-moulded' bowl.

In Egypt, where the glass industry was revived in the 26th dynasty (*c.* 664–525 BC), mosaic glass was being produced again at least from the reign of Nectanebo II (*c.* 360–343 BC). Typical of the time when the Ptolemies were in control (*c.* 323–30 BC) are intricate slices showing the mosaic technique at its finest. Coloured canes and other shaped elements were bundled together to form the desired face, figure, or pattern that was visible at both ends; the whole was heated until it fused and drawn out, thus miniaturizing the design. The resulting cane was then sliced like bread (fig. 12). Often only half a face was depicted on one slice, and two slices, usually from the same cane, were then joined together down the centre to show the complete face on a square ground. Many slices, however, showed a complete figure or pattern, and they were often inlaid into other materials such as wood.

The mid-second century BC found the glass industry in full production. Glasshouses evidently established on the coast of Syria and Palestine produced a large number of bowls of various shapes, usually hemispherical or conical with pointed bottoms, in glass generally either colourless or of rather dull colours such as amber or green. They were usually decorated with concentric circles on the bottom or grooves near the rim on the inside or the outside. Made for nearly 100 years, these bowls were exported to sites in the eastern Mediterranean and occasionally to the West.

The first century BC saw the introduction of new types of mosaic and monochrome vessels. The glasshouses producing the bowls just described were evidently now responsible for a variety decorated with ribs on the outside, the forerunners of a series from the Roman period with evenly spaced ribs, often described as 'pillar-moulded', that were produced in both Eastern and Western glasshouses in monochrome and mosaic glass (fig. 13). The ribs were evidently achieved by pressing a radiated ribbed mould on to a preformed disc of soft glass, before the slumping process described above. Innovations of the first century BC in mosaic glass included colour-band glass, when canes of different colours laid side by side were fused together, and gold-band glass used together with coloured bands to make bottles for scented oils and perfume. The latter were formed around a core and were probably made alongside the latest series of core-formed cosmetic bottles discussed above.

By the time of Augustus, the first Roman emperor (27 BC to AD 14), the glass industry was in the process of being revolutionized by the invention of glass-blowing, but until the middle of the first century AD non-blown glass continued to be made in a wide variety of colours and types. An important development is the establishment of factories in Italy, where glass is found for the first time on several sites. Production continued in the eastern Mediterranean and many of the types, such as 'pillar-moulded' bowls (fig. 13), have their origin in the

preceding Hellenistic era. Innovations include a wider variety of patterns and more brilliant colours. Coloured strip mosaic, that employs short strips of coloured cane, was used particularly in Italian factories, perhaps in Rome itself. The city is probably the source of magnificent ribbed bowls on tall feet, made of this type of mosaic glass. Illustrated here is the only surviving complete example which might be Roman (fig. 5).

Blown glass had become the norm by about AD 50 and by the end of the first century AD most production of non-blown vessels had ceased. However, there are a few later series in both monochrome and mosaic glass, and core-forming was revived in Syrian glasshouses for pendants in the late Roman period and for vessels in the fifth and sixth centuries AD. Throughout the Roman imperial period, too, non-blown glass continued to be used for a variety of items other than vessels, notably for jewellery. Glass tesserae (cubes) were regularly incorporated in both wall and floor mosaics and another type of wall and floor decoration known as *opus sectile* made use of coloured marbles and sometimes also glass cut into

14. *Egyptian terracotta group, from the Roman period, showing Eros (the son of the Greek goddess of love) at a glass furnace holding a blowing iron and a crucible (fire-resistant container). The furnace has two openings essential for firing glass.*

geometrical shapes. In the late Roman period figures were sometimes included in the design and some panels of Egyptian manufacture are made entirely of glass. Plaques showing both figures and foliage designs may have decorated walls or possibly furniture or containers. Until the mid-second century AD Egypt was the main centre for the production of rectangular tiles, usually showing groups of stylized flowers and plants in a grey-blue ground.

Blowing Glass: A New Technique

Blowing heralded a complete revolution in the glass industry, and remains the foremost method of making glass by hand to the present day. Discovered in the middle of the first century BC in the Syro-Palestinian area, long associated with glass manufacture, blowing enabled the production of glass vessels in a wide variety of shapes and sizes more easily and quickly than by any earlier technique (fig. 22). The first requisite for blowing glass is a hollow tube (fig. 14). Examples of glass were found with small bottles in a context of 50 BC. Here one end of a glass tube was pinched shut and then inflated by blowing through the open end to form a bottle, and it is possible that bottles continued to be produced in this way that required no elaborate furnace or technology, although no remains of such glass tubes have been found with other glass debris. The lack of finds also precludes the use of clay tubes, and it seems likely that most pipes for blowing glass were of metal. Only by the use of a metal pipe could the glass-maker in antiquity produce the wide variety of shapes and sizes of glassware that has survived. Molten glass, crucibles and other equipment including a furnace, a marver and a pontil would all have been necessary in earlier times as well.

By the close of the first half of the first century AD blown-glass vessels had become the norm, and within the next fifty years other methods of glass vessel production had all but disappeared. Factories already established in the Syro-Palestinian area and in Italy increased their output, and new glasshouses were established all over the Roman Empire. In Italy, glass factories at Rome and in Campania are mentioned in literature of the first century AD, and a glass-maker (unusually a female) records her origin as Aquileia in the north on two bottles found in Switzerland. Funerary inscriptions mentioning glass-makers occur in Lyons (Gaul), Athens (Greece), Mauretania (Morocco) and Dalmatia, but otherwise

glass-making sites are identified from finds of furnaces and tools, and also glass lumps and stocks of vessel fragments, such as might have been of use to the glass-worker. However, many more must have existed than have hitherto been identified to produce the vast number of Roman glass vessels and objects that have survived. The important glasshouse at Cologne in the Rhineland was perhaps founded in AD 50, when the Emperor Claudius made the town a colony at the request of his wife, Agrippina the Younger, and the quality and quantity of glassware on military sites suggests that the Roman military made its demands on the industry. But fine glassware also occurs on Roman sites with no military connections, and Roman glass found beyond the boundaries of the Roman Empire in northern Europe, Russia and Afghanistan was probably imported principally from glasshouses in Syria or the Rhineland. Aquileia is mentioned again in documents of the third century AD that shed some light on the organization of the Roman glass industry by drawing a distinction between glass-cutters and glass-makers.

Some forms of free-blown glass introduced in the first century AD continued to be made for the next two or three centuries, under-going various modifications. These included perfume bottles and larger bottles for wine or oil, and cups, plates and bowls of natural bluish-green or light-green glass made until the closing years of the Roman Empire. Differences in the forms of these common blown vessels allow Eastern products to be distinguished from Western and sometimes the assignation of a particular group to a certain area. Italian workshops favoured coloured glass and in the first century AD produced a number of jugs, jars and flasks decorated with coloured blobs that were picked up on the vessel while it was warm so that they became embedded in the glass. From the factory at Cologne in the Rhineland come flagons, with long necks and angular handles, and globular jars, decorated with ribbing.

Blowing into a decorated mould, or mould-blowing, was introduced about AD 25 and this technique

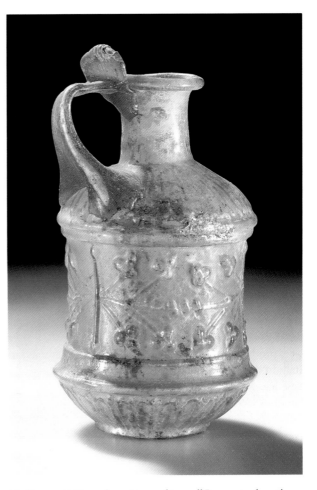

16. *The mould-blown decoration on this small Roman jug from the 1st century AD, is extremely sharp and crisp. The iridescent surface effect is due to the chemical reaction with the soil in which this jug was buried.*

15. *Hardly any Roman moulds for glassmaking have survived. This Islamic metal dip-mould was used much later, in the ninth or tenth century. The Romans probably had one-piece moulds, but more sophisticated, multi-part moulds were in widespread use.*

both determined the vessel's shape and imparted designs. Moulds of fired clay (terracotta) seem to have been preferred, but examples of stone, plaster, wood, and sheet metal have also been found (fig. 15). Studies of mould-blown vessels suggest the use of multipart moulds that would have required great skill on the part of the mould-maker and the glass-blower. A fine early group, made for one or two generations after AD 25, often carry Greek inscriptions with slogans such as 'your good health' or 'success to you'. Particularly significant are the names of makers, one of whom is Ennion. Another series consists of small bottles, jugs, and boxes of deep coloured translucent, opaque white, or blue glass made in moulds of three or four parts that have several sides, often six. They are decorated with fruit, flowers, or symbols the meaning of

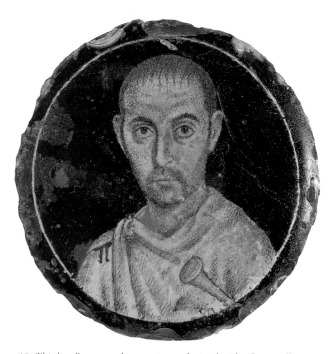

19. *This late Roman male portrait was depicted with a fine needle point in gold leaf laid on blue glass, before it was covered with a layer of colourless glass.*

gold leaf with added painted (or enamelled) details before being sandwiched between two colourless layers (fig. 19). Most are roundels evidently from the bottom of bowls, but some are simple medallions. Many of those showing Christian scenes come from catacombs in Rome.

Cutting was one of the most common decorative processes for the Romans, as it had been in earlier times, and we have already noted the distinction drawn in third-century AD written records between glass-makers and glass-cutters. Glass was always cut when cold, and the tools employed were no doubt similar to those used by other craftsmen, particularly gem engravers. Certain linear and facet-cut designs may have been made with wheels, but these could have been simply formed of a pierced stone on a stick with a hand-turning device and fed by easily available abrasives such as sand or wood ash (fig. 18, far left). Engraving may have been undertaken freehand with a flint or similar tool. Polishing and some cutting could be achieved using files of metal or wood fed by abrasives, and the easiest way to form the decorative grooves often found at the rims of vessels is to use such equipment while the vessel rotates slowly on a device like a potter's wheel.

The apogee of glass-cutting in antiquity is represented by 'cage-cups'. A thick blank was blown, and then cut away, perhaps using simple files bent at the end and fed by abrasives, sometimes to create an openwork design connected to the background by 'bridges' hidden behind the decoration, though for several the 'bridges' (or 'cages') form the design. The majority were evidently made in Cologne in the later third or fourth century AD.

The story of Roman glass comes to an end at the beginning of the fifth century AD when the Roman Empire finally collapsed in the West, but Roman traditions were to persist in the East for several hundred years. Cutting and engraving to a high standard persisted in Syria into the sixth century, and experiments with trailing produced an imaginative series of perfume bottles with basket handles and often double bodies.

Glass of the Franks and Saxons

The chief inheritors of the Roman Empire in the former northwest provinces were the Franks, an amalgamation of Germanic barbarian tribes. Glass-making flourished under Frankish control in the long-established glasshouses in the Rhineland, Belgium, and northern France. Different types of drinking vessels were made, among which the best known are 'claw beakers' (fig. 20). The claws were formed by dropping hot glass on to the wall of the vessel, and pulling part of the wall out and down to form a claw, leaving a hollow on the inside, a particular feature of the surviving claws. Cologne was a centre of production, but many have been found in southeastern England. It is possible that glass-makers accompanied the Germanic tribes, including the Angles and Saxons, who arrived in England following the Romans' departure in AD 410, and that they founded glasshouses in Kent as early as the fifth century AD. 'Bag beakers', that take their name from their bag-like appearance, were among new types introduced in the late sixth century (fig. 20).

Until the ninth, if not the tenth, century AD glass was quite plentiful, if generally utilitarian, and some colourful pieces were produced in Continental and even British glasshouses. However, nothing of the quality of the finest vessels of earlier periods of antiquity was made in European glasshouses before the Italian Renaissance.

20 (opposite). *A 'bag beaker' and a 'claw beaker', both excavated in Kent, where they were probably made by Saxon glass-makers.*

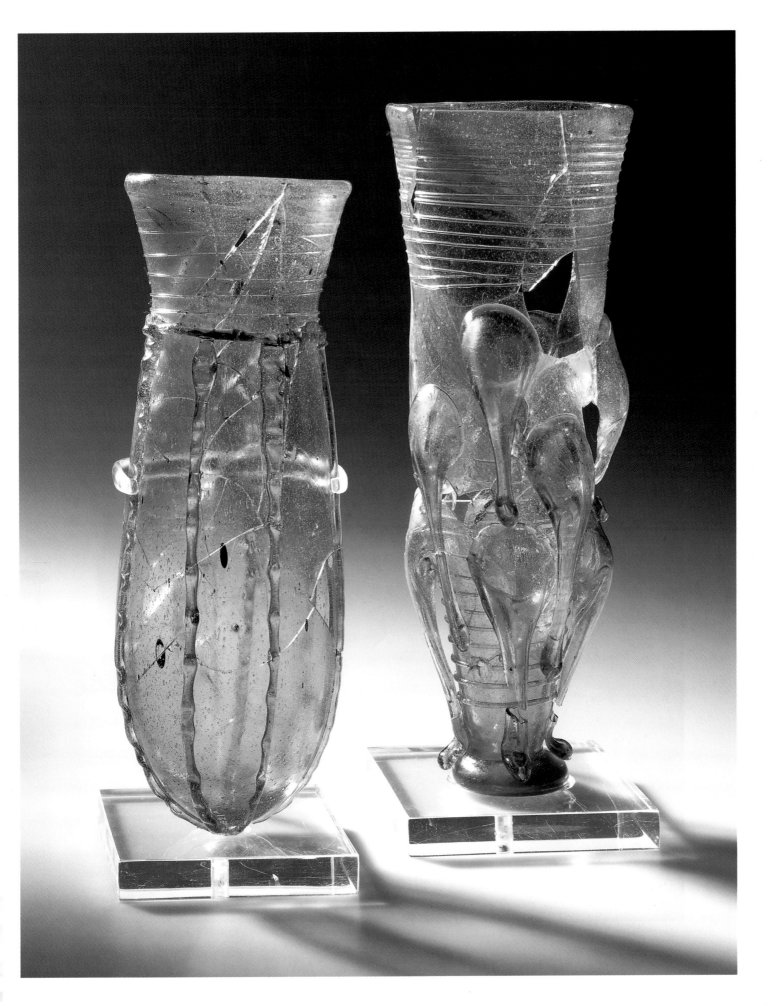

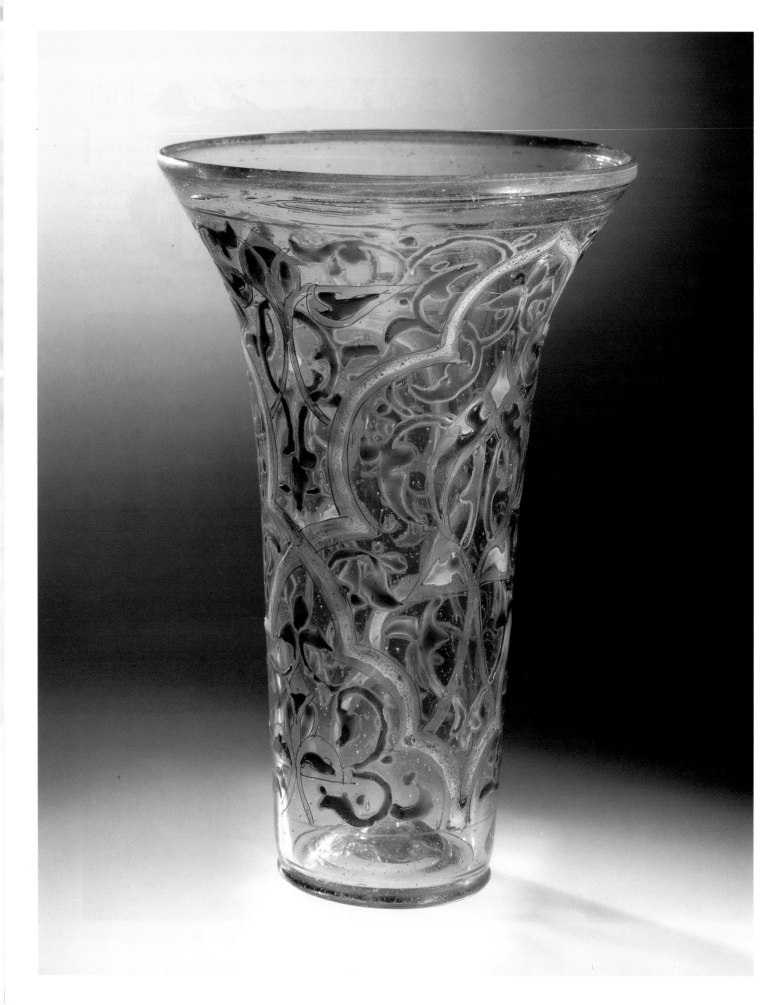

GLASS FROM THE ISLAMIC WORLD

Islam and the Islamic World

The sudden rise of Islam as a major world religion and civilization is one of the most astonishing episodes in the history of mankind. In about 610 AD the Prophet Muhammad, a merchant from Mecca in Arabia, began to receive revelations of the new religion to be called 'Islam', or 'Submission to God', the final and true monotheistic faith of which Judaism and Christianity were deemed to be imperfect predecessors. By the time of Muhammad's death in 632, all the tribes of Saudi Arabia were united in allegiance to Islam. After his death, they were organized into armies that swept north, west and east to conquer territories in the name of the new religion. Directed by the caliphs (the successors to the Prophet) in Mecca, within a mere 10 years the Islamic armies had taken control of Syria and Egypt, the richest Byzantine provinces, and had destroyed the Iranian empire. To administer the enormous new territories, the Islamic capital was moved first from Mecca to Damascus in Syria in 660 AD, then to Baghdad in Iraq in 750 AD. By this date the Islamic armies had penetrated deep into Central Asia and had crossed from North Africa up into Spain, their northward progress finally being stopped near Poitiers, in southern-central France, by Charles Martel, the 'Hammer of the Moors', in 732.

The transformation of this speedy conquest into a stable and unified empire is no less astonishing. Political disintegration soon began to divide the Islamic world, but an intellectual, cultural, and economic unity continued, underpinned by the unity of faith. Certain aspects of Islamic civilization have profound implications for artistic and industrial manufacture.

25. *The good fortune of the Musgrave family of Edenhall was deemed to depend on this beaker's preservation. It must have been brought to Europe from Syria soon after it was made there in the 13th century.*

Trade and the City

To a great extent the character of the new Muslim world was determined by the growth of large cities. New cities of enormous size were founded in the early Islamic period – such as Baghdad, and Fostat (old Cairo) – while old ones, such as Damascus, were developed. These cities, with populations of tens or hundreds of thousands, undreamt of in Europe at that time, generated enormous wealth in manufacture and trade. Trade, greatly facilitated by the ease of travelling through the unified Islamic world, was a particularly important economic force. The immediate locality of any big city would provide basic foodstuffs, but the bazaars were filled with specialities from across the entire Islamic world: spices, perfumes, textiles, metalwork, ceramics, and glass would be brought hundreds of miles from their place of origin to supply the great urban centres with their luxuries. The wealth gained through this trade was not just concentrated in the hands of an aristocracy, but was spread down through the merchant and professional classes. The possibility of travelling easily and widely through the Islamic world was exploited not just by merchants, but also by craftsmen and artisans, who would move long distances with their families to find profitable new markets.

Uses of Glass in the Islamic World

The history of Islamic glass is generally divided into three periods: the first lasting until the eleventh century, the second from the twelfth to the fifteenth century, and the third up to the present day. Throughout the first two periods, glass was largely a consumer item, competing with other materials, especially silver, bronze, and fine ceramics, to provide, if not always luxuries, then the accoutrements of graceful living. More functional glass,

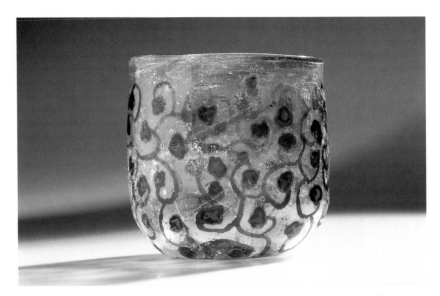

30. The debased vine-scroll on this 8th-century Syrian cup shows the continuing influence of late classical art.

frequently seen: bronze and silver provide the commonest prototypes, while carving in hard-stones such as rock-crystal or agate inspire the more ambitious wheel-cut work.

Painting with lustre pigment – a kind of silver stain – was a new Islamic invention, perhaps developed from late forms of Roman enamel painting on glass. Lustre's brilliant metallic reflections transformed everyday wares into objects of great luxury (fig. 30).

Enamel Decoration

Glass manufacture in Iran seems to have declined from the twelfth century. In Syria and Egypt, on the other hand, we see a transformation. Interest is now focused not on the manipulation of the surface as in the early period but upon painted decoration. Lustre-painted glass gave way, first to gilded, then to enamelled glass. Enamel pigments were made by grinding brightly coloured glass or minerals in oil. This mixture was than painted on to a finished object, and the piece reheated at the furnace, which made the colours fuse to the surface. A brilliant palette of red, blue, black, green, white, and yellow enamels, often combined with gilding, was fully exploited by the glass-makers. Elaborate arabesques are contained within friezes and panels, and often combined with inscriptions, sometimes giving the name of the sultan or his courtiers (fig. 31). Drinking beakers and serving bottles predominate in secular glass, where figural and human representation is also found. These objects were

evidently expensive, and were highly sought-after, as much outside as inside the Islamic lands. Pieces have been found in China, and throughout Europe. The fabled 'Luck of Edenhall' (fig. 25) made in Syria in the middle of the thirteenth century, had arrived in Europe very soon afterwards, perhaps as a treasured possession of a knight returning from the crusades; a leather case was made to protect it. The glass was long in the possession of the Musgrave family, from Edenhall in the north of England, where by the eighteenth century the myth had grown that it had been left behind by a party of fairies disturbed in their merrymaking near St Cuthbert's Well. As they vanished, one is supposed to have cried out: 'If this cup should break or fall, farewell the luck of Edenhall!'

The lamps made for mosques and other religious buildings in Syria and Egypt form an important group. In the Islamic Museum, in Cairo, a whole sequence of lamps is displayed which date from the thirteenth to the fifteenth century. The sequence is terminated, however, by a lamp in the traditional style, but clearly made to order in Venice. At some point in the fifteenth century, the Islamic glass industry had simply died out. Venetian imports continued to supply some luxury items, but it appears that in general much less glass was used. The disappearance of the Islamic glass industry has never been satisfactorily explained; some see its cause in the destruction of Syrian cities in the early fifteenth century by the Central Asian warlord and emperor, Timur (Tammerlane). Others blame the undercutting of the local market by

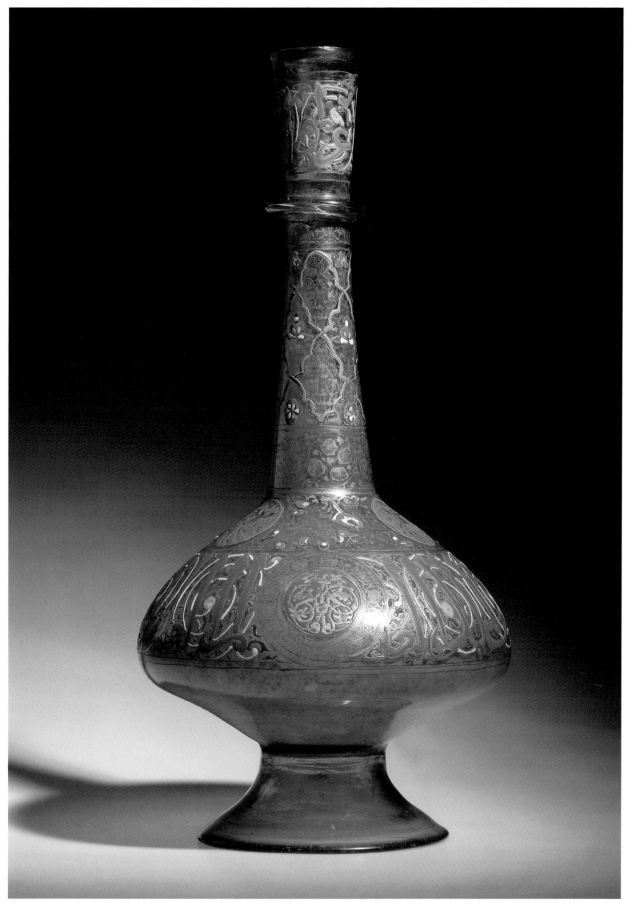

31. *Enamelled glass can produce a splendour of colour, unmatched by pottery or even silver and gold, as seen on this 14th-century bottle from Syria or Egypt.*

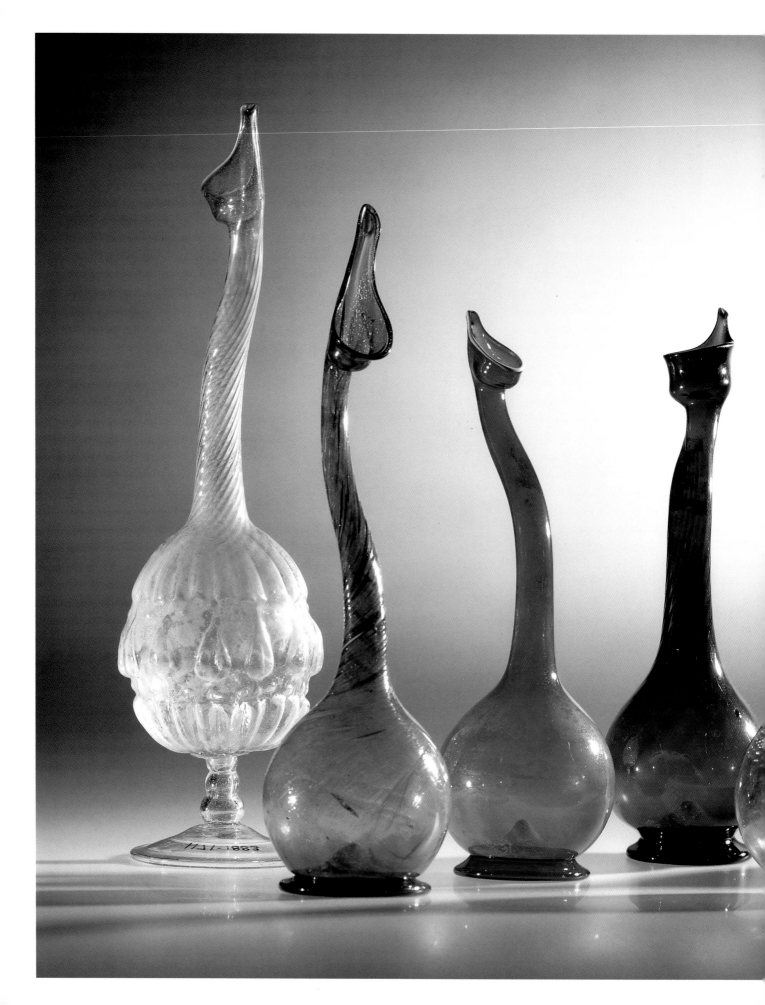

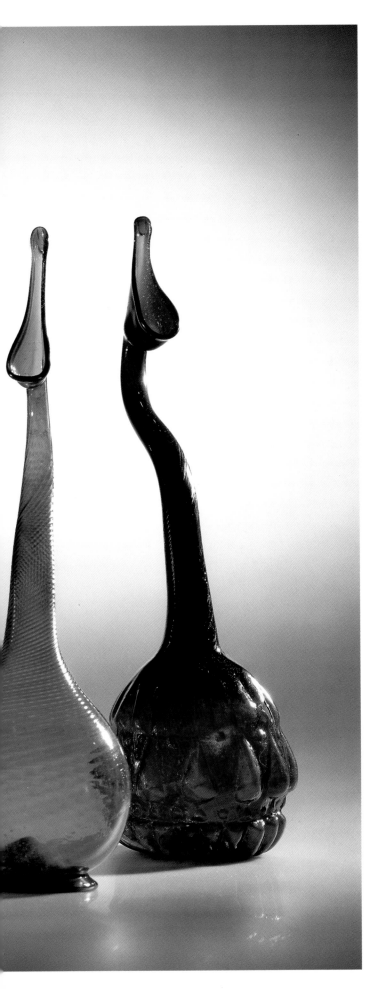

Venetian glass-makers. What is indisputable is that fine quality glass ceased to be made anywhere in the Islamic world for some centuries to come.

Late Islamic Glass

In the later period, the Islamic world relied generally on glass imported from Europe: initially from Venice and then from Bohemian glasshouses, which specialized in making glass in an 'Islamic' style specifically for export.

There is evidence of some later glass manufacture in the Islamic world – in Turkey from the sixteenth century, and in Iran from the seventeenth century. However, it appears not to have been fine glass, and consequently their products, not carefully preserved or sought after, are largely unknown. In Turkey there are reports of vessel and window glass-makers in the sixteenth century, and of people making dishes and bottles in Istanbul during the seventeenth century. A French traveller in Iran in the seventeenth century, Jean Chardin, reported that the art of glass-making had been known for less than a century when an impoverished Italian had reintroduced it, and that '... most of the glass is full of flaws ... and is greyish'. Jean Baptista Tavernier, another seventeenth-century traveller in Iran, reported that in Shiraz ' ... bottles are made in considerable quantities, both large and small, to hold rosewater and other perfumes... They also make ... vases into which to put the pickled fruits which are exported'. Large flasks were reported to be made locally for the export of wine – a famous and much sought-after product of Shiraz. These utilitarian products have not survived, and almost no glass can with any degree of certainty be attributed to Middle Eastern manufacture between the fourteenth and the nineteenth century.

In the nineteenth century, under the impetus of a nationalist promotion of indigenous arts and crafts, and the establishment of technical colleges on the European model, there were again attempts to revive glass-making. This was most successfully achieved in Iran, where with European help a prolific industry was established. Their best known products are fanciful perfume sprinklers (fig. 32), based on shapes seen in earlier miniature painting. Popular in Europe as 'exotic' decoration, they are often optimistically, and wrongly, dated to the sixteenth century.

32. *The myth that these 19th-century bottles were to collect the concubines' tears in the sultan's harem added to their appeal for European collectors.*

Lighting the Mosque

Enamelled-glass mosque lamps are some of the most spectacular and prized examples of Islamic glass-making. They frequently bear a famous verse from the Holy Qur'an which underlines the symbolic importance of the lamp as an object and glass as a material, as well as of light itself:

> Allah is the Light of the heavens and the earth
> The likeness of His light is as a niche, in which is a lamp
> The lamp in a glass, the glass as it were a shining star …
> Sura XXIV, V. 35

Inscriptions on enamelled glass lamps also often include the name and titles of the patron – a sultan or one of his courtiers – who built the mosque or tomb that they once decorated. The lamps thus serve both to symbolize the presence of God and to act as a reminder of the piety of the patron. The lamps are generally heavily decorated and this raises the question whether in fact they actually functioned as lamps. It is unlikely, given their size, that these vessels were filled with oil with a lit wick floating on it. Any light inside would have made the lamp glow with rich colour, like a stained-glass window, but would not have cast much illumination. It is more likely that light for those at worship or study within the mosque or tomb was provided by more numerous and simpler fittings, and that these lamps filled a decorative and symbolic, not a functional role.

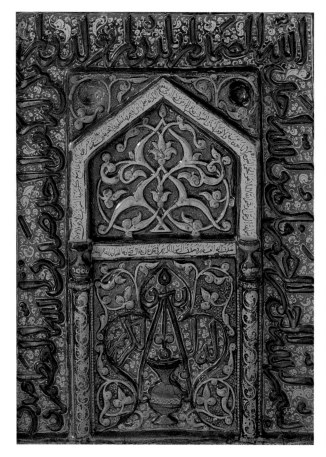

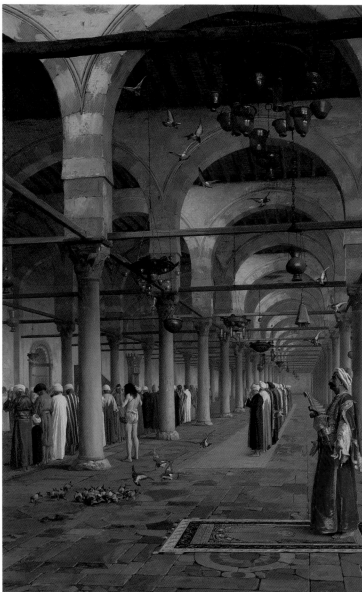

33. The decorative motif of a hanging lamp is frequently found on tombstones and on mihrabs, the niche in a mosque that indicates the direction of prayer towards Mecca, which suggests that real lamps may traditionally have been hung in this way.

34. *Prayer in the Mosque of Amr*, painted by French artist Jean Léon Gérôme in 1872, is a fanciful Orientalist scene. However, it shows a mixture of simple chandeliers for illumination and more ornate lamps hanging as symbolic decoration, such as may well have existed in the late medieval period.

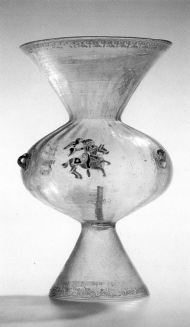

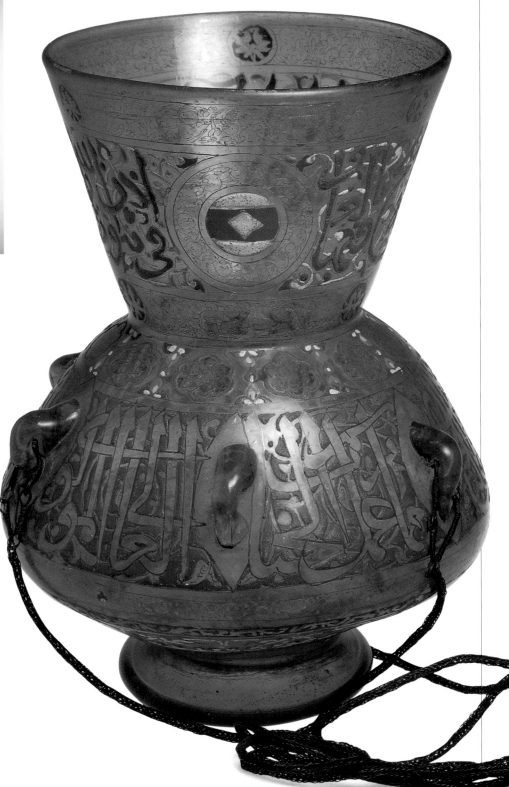

35. The glass tube in the centre of this lamp was intended to hold a wick, and the lamp would have been partly filled with oil (or as an economy measure, oil floating on water). The sparse decoration would allow the light to shine out. The figural decoration, forbidden by the pious in religious contexts, show that this lamp was not a mosque lamp, but was intended for secular use.

36. The inscriptions give the titles of Saif al-Din Aqbugha, an official in the service of the Egyptian Sultan al-Malik al-Nasir (r. 1331–42). It is one of perhaps several dozen that were originally made to decorate the patron's building. The suspension chains are old and may be original.

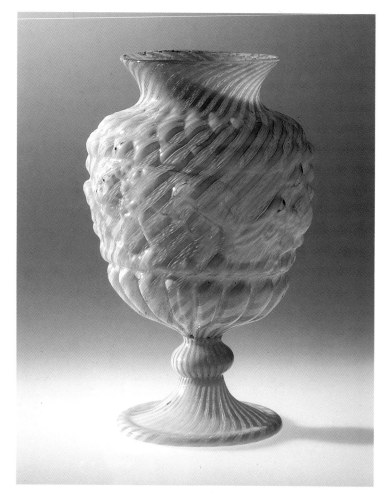

50. *The filigree patterns are deliberately distorted through mould-blowing in this late 16th-century vase, to form complicated patterns.*

or miniature cups and bottles. Marcantonio Coccio Sabellico, the same author as quoted before, wrote around 1495: 'But consider to whom did it first occur to include in a little ball all the sorts of flowers which clothe the meadows in Spring. Yet these things have been under the eyes of all nations as articles of export ...'

Filigree glass was, almost certainly, also inspired by a Roman example. It consists of colourless glass, incorporating patterns of opaque canes. However, unlike millefiori glass, the position of these canes is precisely controlled. The technique must have been invented by the Serena brothers, who applied for a patent on this type of glass on the 19 October 1527 stating that their work was, '... as never made before'.

There are two different ways of making filigree glass. The first method involved picking up a row of carefully arranged thin opaque-white canes on a bubble of colourless glass. The canes were secured in a perfect parallel pattern by laying them out in grooves on a flat surface, or in the grooves of a conical dip mould. In the first case, the bubble would be carefully rolled over the surface, and in the second it was gently lowered (pushed) into the mould. In both cases the canes immediately fused with the main bubble. They could be left raised in relief or they could be marvered into the colourless glass to form a smooth surface.

The second technique was certainly known by the middle of the sixteenth century and was used to achieve even greater precision and more dense patterns. For this prefabricated canes were used, made of colourless glass with a core of opaque white. Lengths of this cane were laid out side by side into a rectangular shape. This was introduced into the furnace so that the canes would fuse together to become one sheet of striped glass. This was picked up on a disc-shaped quantity of molten glass attached to the blowpipe. The sheet would thus be rolled up to form a cylinder, which could subsequently be closed at the end opposite the blowpipe, forming a glass bubble that could be further shaped in the usual ways. Although the first method probably predates the second, both techniques are combined in many sixteenth-century pieces.

Glass made with such white canes is called *vetro a fili*. More complex patterns could be achieved by using prefabricated canes, which already incorporated several opaque canes, twisted around each other. Such glass is known as *vetro a retorti*. Patterns could even become more complicated and intricate when they were distorted by further manipulation of the glass bubble. The whole pattern could become a spiral by simply twisting pontil and blowpipe in opposite directions. It could also be deformed by blowing into a patterned mould (fig. 50).

The most complicated variety of filigree glass is called *vetro a reticello* or network glass. For this a beaker-shaped vessel was prepared of twisted vetro a fili. This was kept hot while another vetro-a-fili bubble was blown

51 (opposite). *In the glass cabinet at Rosenborg Castle, in Copenhagen, the glasses are an integral part of the overall decorative scheme. Many of the pieces are executed in* vetro a reticello.

EUROPEAN SPLENDOUR

Enamelled Glass from the Holy Roman Empire

In order to compete with fashionable and expensive Venetian imports, from the 1530s some of the princes of the Holy Roman Empire poached glass-workers from Murano and set up their own cristallo manufactories in southern Germany and the Tyrol. These produced luxury glass which only the wealthiest families in thriving towns such as Augsburg and Nuremberg could afford. They commissioned mainly tall, elegant beakers (*Stangengläser*, literally 'pole glass') enamelled with their coats of arms, for display on the sideboard (*Kredenz*) or use on important occasions.

Even after enamelled glass had ceased to be produced in Venice, it remained popular with the German middle classes. During the sixteenth century, factories producing the cheaper traditional German forest glass expanded and increased in number throughout the imperial Länder to meet this demand. (These now equate to various regions in modern Germany, as well as the Tyrol in Austria, Silesia in Poland, and Bohemia in the Czech Republic.)

Most glasshouses were clustered around the Ore Mountains (Erzgebirge) which were rich in useful glass-making minerals and wood for fuelling the furnaces. This was also the most technologically advanced region, for instance, in terms of furnace construction and the development during the 1570s of the process of decolorizing glass with manganese dioxide. Coloured glass in dark blue, brown, white, and red was highly prized in the late sixteenth century (fig. 70). This was especially the case after Christoph Schürer, owner of the glassworks, Eulenhütte, discovered smalt, a mixture of cobalt oxide and white quartz which colours glass blue; his works produced enamelled blue glass steadily between the 1570s and 1610s. The Schürer and Preussler families were two of the main glass manufacturers in the area.

Many Saxon works moved to Bohemia, however, for economic and political reasons. Following the founding of the Bohemian state in 1627 and during the Thirty Years' War, Protestant glass-makers drifted back to Saxony.

Potash glass, being less ductile than cristallo, resulted in the production of sturdy, full forms, the most popular of which, from the 1570s on, was the massive cylindrical beaker called the *Humpen* (literally, mug or tankard), derived from the earlier *Stangenglas* (fig. 69). Humpen often had lids and afforded a large area for a bold painting style and diverse subject matter. They were designed to hold a good quantity of beer, even then a favourite German drink. Before the 1580s, the Humpen was usually referred to in documents as a *Willkomm*, *Luntz*, or simply *Glas*. Usually for communal use, they would be held in both hands as they sometimes held four litres or more and stood up to 60 cm (24 inches) high. Apparently, a guest was expected to drink the entire contents of the Willkomm (welcome) on arrival. Another type of Humpen, the *Passglas* (measuring glass), is marked with enamelled or trailed bands, representing portions. One had to drink an exact measure before being allowed to pass the glass on.

Other common types of glass vessel were bellied jugs similar to those in stoneware; mugs with pewter lids for cider or fruit wine; bigger tankards for wine; small beakers for liqueur and schnapps; and goblets, tumblers, and flasks. Enamelling on these vessel types is less precise and delicate than Venetian enamelling, and applied more boldly. Besides purely ornamental decoration, motifs can be divided into several distinct genres.

Political imagery appears mainly on *Reichsadlerhumpen* (imperial eagle beakers) shown opposite (fig. 69, left) and *Kurfürstenhumpen* (electoral princes beakers). The former depict the imperial eagle with the arms of the electors and members of the Holy Roman Empire either

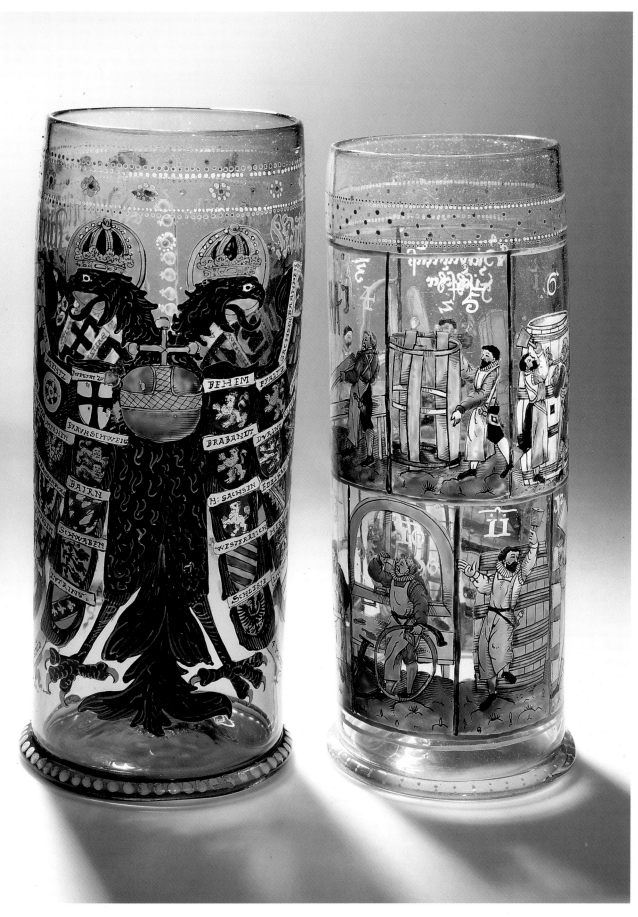

69. *Imperial imagery on a Reichsadlerhumpen (left) and a Humpen with a 12-scene sequence (right), depicting the processes involved in barrel-making*

with a crucifix (mainly 1571–1600) or an orb (mainly 1585–1743). The latter show the emperor with the electors either standing (mainly 1591–1605) or on horseback (mainly 1600–70). Otherwise they were made with little variation over the centuries, and indeed the Reichsadler design was used until at least 1683 as a compulsory test piece for aspiring guild masters. The formal images, based on literary and print sources from the fifteenth and early sixteenth centuries, present an idealized view of the structure of the empire.

The *Ochsenkopf* (ox-head) motif is an unrealistic depiction of a pine-clad mountain with bovine features, regarded as being the highest in the Fichtelgebirge between Franconia (now chiefly Bavaria, Hesse, and Baden-Württemberg) and Bohemia. Another important group shows trade guild emblems and depictions of guild members (fig. 70, right). Other motifs include biblical, historical, allegorical and mythological scenes; fables, hunting scenes, playing cards, musicians, drinking parties, toasts or pledges (sometimes wedding gifts); and landscapes. *Hofkellerei* (court cellar) glasses from the Saxon court are painted with the arms of the Elector of Saxony and were produced in vast numbers for use at banquets.

Towards the end of the seventeenth century, the new finely engraved and enamelled potash-lime glass began to eclipse the traditional enamelled ware which degenerated into naive folk art of a repetitive nature. Marienberg (a Preussler workshop founded in 1486) was one of the last manufacturers of high-quality wares, stopping its production in 1698. After that, large quantities of flasks and beakers, fairly crudely painted with a limited range of simple stereotype motifs and little regional variation, were produced for a wide popular market. Some were made specifically for export or were produced by Bohemian émigrés in Spain and Portugal.

The first copies of enamelled glasses of the 1570–1720 period appeared as early as 1798. The manufacture, however, of direct reproductions of original glasses, and Historicist glasses whose ornament stems from Dürer woodcuts and the like, began in earnest from the 1860s. Copies were not always made to deceive, but to give people the chance of owning traditional glassware. A number of firms such as Alber, Heckert, Stegenbach, Egermann, Steigerwald, Loetzsche Hütte, Klostermühle, and Weiseler produced copies of varying quality. Some are very difficult to distinguish from the originals, while others may look over smooth and fresh, or may have even been signed.

70. *Blue glass was popular in the late sixteenth century. The small mugs are painted with scenes from fables.*

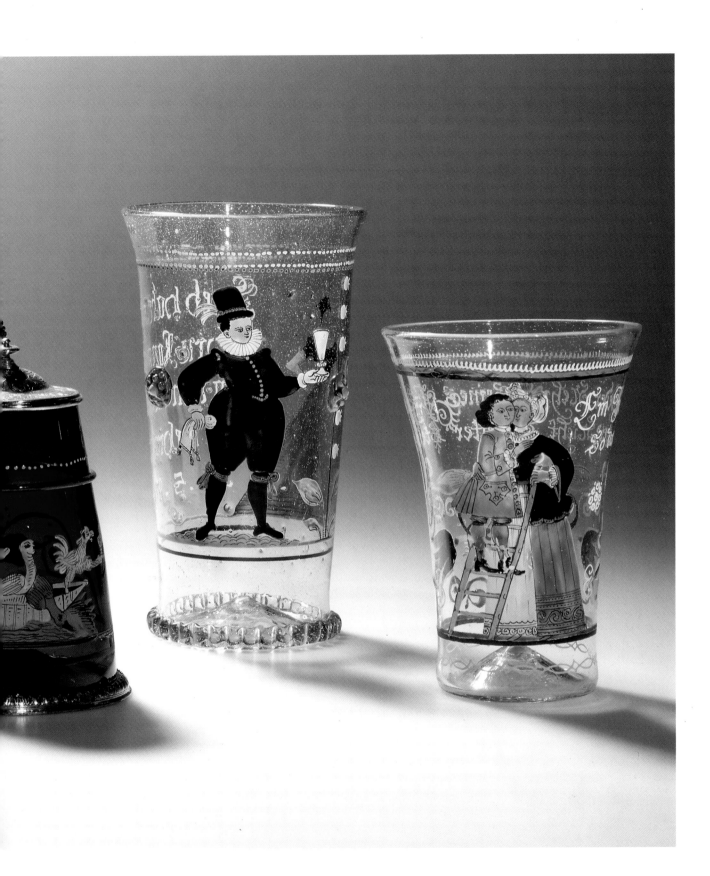

Independent Painters in Germany and Bohemia

In about 1660 a new technique of painting on glass was developed in Nuremberg. This was quite different from the Venetian technique of enamelling, which characteristically used broad areas of opaque enamel colours. Instead, the design was painted with a fine brush using low-fired translucent black and sepia-brown pigments, which allowed subtle tonal gradations and fine detailing of a type that would have been impossible to achieve following the Venetian technique. Sometimes touches of other colours were added, and occasionally a much fuller palette of translucent colours was used. Details were frequently incised into the enamels with a point, before firing. Such work was usually, but not exclusively, confined to small vessels, and was carried out by glass decorators who worked independently of the manufacturing glassworks. These painters, many of whom also decorated pottery and porcelain, are known by the German term *Hausmaler* (literally 'house-painter') and the technique is called *Schwarzlot* (black lead).

Schwarzlot decoration is similar to the method used by stained-glass painters, and it is significant that Johann Schaper (1635–70), its earliest known and most accomplished practitioner, was a stained-glass painter by training. A small school of Schwarzlot painters flourished at Nuremberg in the last forty years of the seventeenth century, and during the early years of the following one. The most talented of these followers of Schaper who enamelled glass were: Johann Ludwig Faber (b. 1660) and Abraham Helmhack (1654–1724) of Nuremberg; Hermann Benkert (b. 1652), who worked at Frankfurt-am-Maim; and Johann Anton Carli of Andernach (d. 1682). Later, in the 1720s and 1730s, work in this technique was carried out in Bohemia and Silesia by Ignaz Preissler (1676–1741) and his followers.

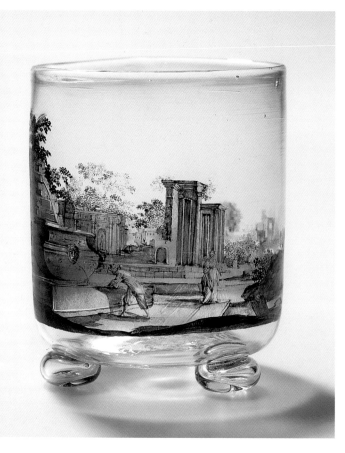

72 (above). Like many of Schaper's compositions, the source for the fountain and classical ruins on this signed beaker was a print, in this case one by Gabrielle Perelle (1603–77).

73 (below). Ignaz Preissler took the scene of Diana and Callisto on the spirit flasks opposite from this engraving after a design by Hendrick Goltzius. The Bacchanalian scene on the other bottle was probably likewise taken from a print.

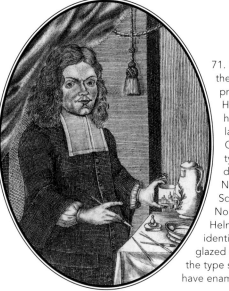

71. In his self-portrait the Hausmaler and print-maker Abraham Helmhack depicts himself holding a late 17th-century German beaker of a type frequently decorated with Nuremberg Schwarzlot painting. No glass decorated by Helmhack has been identified, but many tin-glazed earthenware jugs of the type shown in the print have enamelling by him.

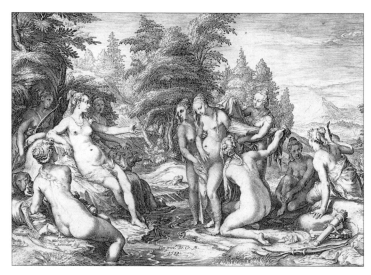

74 (above). Sweetmeat glass and beaker, and tea-bowl and beaker of Chinese porcelain, all enamelled in black with touches of colour, by or in the manner of Ignaz Preissler. Letters and accounts for the period 1729–39 show that in addition to painting glass Preissler decorated Chinese porcelain for his patron Count Kolowrat of Kronstadt in Bohemia.

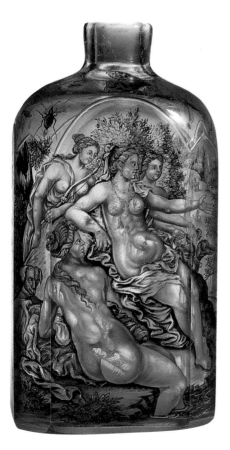
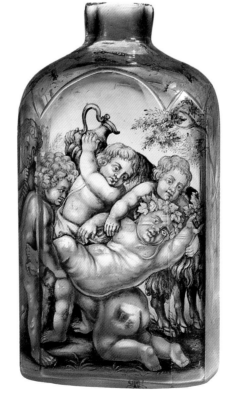

75 (left). The decoration of these spirit flasks is by Ignaz Preissler, who is known from contemporary accounts to have painted in a combination of black and red touched with other colours. They probably date from before his move to Kronstadt, where he is first recorded in 1729.

was trained at Munich, where there was an established tradition of hard-stone engraving, and where glass was certainly being engraved as early as the 1580s. By 1588 he was attached to the court of Emperor Rudolph II in Prague; and with the exception of the years 1606–8, spent in Dresden, he remained there until his death. In 1608 he was created 'Imperial Gem Engraver and Glass Engraver', and in the following year he received an exclusive privilege to engrave glass in Hapsburg lands. Lehmann's engraving on glass is largely confined to work on flat panels (fig. 78): these are rich in symbolic allusions to contemporary political events and to the upheavals at the start of the Thirty Years' War (1618–48), but their quality is variable.

Following Lehmann's death, in 1622, the imperial privilege was inherited by his pupil, the Nuremberg-engraver Georg Schwanhardt (1601–57). Although at least one glass engraver had earlier decorated glass in the city, Schwanhardt can be considered the founder of Nuremberg's famous tradition of fine glass engraving. From about 1660 until the second decade of the eighteenth century, engraving in Nuremberg was characteristically carried out on a distinctive type of covered presentation goblet standing on a tall, multi-knopped stem (fig. 79); precisely where these glasses were made is not known. Subjects included portraits, armorials, calligraphy, and hunting scenes. The engravers were noted craftsmen in their day, and their work was prized throughout Northern and Central Europe. Some fine Nuremberg engraving from the early eighteenth century is also found on ruby glass.

The vessels used by the Nuremberg engravers were of a clear and hard metal, but they were blown relatively thinly, and were not ideally suited to engraved work. In the last two decades of the century, after the new lime-rich glass had been introduced, spectacularly deeply cut and carved work was realized for the first time at the cutting mills of the rulers of three Hapsburg states – Brandenburg, Kassel, and Silesia.

Friedrich Wilhelm, the Elector of Brandenburg, established his first glasshouse in 1674. Subsequently he employed the alchemist and glass arcanist Johann Kunckel in 1678, and moved the glassworks to Potsdam (fig. 84). Two years later Martin Winter (d. 1702) was engaged as a glass engraver (being paid a salary equal to that which Kunckel himself received), and an engraving workshop was established at Berlin. Winter and his nephew and pupil Gottfried Spiller (1663?–1728) created

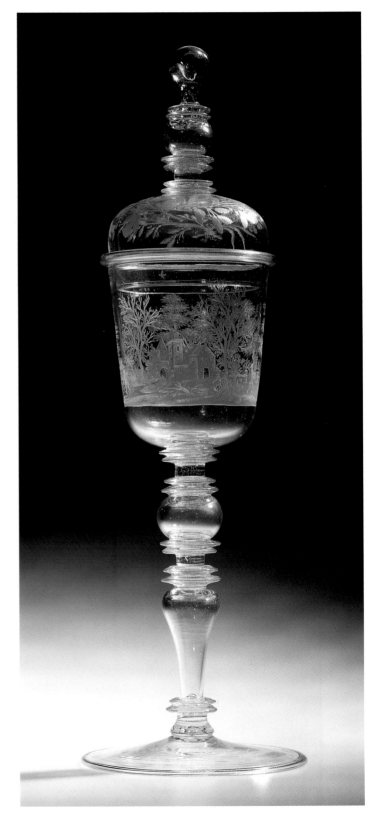

79 (left). *This distinctive type of tall standing cup was favoured by the Nuremburg engravers in 17th and early 18th centuries. It is not, however, known where they were made.*

80 (right). *The glass was possibly commissioned from the Potsdam-Berlin workshops by the Trier goldsmith Peter Boy, who made the enamelled gold knop in about 1701.*

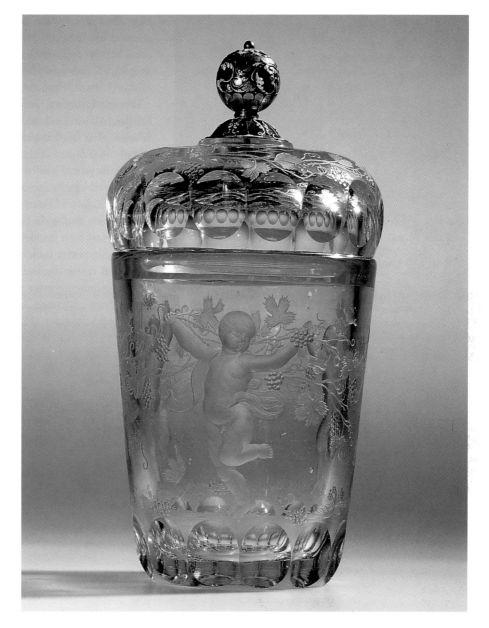

a distinctive body of work, the most characteristic products being massively thick cylindrical beakers and tall standing cups, carved in relief and engraved in intaglio with putti, armorials, and other subjects (fig. 80). Heavy goblets continued to be made at Potsdam and to be cut and engraved at Berlin until 1736, when the works were transferred to Zechlin.

The cutting mill at Kassel was started by the Elector of Brandenburg's nephew, the Landgraf Carl of Hesse; and the two men are known to have corresponded about glass-making as early as 1682. Two highly gifted engravers were employed at Kassel for work in high and low relief: Christoph Labhardt, and his pupil Franz Gondelach (active 1689–1717), some of this engraving being carried out on Potsdam glass.

In 1685 Count Christof Leopold Schaffgotsch of Silesia appointed Friedrich Winter (d. before 1712; brother of Martin Winter), as his glass-engraver, subsequently also awarding him exclusive privileges. A cutting-mill was built for Winter's use at Hermsdorf and was completed in 1690–1. This was equipped with water power, which facilitated deep undercutting and carving in the round.

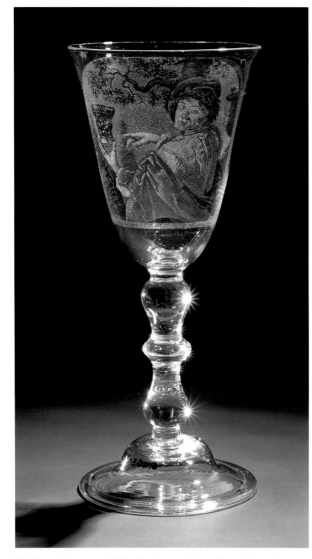

90. *Frans Greenwood of Dordrecht, near Rotterdam, is thought to have been the inventor of 18th-century stipple engraving on glass.*

Though some good stippling was done in the earlier decades of the nineteenth century, the Dutch tradition of glass engraving shortly came to an end when it went out of fashion as a pastime and as a decorative art.

The Biedermeier Style

The Napoleonic Wars of the late eighteenth and early nineteenth centuries had a devastating effect on the mercantile and social structures of Europe. After peace was finally established in 1815, the changes brought about by the shift in social and economic patterns meant that across Europe there was a new middle-class public to be satisfied and increasingly competitive international markets to be won.

At the beginning of the century the most influential product, internationally, was English and Irish clear, colourless glass with brilliant wheel-cut decoration. All over Europe, Russia and the United States, glass-makers adopted this style, which was well suited to decorate the heavy Neo-classical 'Empire' shapes of the first 15 years of the century.

With the emergence of a new social class, a new style developed which was much more intimate and lighter than the imperial style of Napoleon. This style became

91. *Throughout the summer months, Dominik Biemann had a business in the fashionable spa town of Franzensbad and relied heavily on the trade of the visiting middle classes, including perhaps the Englishman Joseph William Blakesley, below, who visited Franzensbad several times between 1839 and 1844.*

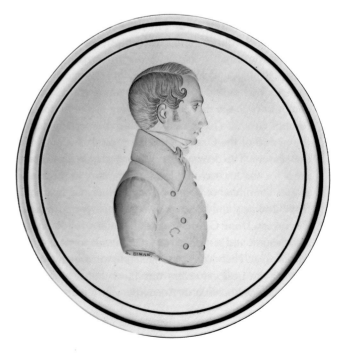

Dordrecht, the most talented being the painter Aert Schouman (1710–92), who also stippled some scenes after his own designs. In The Hague stipple engraving was taken up by the professional glass-engraver David Wolff (1732–98). His works are among the finest and most detailed. From a surviving invoice we know that he charged a very high price, undoubtedly reflecting both his remarkable skill and the elaborate nature of his work. During the heated struggle between Orangists and Patriots, Wolff stipple-engraved portraits of Stadholder William V of Orange and his wife, as well as those of leading patriots.

known as *Biedermeier*, after a fictional character invented by Ludwig Eichrodt in 1855–7, who was a caricature of the bourgeois citizen that typified the new market. It was, however, adopted by both the Austrian Imperial family and German princes, whose taste was otherwise rather grand and elaborate.

Biedermeier glass-makers placed an emphasis on detailed decoration and new subtle colours. Engraved and painted scenes appealed to the new bourgeoisie: portraits, romantic scenes, and allegories of love and friendship, as well as, landscapes, local views, flowers, and insects were especially popular.

The most common vessel shape became the beaker. Ideal to keep or to be presented as a souvenir, it provided a perfect vehicle for such decoration. As a result mostly single pieces were produced. Shapes were sturdy and heavy and often accentuated by deep cutting.

At the top end of the market, highly skilled engravers such as Dominik Biemann (1800–57) and the less well-known Heironymous Hackel catered for the latest generation of Central European aristocracy as well as for the newly wealthy, who visited the towns of southern Germany and Austria to take the spa waters or admire the scenery. Biemann specialized in extremely accurate but stylized portraits of his patrons, shown strictly in profile (fig. 91). Souvenir beakers were made in quantity, engraved with local views. Richly decorative, coloured, cased, deeply cut and gilded beakers and goblets, sometimes on a grand scale, were produced both for home and export markets in Bohemia and Germany. The most favoured subject for these pieces was that of the hunt, giving the skilled cutter ample scope in both drama and subtlety (fig. 92).

The Biedermeier style was, however, best expressed in a different glass medium. Enamel painting was revived, harking back to its heyday in the seventeenth and early eighteenth centuries. Friedrich Egermann (1777–1864) from Nový Bor (Haida), in Northern Bohemia, was one of the most important exponents, not least for his invention of the application of a thin staining in yellows (with silver sulphate) and red (with copper sulphate) to the glass surface in 1816 and 1832, respectively. Egermann, a chemist and technician, trained as a painter at Meissen. Other painters who are associated with him and were equally skilled include Samuel Mohn (1762–1815), who settled in Dresden, and Anton Kothgasser (1769–1851), who was a decorator at the Vienna Porcelain Factory, as well as a painter on glass (fig. 93). The work of these

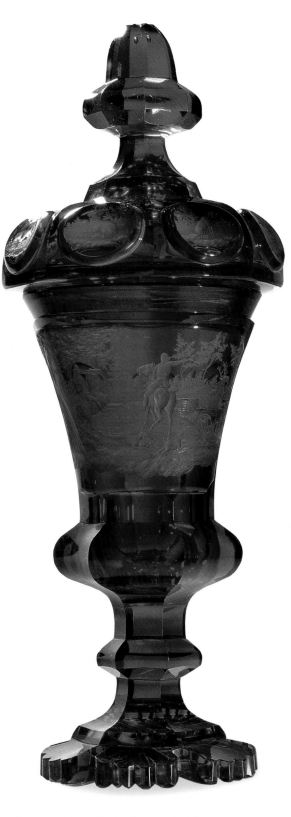

92. *The shape of this goblet has been largely defined by cutting in broad planes, before the engraved hunting scenes were added.*

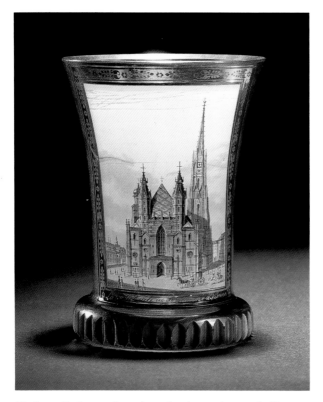

93. *Anton Kothgasser, formerly employed as a painter at the Vienna Porcelain Factory, opened a studio in Vienna around 1813, employing a small team to produce painted beakers like this.*

independent painters or *Hausmaler*, mostly confined to simple beakers, is characterized by extremely fine painting, even more detailed then that of the Schwarzlot painters of the late seventeenth and early eighteenth centuries (figs 71–75). Similar motifs to those used in engraving were employed, but a particularly popular subject was that of the townscape. Doubtlessly intended as souvenirs, they minutely depict the churches and squares of Dresden and Vienna.

The most distinctive contribution to nineteenth-century glass by Bohemian glass-makers like Egermann was probably the technical developments which led to a previously unachievable palette of rich and varied colours. In 1816 François de Longueval, Count von Buquoy (1781–1851), who owned glassworks on his estate at Nové Hrady in southern Bohemia, invented a dense, opaque, black, and red glass in emulation of Josiah Wedgwood's red and black stoneware, which he patented as 'Hyalith'. These dark colours proved extremely suitable for gilded decorations in Neo-classical or chinoiserie styles. Egermann took Buquoy's Hyalith and developed it further by

mixing different colours of opaque glass, resulting in a fine marbled effect to imitate semiprecious stones, which were given the name 'Lithyalin' (fig. 94). This marbled effect was best shown when the surface of the glass was cut with broad facets, revealing the different layers of coloured glass. As colourful glass came back into fashion, opaque white, clear red, blues, and yellows were applied over colourless glass providing two or even three layers through which wheel-cutting – cameo-style – gave a three-dimensional effect. Uranium provided the base for a fluorescent green and yellow glass, produced by the Austrian Josef Riedel (1816–94) at his glassworks in the Isergebirge, which were named 'Annagrunn' and 'Annagelb' after his wife. Opaline glass, milky-white or in limpid blue, pink or green, became particularly popular in France from the 1820s onwards. Sulphides, or cameo incrustations, porcelain plaques embedded in clear glass, were first developed in France at the Desprez Studio by Pierre Honoré Boudon de Saint-Amans (1774–1858), quickly followed by Apsley Pellatt (1791–1863) in England (fig. 129).

The Move to Independence: American Glass

Apart from two short-lived attempts to establish a glasshouse in Jamestown, Virginia, in the early seventeenth century, the American glass industry only became firmly established in the eighteenth century. Some large glassworks, started by German entrepreneurs, produced wares in the German-Bohemian and English styles. Imports from these countries, however, still maintained a very important share of the market. This balance changed dramatically in the early nineteenth century, when the importation of foreign wares was almost completely stopped, due to a series of events. A trade embargo between 1807 and 1814, the Napoleonic Wars and the War of 1812, between the United States and Britain, gave an enormous boost to the glass industry. By 1812 the number of glasshouses had risen to 44. By 1850 there were as many as 94 glasshouses. Although window glass was the main product, fine tableware was made in growing quantities. Well into the nineteenth century pincering remained popular, while mould-blowing became the most important technique. The more prestigious objects either have engraved decoration or are cut in the English style.

94. *This Lithyalin jug dates from about 1830. The differently coloured layers may be clearly seen through the wheel-cut planes.*

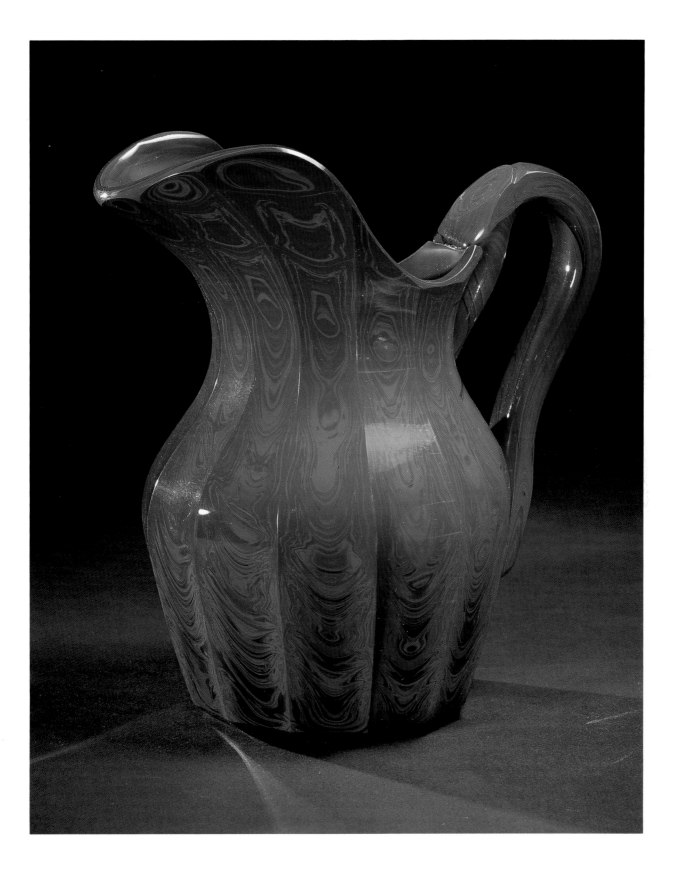

Chinese Glass

Glass has never been as important in China as in the West. While glass beads and glass-paste inlays were made as early as the fifth century BC, other materials such as ceramics and jade were accorded higher status.

Little is known about the history of glass-making before about 1640, when the writer Sun Tingquan gave a description of the glass industry at Shandong in his 'Liuli Zhi' (memoir on glass). Sun describes glass-blowing and even the making of filigree glass. At the end of the seventeenth century a glasshouse was set up in the Forbidden City, Peking, with the help of a German Jesuit priest. The dating of glass from the eighteenth century and before is difficult. Wheel-engraved reign marks were introduced at the end of the reign of Emperor Yongzheng (r. 1723–35), but his successor Qianlong (r. 1736–95) reigned for such a long time that these do not help much.

Chinese glass-makers often treated glass to create effects similar to those achieved in other media, such as moulded porcelain or carved hard-stone. Carving became, in fact, the predominant decorating technique. This could be limited to a simple carved footring or rim, or extended to more ornate low-relief carving. Cameo carving, through the outer layer of cased glass became popular towards the end of the eighteenth century. Never an export article of any significance, Chinese glass was not appreciated in the West until the late nineteenth century. The Victoria and Albert Museum was one of the first museums to collect it.

95. The earliest glass in China seems to have been made in the Warring States Period (481–221 BC), when beads and cast inlays appeared. Many items have been found in the graves of local rulers in north China, in Henan province. Beads with inset eye patterns derive from Egypt, though an unique feature of Chinese beads is an offset centre to the eye.

96. Glass vessels from the Qing dynasty (1644–1911) often imitate porcelain in both shape and colour. The silhouettes of these bottles from the Kangxi (1662–1722), the Qianlong (1736–95), and the Xianfeng (1851–61) periods, illustrate their gradual change in shape during the 18th and 19th centuries. The Victoria and Albert Museum also has similar blue bottles of the Jiaqing (1796–1820) and the Guangxu (1875–1908) periods.

97. The shape of this bowl mirrors porcelain examples of the Yongzheng and Qianlong reigns. The brilliant pink colour, derived from colloidal gold, was an invention of about 1720. It was likely to have come from Europe through the Jesuits, who supervised enamel painting on copper and glass at the Imperial Palace in Peking, and who could have been familiar with the work of Johann Kunckel (fig. 84).

98. This jar is thin and translucent, unlike the majority of 18th-century opaque-glass vessels. Its manufacture and design are of an extremely high quality. The flower panels on the shoulder, and the landscape panels around the neck, stand in relief, necessitating large areas of glass to be ground away. The decorative patterns are close to those painted on 18th-century porcelain.

99. One of the commonest uses for glass in China was for snuff bottles, many of them cased in contrasting colours. The habit of snuff-taking spread to China from the West during the 17th century and became established in the 18th century. These bottles from the late 18th and 19th centuries are decorated with typical motifs: lotus flowers, fish and a figurative scene.

100. The elegant design of fish, shellfish, and lotus was cut and ground through a thick overlay of glass, to reveal the turquoise, which has in turn been worked into a rippling lotus-leaf pattern. It is known that Japonism inspired late 19th-century Western designers, such as Emile Gallé, but pieces like this vase illustrate the lesser known influence from China.

BRITISH SUPREMACY

The Venetian Style in Britain

In common with other European countries, the history of English glass in the sixteenth and seventeenth centuries is centred around the quest for clear cristallo to replace the substantial importation of luxury glass from Venice, which had begun at least as early as 1399. Other similar attempts were being made to free Britain from dependence on imported goods: in the late sixteenth century Netherlanders successfully started manufacturing delftware tiles and drug pots in England made from native materials, but attempts to make salt-glazed stoneware ale mugs of German type failed through an ignorance of the process and lack of suitable clays and kilns. Cristallo glass, however, was so highly prized and so difficult to make that skilled and knowledgeable glass-makers from Venice and Altare were lured to Northern Europe in the hope that they would reveal their secrets and help to create fortunes.

When glass-making secrets reached the Netherlands and France, it was not long before they were brought to England, a country with wealth but poorly developed manufacturing industries. In 1587 Jean Carré, an experienced glass-maker originally from Arras, fled from religious persecution and settled in the Weald of Kent, the English forested heartland for making iron and glass, where he formed a partnership with other immigrants from Lorraine and Normandy to make window glass. By 1568 he was making *façon de Venise* glass, using imported soda or barilla from Italy, at Crutched Friars in London, thus for the first time adding luxury glass to the traditional branches of window and utilitarian forest glass in England. After the de Hennezels (one of the great Lorraine glass-making families working in England) had left the partnership, Carré imported nine Venetian glass-workers, of which the most significant was to be Jacomo Verzelini, a glass-maker with 25 years experience behind

him who arrived in 1571. When Carré died in 1572, and the business foundered, Verzelini was able eventually to acquire the working cristallo glasshouse in London with a ready market for its products.

By December 1574 Verzelini had obtained, against stiff opposition from the trade, a 21-year monopoly to make 'drynkinge glasses' of a Venetian type and to train English glass-workers, protected by a simultaneous embargo on luxury glass from Venice. The resulting products, made by Italian glass-workers and indistinguishable from the fragile contemporary Venetian and façon de Venise glass made on the Continent, would quickly have perished but for the fortunate custom of preserving inscribed objects as family heirlooms. There are 12 surviving engraved drinking glasses, with dates between 1577 and 1590, which can be attributed to Verzelini, firstly because of their English dedications, and secondly because of the recorded presence in London of a French immigrant glass engraver, Anthony de Lysle, about 1585 (fig. 101). In common with all soda glass from the period, the metal of these thinly blown and wrought glasses, with mould-blown stems, cannot truly be described as clear; but with their high quality, their short life expectancy and the complete absence of competition, manufacture proved profitable enough to enable Verzelini to retire to Kent in 1592, well before the expiry of his monopoly in 1595.

Although the glass vessels produced during this period survive mostly in a fragmentary state, the subsequent history of cristallo manufacture in England is well known from documentary sources. With the prospect of high-profit margins, speculators with connections at Court engaged in ruthless tactics to obtain a monopoly. Upon Verzelini's retirement, the courtier Sir Jerome Bowes immediately acquired a continued patent for cristallo, building a new glasshouse at Blackfriars, which was soon taken over by William Robson who in 1606 extended the patent for 21 years.

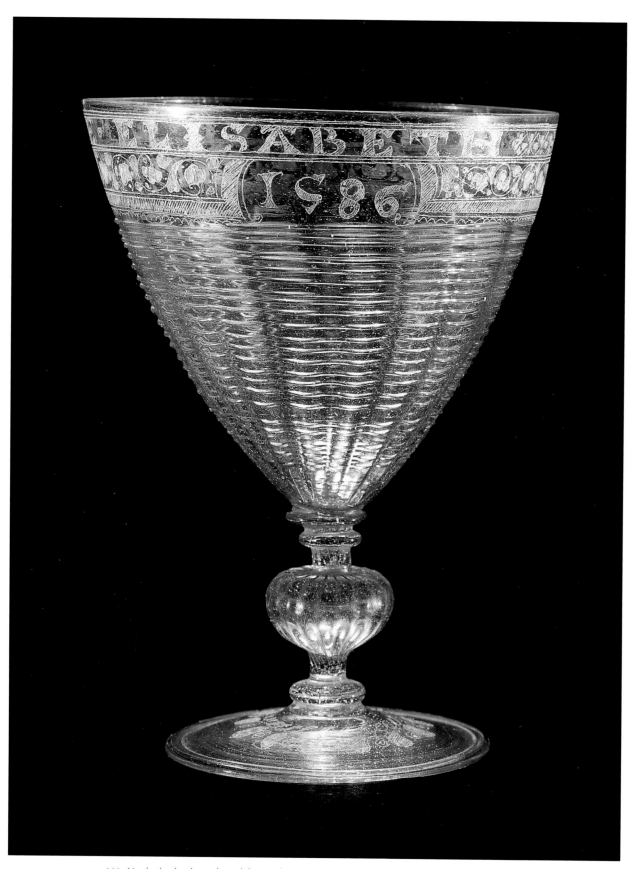

101. *No doubt thanks to their elaborate diamond-point engraved decoration, no less than 12 goblets
attributed to Verzelini's workshop in London, c. 1577–90, have survived.*

Coal-Fired Furnaces

At this point politics took a hand. The forests of Britain, which supplied timber for ship building, were depleted to such an extent that in 1611 Sir Edward Zouch was able to obtain a privilege to make window glass using coal-fired furnaces. The resulting patent, which included drinking glasses and supplanted the existing Robson patent, was confirmed by Royal Proclamation in 1615; but most importantly, it forbade the use of wood for glass-making, and marked the end of forest glass in England. From this period onwards glass-making was tightly controlled and centred on London, forcing the old immigrant glass-makers of the Weald, tenaciously championed by Isaac Bongar and backed by the forest-owning classes, into steep decline. When later the industry expanded, it was entirely guided by the paramount search for cheap coal.

Almost immediately the patent passed into the hands of a partnership headed by the enterprising Sir Robert Mansell who, until the furnace design was perfected, initially found himself forced to use superior and expensive Scottish coal for crystal glass manufacture in London. One of the solutions to the problems, the covering of glass pots to exclude smoke and ash, was to be a significant factor in the later development of lead crystal glass. Another unexpected result of these experiments was the discovery that the use of uncovered glass pots would produce an almost black glass which, with its light-excluding properties, proved ideal for the storage of wine. An important innovation at this time was the establishing of the great manufacture of broad window glass at Newcastle, from where it was transported, using the existing fleet of coal-carrying ships to London. Although Mansell, after many vicissitudes, achieved technical success with coal-firing and therefore laid the foundations of a great future industry, he never managed to balance high overheads with the price restrictions in force. The patent was finally surrendered to the Privy Council in 1642, when crystal glass-making all but ceased for the duration of the Civil War.

The fragility and ephemeral quality of drinking glasses at this period was not only integral to their material and design, but was also considered desirable. The concept of conspicuous consumption by the wealthy is not a new one. Although few complete examples survive, the range of shapes of these home-produced utilitarian drinking glasses can be reconstructed from excavated fragments.

Beer glasses were variations on the beaker type. For wine glasses, stems included the dragon-like wrought type, the mould-blown lion-mask variety favoured by Verzelini, and a simplified knop with 'ladder' moulding which followed in the early seventeenth century, together with slim cigar-shaped stems derived from metalwork proto-types. The quality of these vessels was said by the Venetian ambassador in 1620 to be more than a match for the products of the Murano glasshouses. It would seem, however, that the limited production capacity of the London glasshouses, combined with the high breakage rate of glasses in use, left the demand for crystal glass unsatisfied. For despite the spasmodic ban on the Venetian glass trade, imports continued: in 1626 over 10,000 crystal glasses were imported. Venetian makers, though consummate craftsmen, were willing to make anything on demand, and the austere taste of English consumers of the mid-seventeenth century is well demonstrated by the detailed drawings of glasses ordered by John Greene and Michael Measey from the Morelli glasshouse in Venice in the period 1667–72 (fig. 53). Conical bowls of various types and ribbed mould-blown knops predominated, while glasses for brandy, wine, and beer were identical but for their size.

The Glass Sellers' Company

The Restoration of King Charles II in 1660 was a signal for a resurgence in living standards, for increased efforts to free Britain from dependence on imported luxury goods and, in the wake of a revived spirit of nationalism, for major developments in the applied arts. The demand for luxury goods attracted speculators, such as the Duke of Buckingham, the richest man in England, who lost no time in applying for a patent and entering into an agreement with an experienced French glass-maker, John de la Cam, to make crystal glass. After a false start, and the departure of de la Cam, Buckingham's new partners Martin Clifford and Thomas Paulden set up a new furnace at the Charterhouse. Significantly, Buckingham's patent was renewed in 1663 to include mirror glass, the importation of which was, somewhat ineffectually, banned in 1664. If the secret processes jealously guarded by the Venetians could be unravelled, this branch of glass-making promised to be extremely lucrative; for until well into the eighteenth century mirror plates were so valuable that they were resilvered, reframed, and sometimes recut, many times over. Another advantage of home

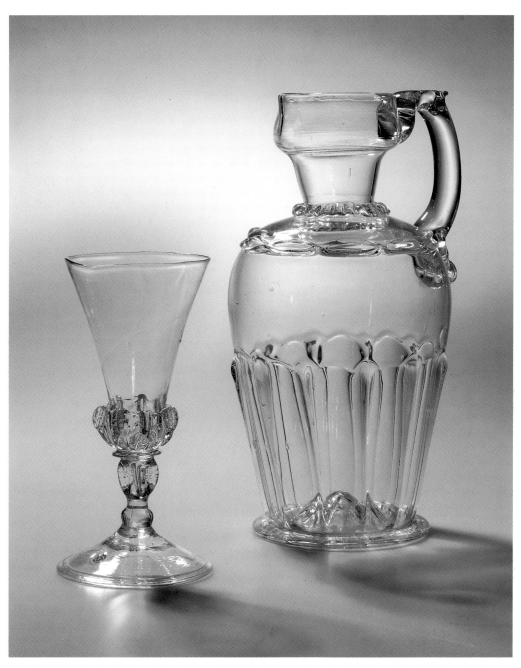

102. *The Venetian influence lingered into the 1690s at least, as shown by the pincered 'propellor' stem. The decanter jug, of Continental faïence shape, would have had a loose, hollow stopper.*

manufacture was the avoidance of a long and hazardous passage by sea. Buckingham's manager Bellingham soon succeeded in making, by the muff process, mirror plates of the highest quality at Vauxhall, while his other glasshouse at Greenwich made inexpensive cristallo vessel glass equal to that of Venice.

With increasing demand for luxury glass and other prospective glass-makers entering the industry, it became essential to have some centralized control over the manufacture, the home market, and the import trade. Thus the Glass Sellers' Company came into being, receiving its Royal Charter in 1664. Now imports, such as those of

John Greene and Michael Measey mentioned above, were strictly regulated by the Company, while its powers extended to makers of the new 'black' wine bottle, and even to the products of the London delftware industry and the new stoneware ale mugs and bottles made by John Dwight at Fulham in the 1670s. To a certain extent the Company also dictated fashion, to the natural advantage of its members. Without this centralized control – which mirrored the active development of the Venetian glass industry several centuries earlier – it is unlikely that the glass trade in England would have made such major leaps at the end of the seventeenth century.

Bottles

Towards the middle of the seventeenth century it was discovered that open-topped pots in coal-fired glass furnaces produced an almost black glass, which successfully excluded light, and was therefore ideal for storing wine. By the 1660s free-blown and rolled bottles with applied string rims were being sealed on the shoulder with the owners' names – private individuals or innkeepers – and sometimes dates, which referred to the date of purchase, not the date of the contents. Though not expensive, these bottles were never considered expendable – they were refilled as often as required by the wine merchant from his wine barrels. Many, therefore, have survived intact and many were exported. By the mid-eighteenth century the cylindrical bottle, blown into an open mould and easy to produce in regular capacities and to lay in the cellar, was standardized.

Hogarth prints depict crude handwritten labels pasted on to globular bottles, but printed wine labels as we know them were probably unknown until about the mid-nineteenth century. Bin labels in the cellar would differentiate the wines, while for serving at table, bottle tickets of various materials could be hung around the necks. Increasingly after the mid-eighteenth century decanters were used at the table for wine, sometimes engraved or enamelled with labels such as 'Red Wine' or 'White Wine' – vague terms which allowed the contents to be varied.

103 (below). Enough dated bottles exist to show their development from their beginnings in the mid-17th century to the establishment of the cylindrical form a hundred years later. Early bottles were free-blown but probably marvered on the floor to produce an angular shoulder. Shorter necks followed in the 1680s, with globular shapes around 1700, and mallet shapes in the 1720s. By the 1740s open moulds were being used, which enabled capacities to become standardized.

104 (right). Cast or engraved metal dies, with shanks to attach them to wooden handles, were used to apply the seals on a blob of molten glass. This practice petered out after about 1820, with the introduction of fully moulded bottles.

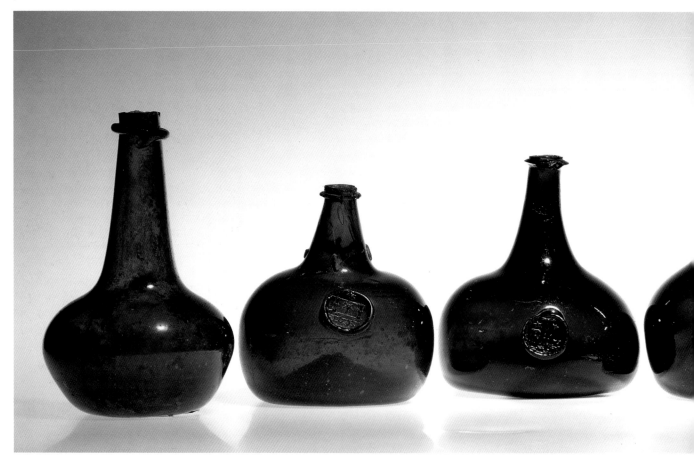

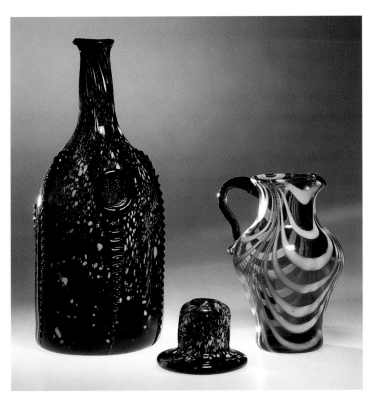

105 (left). Although bottle houses usually made only strictly functional objects, a simple method of producing highly effective decoration evolved, perhaps through a chance discovery. White glass chippings were rolled into a bubble of black glass, which was blown further, and perhaps twisted to form bottles, inkwells, flasks, and rolling pins.

106 (right). The open bottle mould was used from the 1740s, but later versions were made in two hinged halves with a foot-operated release mechanism. Henry Rickett's patented a mould for the complete bottle in 1821, which transformed the industry.

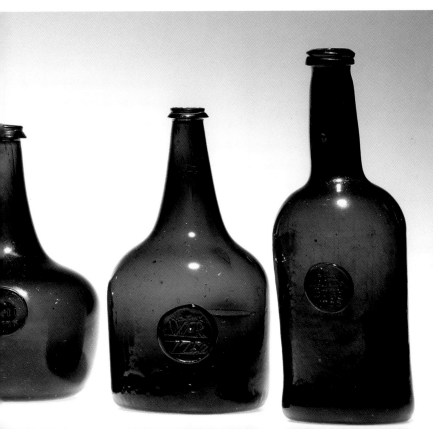

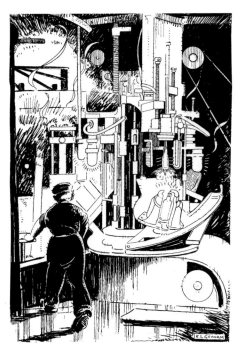

107. From the early twentieth century onwards bottles were being made by automated machines using compressed air. The ancient role of the bottle-maker now became that of machine-minder.

108. *Some Venetian cristallo versions of the German roemer were imported and, although German wine was not drunk in large amounts in England, the demand was enough for Ravenscroft to have made his own. The raven's head seal is known to have been used in 1677.*

Lead Glass: A New Material, A New Style

By the 1670s it was generally agreed that English glass was as good, or better, than Venetian, although of course the basic soda metal suffered from the same extreme fragility. At this point George Ravenscroft, a wealthy merchant in the Venetian trade, decided to set up a glass furnace, with workers from Murano, at the Savoy in London, for which in 1674 he petitioned the king for a patent to make 'a perticuler sort of Christaline Glasse resembling Rock Cristall'. In this he was encouraged by the Glass Sellers' Company, who recognized his ambition to make something new and better than mere copies of Venetian imports, and who allowed him to operate both the Savoy furnace run by Venetians, and another at Henley-on-Thames run by glass-workers from Altare. Meanwhile he came to an amicable agreement with the Duke of Buckingham whose patent remained in force until 1677. The potentially beautiful new 'fflint' glass,

however, so-called because it used calcined pebbles imported from Italy, initially suffered from a lack of the stabilizer calcium in the mixture, which caused crizzling, a network of fine internal fissures. Efforts to eradicate the problem continued until late in 1676, when it was announced that glass made from the newly perfected formula would be marked with a seal, a premature declaration which also appeared in 1677, when a raven's head seal (fig. 108) was to be used – presumably only until stocks of the old crizzled glass had been sold at home or exported. While adjusting the deficiencies of his glass batch at this time, Ravenscroft coincidentally added large amounts of lead oxide, the use of which previously had been confined to paste jewellery. The result was an entirely new type of glass, which did indeed resemble rock crystal, and which, in spite of a much higher cost than that of imported glass, instantly appealed to the public. The Savoy glasshouse thus prospered until Ravenscroft's retirement in 1679, when his manager Hawley Bishopp was left to continue manufacture of the glass. With the expiry of the patent in 1681, the secret of flint glass (and the addition of as much as 27 per cent of lead oxide) gradually became known, to the inestimable benefit of the English glass industry.

The discovery of vessels bearing the raven's head seals, long known from documentary evidence, enabled the first certain pieces of Ravenscroft's glass to be published in 1925; and it is now widely thought that the 'S' marked group of glass (with a similar chemical composition, including lead) is also of Ravenscroft manufacture. A list of glass which accompanied an agreement with the Glass Sellers' Company in 1677 provides a useful guide to Ravenscroft's products, all the more useful because the utilitarian objects such as wine and beer glasses have all perished, while a number of specialized vessels such as posset pots (spouted vessels used for a winter drink of spiced and curdled ale) and roemers (for German wine and originally of green glass) have survived (fig. 108). Most of the sealed pieces show crizzling to some degree, but we may assume that after about 1677 a reliable formula for heavy clear lead crystal was used at the Savoy glasshouse, and from about 1681, when the patent expired, at the other glasshouses such as Southwark. By the end of the century, the formula had become completely reliable, and the making of lead glass had taken root in the major port of Bristol, as well as the West Midlands where coal and refractory clay for crucibles or melting pots was easily available.

To a great extent, the slow-cooling properties of Ravenscroft's glass dictated its forms, which must have run counter to the natural inclinations of his Italian glass-workers. Dip moulds were extensively used, giving a band of ribbing around the base on a second gather of glass, much like the gadrooning (convex ribbing) on contemporary silver. Since it proved impossible to blow the metal thinly, and to ornament the forms with fine pulled ribbons and threads of glass in the fantastic manner of Venice, these features were simplified (fig. 102) and virtue was made out of necessity in the creation of a new and essentially English style of decoration: applied and stamped prunts, heavy pincered ribbons, chain trailing, and the Ravenscroft hallmark 'nip't diamond waies' (mould-blown ribbing pulled together with pincers in the molten state, forming a mesh pattern). For large plain objects such as jugs and basins (fig. 109), the material admirably suited

109. Ravenscroft's wine and beer glasses have all perished, whereas sturdy and rarely used pieces have survived. Jugs and basins of this type (these examples were not originally a pair) were not mentioned in his price list.

the massive proportions, and heralded the austere forms of the end of the seventeenth century. It may be assumed that other contemporary London glasshouses made virtually identical forms – simple but strong shapes with distinctive profiles, which gave less and less indication of Italian ancestry.

The fact that English drinkers had abandoned their love of fragility for the certainty of using a drinking glass more than once is shown by the popularity, and the greater cost, of the heavier 'double fflint' over 'single fflint' in the last two decades of the seventeenth century. By this time the term 'flint' had become synonymous with English lead glass, to be replaced yet again in modern times by 'lead crystal'. Grand ceremonial goblets (fig. 110) for communal drinking were still made (probably the 'State Glasses & Covers' mentioned in inventories), often with stems enclosing coins of the period; but increasingly glasses were made for individual use. About 1690 the logical development of the conical vessels shown in the John Greene papers appeared: a thick round funnel bowl, with a knop that was either plain or

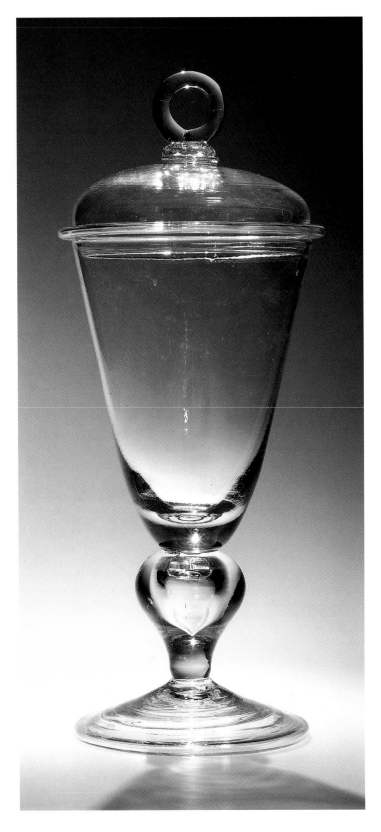

enclosing a tear, and a heavy wide foot. The English baluster was made in many shapes and sizes until the 1720s, and typifies the taste of the period. In diluted form, the cheap gin glass carried the baluster style until well into the eighteenth century. Decanter jugs, jelly glasses, short conical ale glasses, salvers (used as trays for serving drinks), punch bowls, and ladles, were also made and have survived.

Decoration was rarely used, but just as the engraved glasses of Verzelini were preserved, so a disproportionate number of diamond-point engraved glasses of the late seventeenth and early eighteenth centuries have survived, together with some untypical examples of coloured glass and pieces with 'cold' unfired painting. Rare examples of English wheel-engraving were probably executed by immigrant engravers from Germany and possibly the Netherlands. Indeed, the new lead glass was soon in demand in many parts of Europe for its suitability for engraving and cutting, except in Germany and Bohemia where glass-makers had developed their own kind of brilliant glass (figs 78–82). As the secret of making lead glass could not be kept indefinitely, after the mid-eighteenth century both the material, and many typically English shapes, were being made in the Netherlands, Belgium, France, and Norway.

The English Drinking Glass

The accession of George I and the German Royal House of Hanover to the English throne in 1715 helped to bring about a change in taste. Apart from the moulded baluster (or Silesian) stem, which enjoyed a brief vogue on drinking glasses before becoming a standard part of the eighteenth-century salver, forms tended to become lighter, with elongated thin baluster stems and more elegant bell bowls. The importing of German cut glass in the early eighteenth century was followed by the beginnings of English glass-cutting, which were to be seen at least as early as 1712 in the mirror plates with edges 'scallopt', probably by German immigrants. The first recorded mention of glass-cutting as a trade was in 1719, after which the edges of expensive dessert dishes were frequently scalloped, and the technique was soon extended to shallow cutting of the surface. The large

110. *Perfected lead glass proved ideal for strong, simple, forms. Huge glasses were used as chalices, and also for communal drinking.*

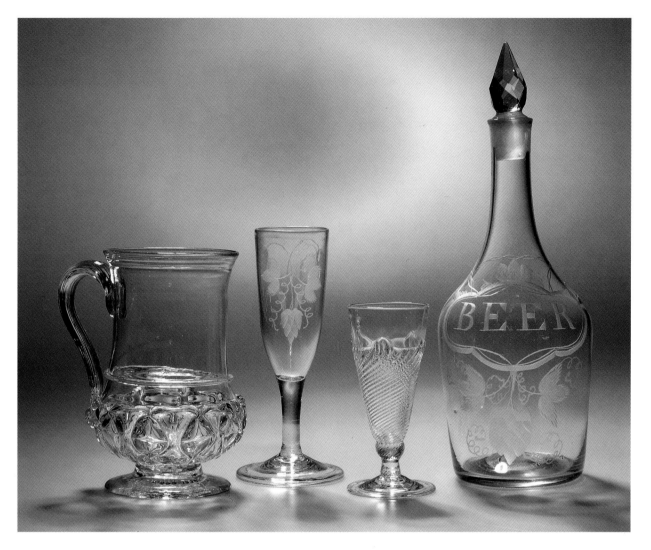

111. *Imported wine was always expensive, whereas beer could be made all the year round from home-grown ingredients. Large mugs were used for weak beer, small glasses and flutes for strong beer which could be stored in a decanter.*

abrasive wheels, either driven by a treadle or water-wheel, would produce crescent cuts which naturally adapted themselves to form a limited range of simple patterns which were polished to achieve great brilliance. Soon the technique was refined, with the use of smaller wheels leading to more intricate patterns, and eventually to standard arrangements of cut flats and diamonds.

In the 1720s, when sophisticated techniques of decoration were as yet unknown, the new quest for lightness led glass-makers to concentrate on developing the basic form of drinking glasses, particularly the stem. From the simple air bubbles or tears, which had been used in two-piece drawn trumpet glasses as well as the balusters, and which were simply made by pricking the molten glass with a spike, it was a short step to pull and twist a ring of bubbles to form the air twist. Thus a straight length of rod could form a complete stem, enhanced sometimes by the magnifying capabilities of a swelling knop. An approximate date for their introduction is suggested by the earliest mention of 'Worm Shank beer glasses' at a shilling each on a glass-seller's bill dated 1738. Made in large numbers during the period 1745–55, the popularity of air twists began to wane with the further invention in the late 1740s of the enamelled or opaque twist stem, made with pulled canes of white enamel in a matrix of clear metal. This type proved capable of considerable elaboration and remained popular until the 1770s, by which time facet-cut stems were well established. It is

shown in the inventory of the glass-dealer Thomas Betts in 1765 that all the main types were made concurrently.

Glasses intended for specific drinks evolved and assumed more distinct shapes during the eighteenth century. Beer, drunk at all social levels, was brewed in large quantities at country houses as well as urban breweries. Strong ale or beer was drunk in small beaker-like glasses which, acquiring a stem in the second quarter of the eighteenth century, became 'flutes' barely distinguishable from those used for champagne (fig. 111). Weak beer was drunk in the home from waisted glass tankards with mould-blown ribbed bases (often enclosing a silver coin) and threading around the rim – a direct descendant of the immediately post-Ravenscroft style which survived as late as the 1860s. Glasses with very slim flute bowls can probably be identified with the Spanish flute known from glass-makers' bills, and were doubtless intended for sherry. Gin continued to be drunk in very basic small glasses, the bowl and primitive baluster stem usually made in one piece. German wine or hock was drunk from glasses derived from the old roemer, with a wide cup-like bowl and prunted stem, sometimes with the traditional green bowl. Glasses for cider were mostly in a square-bucket form with an enamel twist stem, similar in size to the large wine and water glasses of the mid-eighteenth century. Dram glasses for spirits and liqueurs had tiny bowls, often on a tall straight stem, but brandy may well have been drunk from those plain tumblers that have now all but disappeared. Wine glasses were not made in matching sets (with the advantage that dozens of replacements of unknown origin could be ordered from a dealer), and their small size perhaps reflects both the high cost of imported wines and the level of activity expected from the servants who refilled them. When the punch bowl was brought out and serious revelling began, the breakage rate, even when not deliberate, must have been high (fig. 113). So-called 'firing glasses' with reinforced bases enabled the drinker to applaud the toasts by banging on the table.

The need to associate different types of drinking glasses with particular drinks perhaps provided much of the impetus to engrave drinking-glass bowls, a practice which started about 1730 with the formal Baroque borders

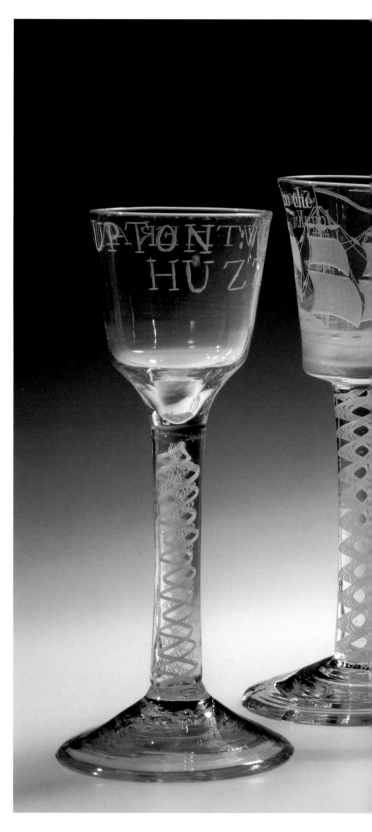

112. *Engraved patriotic and political slogans – commemorative only in the sense that they can now be dated – were well suited to glasses for serious drinking. Jacobite clubs and masonic lodges also had their own special glasses.*

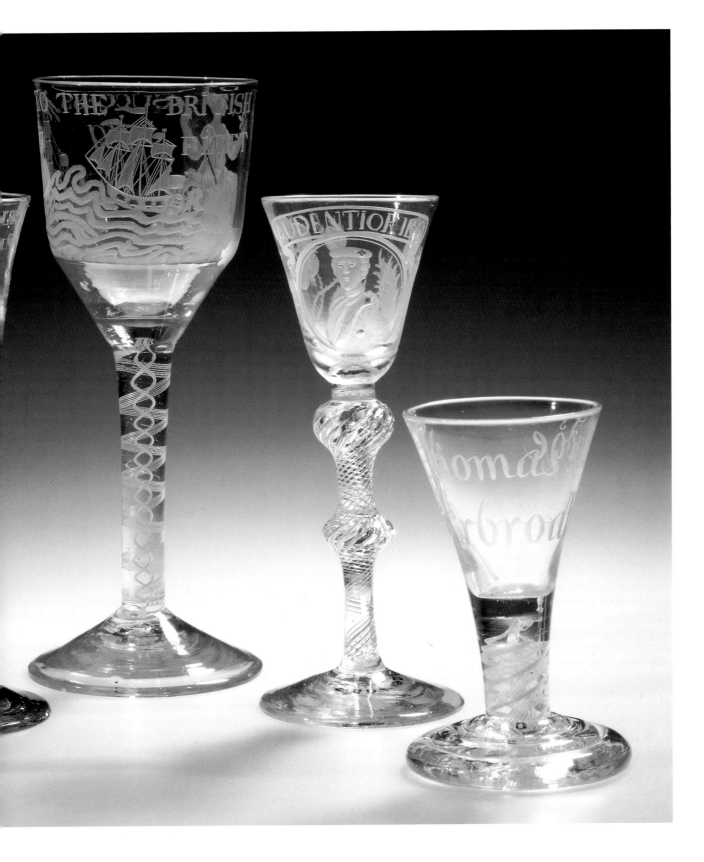

reminiscent of those on Meissen porcelain. No doubt German or Bohemian engravers were involved in introducing the use of treadle-powered small copper wheels that cut glass with the aid of abrasive powder, but the techniques were soon assimilated by their English pupils. After the mid-eighteenth century, when some sort of engraved decoration became the hallmark of all decent quality drinking glasses, 'flowered' glasses rapidly became popular, with vine leaf patterns for wine glasses, and hops and barley for beer, as the most common (fig. 111). Botanically accurate flowers and stylized Jacobite roses appeared in the mid-century, together with inscriptions, mainly limited to those with portraits of Prince Charles Edward Stuart, to parliamentary election slogans, and to Bristol privateer ships (fig. 112). Diamond-point engraving, which is far better suited to long inscriptions, was also practised in the first half of the eighteenth century, most notably on the 'Amen' group of Jacobite glasses. Bowls to be left plain were often mould-blown in various

patterns; but with the fashion for plain ovoid bowls and the appearance of a new stemless goblet called a rummer around 1780, engraving of continuous landscapes, hunting scenes and commemorative scenes became popular. These mostly anonymous engravings are competent but rarely inspired, and do not bear comparison with contemporary German, Bohemian or Dutch examples.

Decanters and Dessert Glasses

As most of the output of British glasshouses in the first three quarters of the eighteenth century was directed at drinking, a range of serving bottles or decanters was also made. The high-shouldered jug of Ravenscroft's period with a loose-fitting hollow stopper, based on Continental

113. *William Hogarth's engraving of 'A Midnight Modern Conversation' shows a private room at St John's Coffee House hired by a group of gentlemen, merchants and clergy in the early 1730s for a punch party, using expendable glasses of many shapes and sizes.*

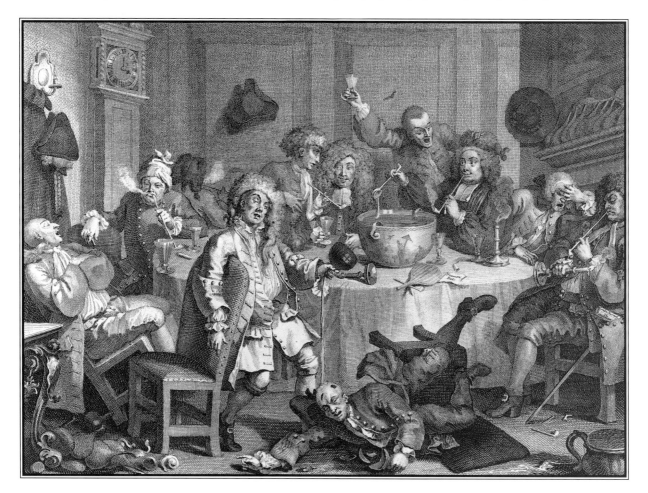

faïence prototypes, went out of fashion about 1700, perhaps because the new squat and rounded black bottle was found acceptable for use on the table. Certainly its later variants were shown in Hogarth prints depicting wild parties, although the taste for decanting wine (which was sometimes a practical necessity) into clear-glass serving vessels for the dining table not only lingered on but gained in popularity. Decanters with cut bottoms appear for the first time on bills of the 1730s, when probably also air-tight stoppers were introduced; both the partially mould-blown wine bottle and the mould-blown cruciform decanter also arrived at this time. Globular 'shaft and globe' decanters with fitted stoppers also seem to date from the 1740s and 50s, when various mallet-shaped decanters (figs 121 and 122) with cut-spire stoppers became highly fashionable, sometimes engraved in the 1760s with imitation bottle tickets (fig. 111). When tall cylindrical wine bottles became standardized and unat-

114. *Matching decanters with bottle tickets, elegant rummers, and pyramids of jelly glasses typify the table glass made at the end of the 18th century. They also make apt props for James Gilray's political satire of 1792, 'Voluptory under the Horrors of Digestion', featuring the Prince Regent.*

115. *By about 1765 virtually all luxury glass had overall cutting. Facet-cutting, in particular, produced brilliant effects at the dining table, when applied to candlesticks, candelabra and elegant heavy decanters of the type shown in this trade card.*

tractive about 1770, decanters responded by losing their shoulders and becoming unashamedly elegant, with a practical broad base, three applied rings around the neck, and tear-drop stoppers. The forms of these late eighteenth-century vessels, which may loosely be described as Neo-classical, were perfectly suited both to their use, and to the heavy lustrous metal.

Another ideal use for lead glass was for dessert dishes and jelly and sweetmeat glasses, which sparkled in strong light, and showed the brightly coloured desserts to advantage. Tiers of graduated salvers surmounted by a 'top glass' with crystallized orange were assembled, to be loaded with jellies, custards, and even little flower vases, to form a table centrepiece (fig. 114). As for candlesticks, the wrought type of the second quarter of the eighteenth century, with feet made from moulds intended for pedestal stems, were superseded in the 1760s by plainer versions with all-over facet-cutting which flashed brilliantly by candlelight (fig. 115).

Chandeliers

The glass chandelier seems not to have emerged much before about 1720, when brass prototypes were copied to provide tiers of candle arms hung from a central column with a globe at the bottom. Soon cutting was applied to all parts, strings of drops and hanging pendants were added; the design eventually became so daring that the arms would not bear their own weight. Narrower, simplified, and rather austere Neo-classical forms followed, succeeded in about 1800 by a completely new type, which typifies the Regency period. Instead of long arms hanging from a central stem, now a wide metal hoop provided anchorage for short arms with nozzles, the framing being concealed behind a shimmering curtain of flat glass drops. This type could be expanded by adding tiers like a wedding cake, and proved to be enduringly popular.

England led the world in the use of gaslight. Fortunately the need for a strong metal gasolier coincided in the 1830s with a fashion for heavy ornament, but thereafter firms like Osler in Birmingham successfully combined metal and glass in a wide range of light-fittings clad, rather than hung, with glass. With the invention of electricity at the end of the nineteenth century, the Regency style chandelier enjoyed a huge revival.

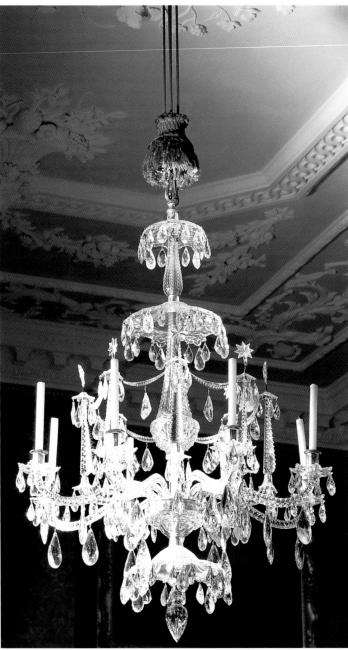

116. Early glass chandeliers and candelabra clearly show their debt to brass prototypes. The heavy arms on this rare survival of about 1720 are not detatchable, but were joined to the main stem when still molten. No attempt has been made to add brilliance by facet-cutting.

117. The design of chandeliers and their arms became increasingly elaborate after the mid-18th century, limited in their width only by the poor tensile strength of the material. The best examples are equally impressive by daylight, and many survive in their original settings. This chandelier (c. 1770–4) can be seen in the Red Drawing Room at Uppark, West Sussex.

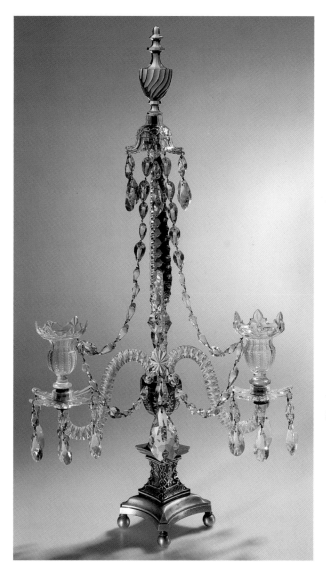

120 (above). The range of goods offered by the London glass 'manufacturer' Colebron Hancock in the mid-18th century included many light fittings, from humble street-lights and hall lanterns to chandeliers. Designs were simple, with sturdy single-curved arms. Brilliant prismatic effects were produced by the overall cutting on the central globes, the hanging lozenge-shaped pendants and the facetted spires. Such was the superior quality of English lead glass that even these comparatively unsophisticated chandeliers were in demand 'for Exportation'.

118. By the late 18th century, sophisticated techniques of decoration and construction were applied to glass light-fittings. Ormolu, gilt blue glass and festoons of cut drops added a magnificent jewel-like effect to the elegant Neo-classical shapes.

119 (right). From the mid-18th century London glass-makers and cutters supplied England and many parts of Europe with the very best quality chandeliers. They might be specially ordered for important houses or public buildings, but off-the-peg versions were also available for purchase or hire.

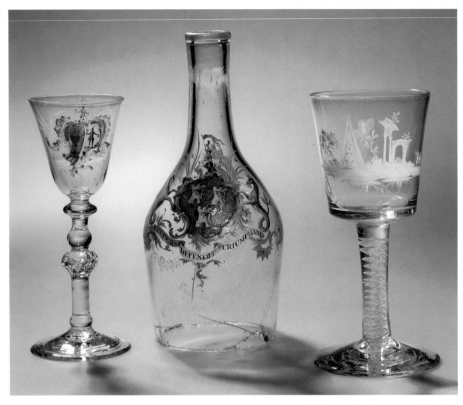

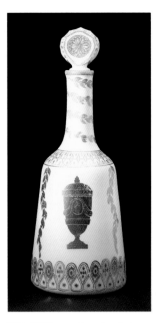

122. *Gilding on functional pieces of white glass, though giving a smart effect, tended to wear quickly. Decanters with this type of decoration appeared in the sale of James Giles's stock in 1774.*

121. *The Beilby family working in Newcastle upon Tyne were responsible for much of the enamelled glass made in England from the 1760s. William Beilby had trained as an enameller in Birmingham.*

England, the Continent, and Colour

By the mid-eighteenth century the reputation for quality of English glass was unrivalled in Europe. As mentioned above, lead glass was used by Continental glasshouses to copy the simple English shapes such as stemmed wine glasses, but the greatest achievement of lead glass in this period – its use for chandeliers and light-fittings, where either sunlight or candlelight would release the light from its brilliant cut facets – was more difficult to imitate. English glass-cutters were even lured away to France, where Anglophilia reigned in the decades before the Revolution. In Britain itself, the chandelier was developed from humble beginnings in the 1720s to such a point that the tiers of long curving facetted arms could no longer bear their own weight.

As regards tableware, with such a perfect fusion of material and form, English glass-makers had little incentive to experiment with techniques common on the Continent, such as enamelling and coloured glass. White glass had been made as early as the late seventeenth

century, but only when expensive English painted porcelain became fashionable in the mid-eighteenth century was it used to produce sets of pure white vases. These were successfully painted during the 1760s with naturalistic flower sprays by enamellers in the Northeast, and with fantastic chinoiseries by itinerant artists in the Midlands (where the same hands may be detected at work on both salt-glaze stoneware and on porcelains). William Beilby, trained by enamellers in Birmingham and the head of a family of decorators, introduced white and coloured enamelling on clear glass at Newcastle upon Tyne from the 1760s onwards (fig. 121). In London, the workshop of James Giles was responsible during the period 1749–76 for the most sophisticated decoration on glass, including gilding in the Neo-classical taste on white glass (fig. 122), and jewel-like enamel decoration and gilding on blue glass scent bottles. In Bristol, Michael Edkins painted and gilded for several glass-makers from the early 1760s, and may have been responsible for the well-known gilt decoration on sets of blue glass decanters, finger bowls, and wine-glass coolers. The making of ruby

glass by a German immigrant, Meyer Oppenheim, in the period 1755–77 was unsuccessful, but by the end of the century purple glass decanters and drinking glasses were being made commercially. Green glasses for German wine enjoyed a revival in the late eighteenth and early nineteenth centuries, and were much reproduced later in the century.

The Market

The path by which products of the urban glasshouse reached the public went through a number of changes in the eighteenth century. At first glass was advertised in the newspapers and sold direct, either from a showroom in front of the glassworks or, more likely, from a factory-owned shop in a smarter area. In about 1740 independent shops specializing in glass began to appear, and when the first English porcelains arrived shortly afterwards, these were sometimes added to the range, leaving the cheaper pottery to be sold exclusively in 'Staffordshire warehouses'. From the mid-eighteenth century trade cards, showing a wide range of goods, were issued by a new type of major glass-dealer, who styled himself as a 'manufacturer' but who used glass bought-in from other makers. When porcelain table services became more common

these firms were able to make up, from about 1780, matching sets in their own cutting shops (fig. 123), thus rendering the glasshouses themselves anonymous and also setting, rather than merely following, the fashion. Sets of glass cruet bottles also were mounted in boat-shaped silver or Sheffield-plate frames in the latest Neo-classical fashion (fig. 125). Royal Appointments for glass-dealers came in the late eighteenth century, and the more elaborate English cut glass became, the grander became the retailers: the emporium of John Blades in Ludgate Hill is depicted in the 1820s as a glittering palace, completely hung with expensive chandeliers, which could be bought or hired for a ball. A similar showroom was maintained by the leading London glassworks, the Falcon Glasshouse of Apsley Pellatt, and a yet grander establishment by the firm of F. & C. Osler (fig. 126); but as the nineteenth century progressed, so the whole ceramic and glass trade in London became focused on a few large retailers such as Mortlock and Thomas Goode.

It has often been stated that the heavy tax imposed on the raw materials of glass in 1745 and 1776 had a restrict-

123. *Very few complete suites of late 18th-century glass still exist. The effect of matching cut and complementary forms on the candle-lit dinner table must have been brilliant.*

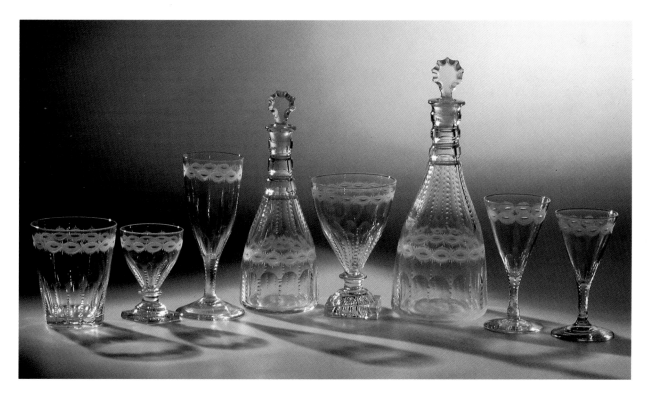

ing effect on the subsequent development of forms, and that the lifting of the tax in Ireland in 1780, with the resulting establishment of glasshouses there by British and Continental glass-makers, was solely responsible for the monumental weight of early Irish cut glass (fig. 124). Whatever the truth of these theories, it is clear that by the early nineteenth century there was little to choose between the identically cut patterns made in Ireland, Scotland, London, Bristol, or Stourbridge. Standardization of deep, but repetitive geometric patterns, such as mitre-cutting (diamonds) was further facilitated by the use of steam-powered wheels, many of which had been installed by 1800 (fig. 127). From this time onwards, weight in glass was a quality increasingly admired, and as cutting skills improved, so the prismatic qualities of lead crystal were enhanced: the step-cutting found on pieces made by perhaps most skilful cutters of all, Perrin Geddes & Co. of Warrington, is astonishingly accomplished for freehand work. One of the best examples of their work is the Prince of Wales service, supplied in 1806–8, with its graduated spiral cutting (fig. 128). So successful was

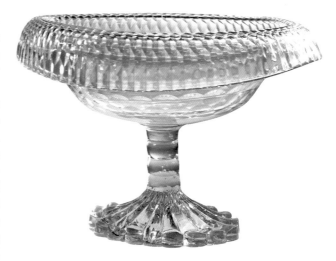

124. *Heavy glass, with minimal cut decoration, was made in Ireland in the late 18th century. Typical forms include 'turnover' bowls with moulded feet.*

125 (below). *Silver or Sheffield-plate cruet stands, filled with elegant cut-glass bottles, were used on fashionable dining tables in the late 18th century.*

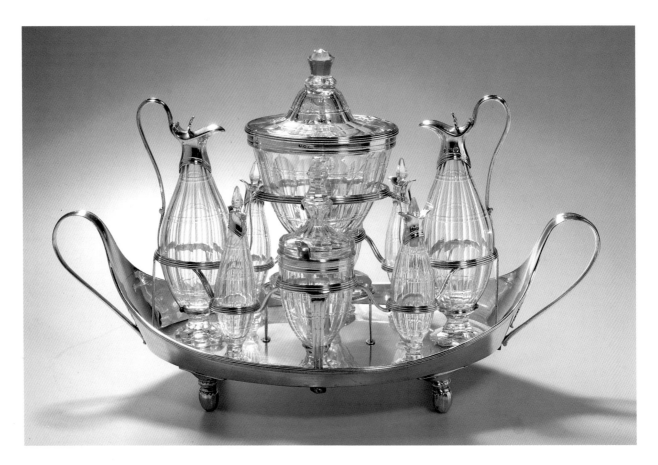

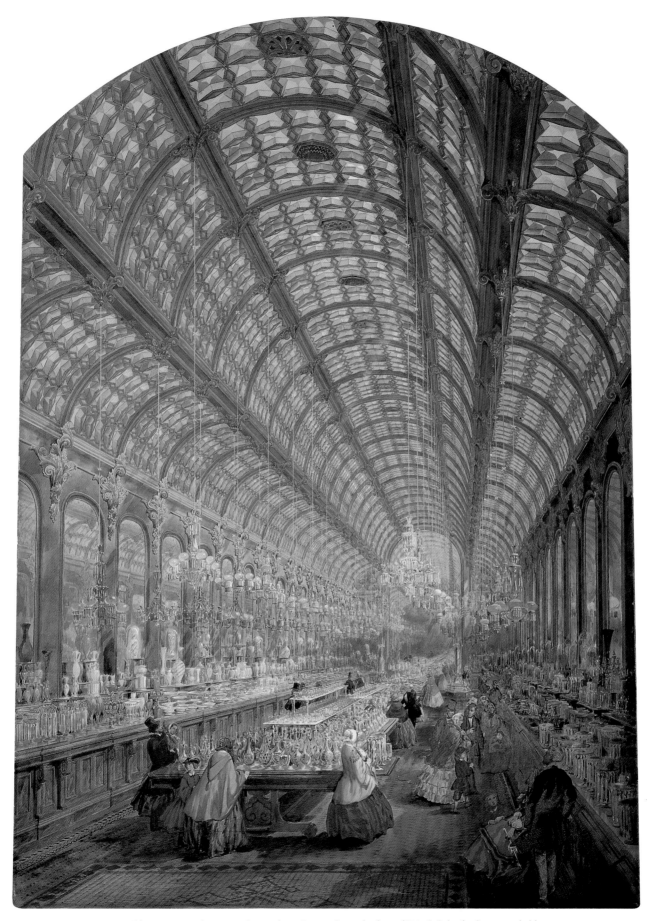

126. *After acquiring their own glassworks in Birmingham, the firm of F & C Osler further expanded by building a spectacular showroom in Oxford Street, London, in 1858–60. This watercolour drawing by the architect, Owen Jones, shows their range of tablewares, chandeliers and gasoliers.*

127 (above). *A trade card for early 19th-century steam powered cutting-mills. The harnessing of steam power to glass-cutting wheels facilitated deep cutting, but also tended to limit the range of cutting styles to horizontal step-cutting, wide flat cuts, and cross-cut diamonds.*

128 (right). *Most of this service, made for the Prince Regent in 1806–8, is still at Windsor Castle. Odd pieces have escaped, such as the two glasses given to the Victoria and Albert Museum by a descendant of the favourite royal pastry-cook.*

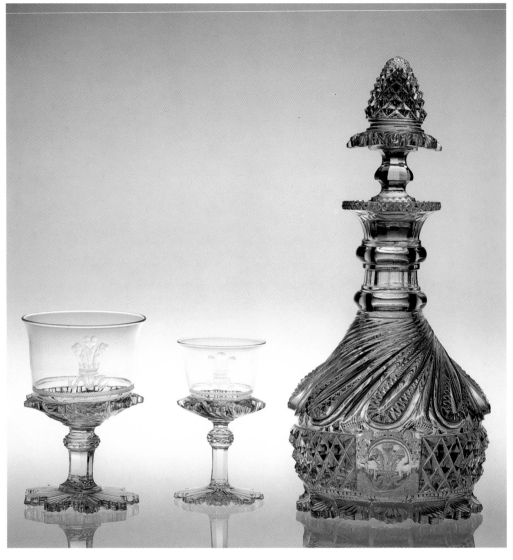

British cut glass that in the first three decades of the nineteenth century the London-dealer John Blades was supplying palatial light-fittings and table services to Eastern potentates, with a warehouse in Calcutta for the Indian trade – a model for trading which was later adopted by Osler in Birmingham. Little stylistic development occurred until about 1830, when the 'broad flute' style, based on wide flats, convex ribbed patterns and spire stoppers, added a distinct Gothic (and Continental) element to the solid Regency elegance. The natural conservatism of buyers of cut glass, together with a move towards heavier glass after the repeal of the Glass Excise in 1845, ensured the continuity of this style for a further thirty years.

Technical Innovation

The early nineteenth century saw experiments with new techniques of decoration, though not on the scale of glass-makers in Austria and Bohemia. The rare use of enamelling on glass decanters and candle shades, linked technically and stylistically with contemporary enamel-painted window glass, was not developed further. A successful Staffordshire potter and glass-maker, John Davenport, patented in 1806 a method of fusing a coating of ground glass to give a matt background for incised landscape drawings, a technique which produced an effect not unlike aquatint engraving. Acid etching was in use from the early nineteenth century, though considered

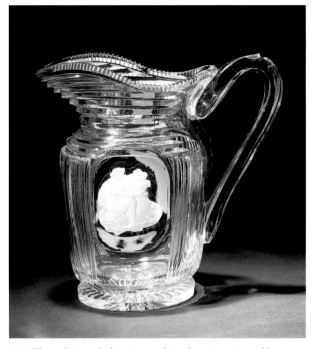

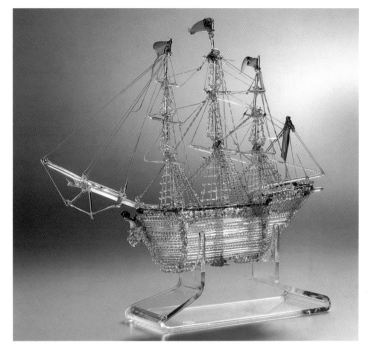

129. *The inclusion of a biscuit porcelain plaque in a piece of heavy glass was a triumph of skill. Apsley Pellatt's 1819 patent further improved on an existing French technique.*

130. *A model of a ship was a perfect form with which to demonstrate the ductile qualities of glass when worked only with a spirit lamp.*

mainly as a quick way of decorating cheap glasses; later in the century it would become vital for new kinds of luxury glass. In spite of its previous invention in France, Apsley Pellatt obtained an English patent in 1819 for his *crystallo-ceramie* process (usually known as sulphide), which consisted of enclosing a biscuit porcelain medallion in a clear glass vessel (fig. 129) or paperweight. Artistically successful, it was made on a limited scale until the mid-nineteenth century, after which it was taken up by other glass-makers such as John Ford of Edinburgh.

The Wider Context

Parallel with luxury glass, other branches of the glass industry continued to satisfy specific markets. London was supplied with bottles from Bristol from the early eighteenth century. Much of the smart Bristol table glass was exported to America where it was also copied, in lead glass, by renegade glass-workers from that city. In the late eighteenth century bottles were sent to London from Newcastle, which was also famed for its broad window glass made by the muff process – cheaper but inferior to the spun and fire-polished crown glass made in London. Good quality drinking glasses for everyday use, often

lightly engraved, were made at Newcastle, and from about 1800 at Sunderland, which also specialized in making engraved commemorative rummers. Window glass, and from the late eighteenth century drinking glasses, were made in the Stourbridge area of the West Midlands, where the industry eventually became centred. Many major towns had at least one glassworks to supply the local market, which included a very limited amount of fancy and ceremonial glass, some of which was intended to be borne aloft in the glass-makers' parades, the history of which extends back to at least 1738 in Bristol. Itinerant lamp-workers earned a living by touring country fairs, making intricate models (fig. 130) and adding dedications in coloured glass thread to scent bottles as love gifts. Generally, the glasshouses stuck to their own speciality, although some rural bottle houses exploited the possibilities of rolling pieces of white-glass cullet into their black-glass vessels to produce unsophisticated but attractive white-flecked jugs, rolling pins, and flasks (fig. 105). The molten ductile nature of these homely vessels was something entirely lacking in contemporary Regency cut glass, and anticipated the rediscovery of the material's primal qualities at the end of the nineteenth century.

Glass in Mughal India

Glass has been produced in the Indian subcontinent since antiquity, but probably only became artistically significant in the Mughal period (1526–1857). Glass production was encouraged from the late sixteenth century, under the dynamic Emperor Akbar (r. 1556–1605). Important centres were located in Bihar, where glass is thought to have been manufactured as early as the second century BC, and Alwar, near the royal cities of Delhi and Agra. The finest glassware from Europe and the Middle East was eagerly sought after, and miniature paintings depict Venetian and Iranian glass, as well as Mughal cups, flasks, rose-water sprinklers, and water pipes. Material evidence, however, is scant until the eighteenth century.

Although Indian glass is usually full of impurities and extremely light in weight, there is an emphasis on striking colours, such as cobalt blue, green, and purple. The decoration of Mughal glass may be highly refined, particularly when gilt or enamelled. Both the gilder and enameller must have worked closely with artists who illustrated and decorated books, as there are obvious correspondences between these arts.

The poor translucency of Indian glass led to a constant demand for superior foreign imports, and in the eighteenth century English lead glass was particularly favoured, though the Dutch also had a flourishing Indian trade. By the nineteenth century the indigenous industry had almost collapsed in favour of foreign imports.

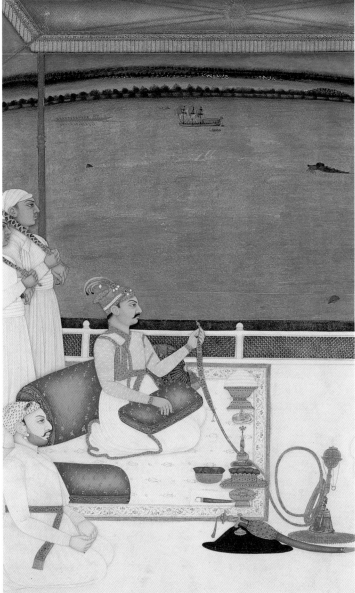

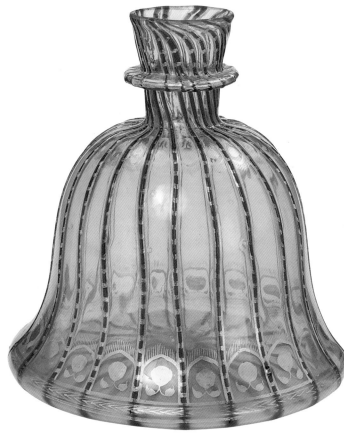

131 (left). Base of a *huqqa* or water pipe. Tobacco was introduced into Mughal India in 1604 from the Deccan sultanates to the south of the empire, via Portugese Goa. The habit of smoking quickly took hold despite strong disapproval from the Emperor Jahangir (r. 1605–1627), which paralleled that of his contemporary, James I of England.

132 (above). Tobacco was smoked by means of a *huqqa*. The base, usually a spherical or bell shape, supported the apparatus for burning the tobacco and was filled with perfumed water through which the smoke was drawn. The image of an emperor or nobleman reclining on a terrace peacefully smoking his *huqqa* became a cliché of Mughal painting in the 18th century. The rose-water sprinkler is also made of glass.

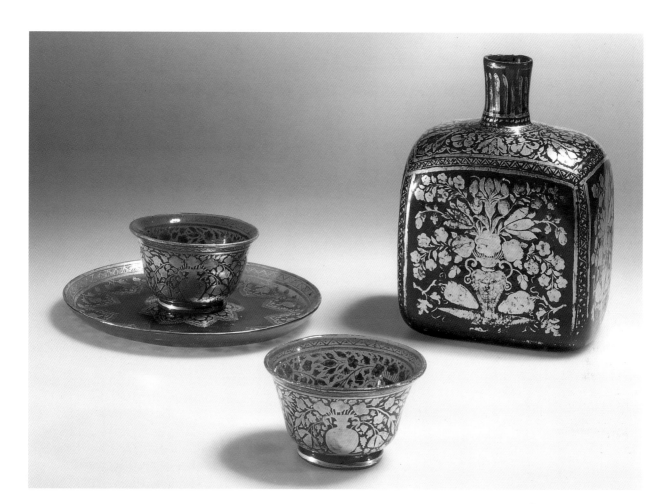

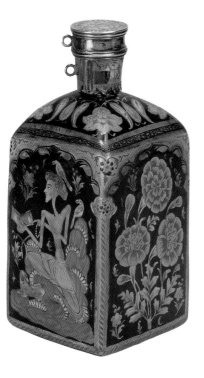

133 (above). Indian miniatures of the 18th and 19th centuries abound with scenes of aristocratic leisure, the participants surrounded by dishes of fruit and vases of flowers next to small, intensely coloured cups, flasks, and bottles, presumably made of glass. These rare examples, with their decoration of blossoms spilling out of golden urns, suggest the setting in which they would probably have appeared.

134 (left). The passing resemblance to case bottles of the Netherlands suggest the craftsmen copied a European model, though the decoration is purely Indian. The cap is made from a silver six stuivers coin of the Netherlands (Provinces of Holland and West Friesland) dating to

c. 1671–4, and is stamped with a Dutch control mark indicating that it is of 'foreign manufacture' and arrived in Holland after 1814 when the mark was introduced.

135 (right). In the 18th century, thousands of pieces of English glass were exported to India. They included the normal wares used for domestic consumption, as well as those made specifically for the Oriental market. The lead composition of this rose-water sprinkler indicates that it is of European manufacture and, given the statistical evidence, was probably made in England.

NINETEENTH-CENTURY ECLECTICISM

136. *From the late 18th century, the landscape around Stourbridge in the West Midlands was dominated by the huge brick-built glass cones, which created the draught necessary for coal-fired furnaces.*

The most characteristic impression of later nineteenth-century decorative glass is of an enormous variety of styles, often dictated by fashionable taste. At the same time, the scientific understanding of glass and its properties, and the invention and spread of new, often industrial techniques led to a wealth of new colours and methods of decorating, and to far more reliable production on a much more extensive scale than ever before.

The demand for glass tableware also expanded dramatically during the century. Plain functional glass for local markets continued to be produced by local glasshouses. With growing commercialism and a concentration on new markets came changes in the old social structures, for no longer could the dynastic glass-making families supply the amount of skilled manpower needed for expansion. From the 1820s onwards glassworks developed into large factories, first in the Southern Netherlands and France but soon also in Scandinavia and Russia. Operations were by necessity simplified with the

introduction of machinery and the influx of unskilled labour; no longer was a sense of individuality or house style either possible or considered desirable. From the mid-1820s Baccarat and the nearby Saint-Louis glassworks were the leading producers of table and ornamental glass in France, outstripping all competitors in size and quality. In the Southern Netherlands, which was to become Belgium in 1830, the major glassworks was established at Val-Saint-Lambert in 1825 with the help of English glass-makers. It proved so successful that the workforce of 400 in 1829 had increased to 2,800 by 1879. Marketing their products through cheap printed catalogues, first used at Baccarat, they flooded Europe with well-made, smartly styled matching table glass at a modest price. The style of these wares initially followed those of English lead glass. But the wide circulation of the printed catalogues reinforced a tendency for nineteenth-century glass shapes to become international. For example, the 1826 catalogue shows the bucket-bowl with knopped stem as 'Wellington', a glass with conical bowl and a stem drawn as 'Anglais', and the inward curving bucket with knopped stem as 'Nelson' – standard shapes which, though of English origin, are found in the catalogues of Dutch and Danish glasshouses as late as 1890.

In Britain itself glass-making remained concentrated in the same areas, which were always situated near the main ports. There was, however, an increasing specialization in production: Bristol gave up luxury glass to concentrate on bottles, Newcastle returned to specializing in broad window glass and bottles, and London increasingly served only the top end of the luxury glass market. Existing glassworks grew and whole areas, particularly

ENGLISH CRYSTAL TABLE GLASS, CUT AND ETCHED.

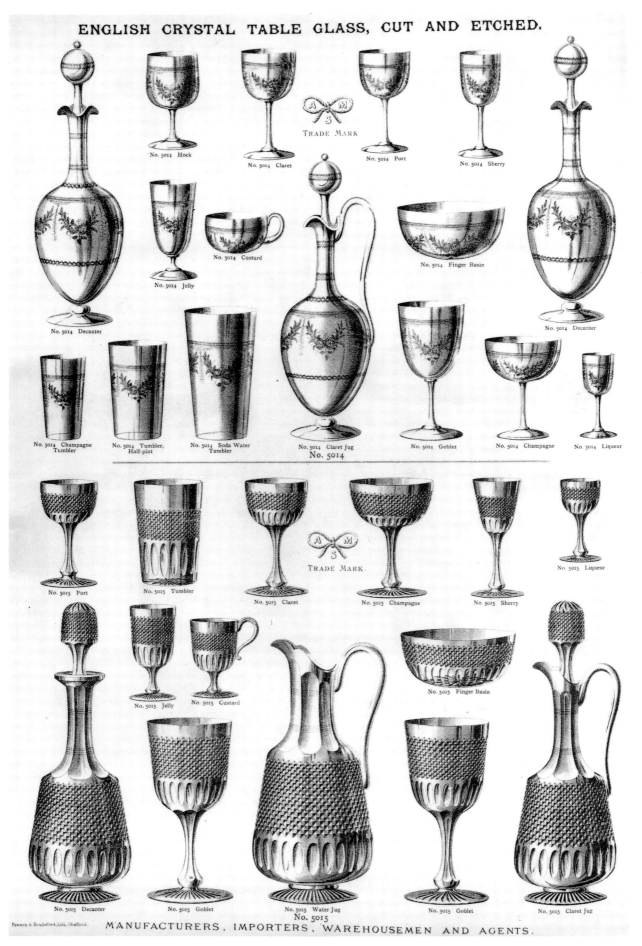

No. 5014 Hock

No. 5014 Claret

TRADE MARK

No. 5014 Port

No. 5014 Sherry

No. 5014 Decanter

No. 5014 Jelly

No. 5014 Custard

No. 5014 Finger Basin

No. 5014 Decanter

No. 5014 Champagne Tumbler

No. 5014 Tumbler, Half-pint

No. 5014 Soda Water Tumbler

No. 5014 Claret Jug

No. 5014 Goblet

No. 5014 Champagne

No. 5014 Liqueur

No. 5014

No. 5015 Port

No. 5015 Tumbler

TRADE MARK.

No. 5015 Claret

No. 5015 Champagne

No. 5015 Sherry

No. 5015 Liqueur

No. 5015 Jelly

No. 5015 Custard

No. 5015 Finger Basin

No. 5015 Decanter

No. 5015 Goblet

No. 5015 Water Jug

No. 5015 Goblet

No. 5015 Claret Jug

No. 5015

Pawson & Brailsford, Lith., Sheffield.

MANUFACTURERS, IMPORTERS, WAREHOUSEMEN AND AGENTS.

137. This British trade catalogue of the 1880s shows two services with no less than seven types of goblets, each for different drinks.

107

those around Stourbridge, became dominated by the typical glass cones (fig. 136). These were cone-shaped brick buildings, which served as a huge chimney to the glass furnace located in the centre of the structure, fed with air by huge underground flues.

The Glass Table Service

The development of an evermore 'polite' society went hand in hand with an improvement, or refinement, of table manners at the end of the eighteenth century. This led to an increase in the use of tableware, but above all to a specialization in its different types.

As early as 1780 London retailers had invented the concept of matching suites of table glass, in order to complement the porcelain and creamware dinner services, which were increasingly in use. Their popularity continued to grow during the nineteenth century. By about 1825 the first whole table services in glass were made, comprising different glasses for red and for white wine, for liqueurs and champagne; beakers for beer and water; and finger bowls, decanters, and jugs. It now became fashionable to line up glasses for different drinks at the dinner table. Such sets continued to grow until the early years of the twentieth century. A full service consisted of not only drinking glasses but also plates and a variety of dishes and comports, including covered dishes for cheese and butter, saltcellars, and sugar bowls – all relating in shape and with matching decorations (fig. 138).

Cutting remained the most popular decoration for tableware throughout the century. The sheer size of the demand urged a rapid development. In Britain, as on the Continent, a network of small cutting and engraving shops was gradually replaced by large centralized factories, which were run by the dynastic glass-making families such as the Stourbridge firms of Stevens & Williams, Richardson, and Webb. Technical inventions followed quickly, reducing the prime cost of decorated glass (fig. 139). From the 1830s, deep cutting of fashionable heavy luxury glass was made possible by the widespread use of steam power, which encouraged the use of all-over cut patterns, and which eventually led to the excesses of the so-called 'Brilliant Cut Style' introduced at the Philadelphia Exhibition of 1876. The cutting of this superior tableware still had to be done by hand, and so there was a growing demand for other, cheaper decorated wares. Further inventions followed in quick succession. Repetitive hand engraving, for instance, began to be

138. *By the 1870s the display of cut-glass tableware often dominated the bourgeois lunch and dinner table. Here it creates the focus for Gustave Caillebotte's dining-room scene* After the Luncheon *(c.1871).*

replaced by acid-etching in the 1850s. The technique of drawing a pattern through a layer of wax covering the surface of a glass and subsequently plunging it into hydrofluoric acid was first practised in the late eighteenth century, but it was not developed seriously until after the 1830s. Capable of great subtlety it was soon applied to luxury pieces. Even when it was patented by French and British glass-makers within a few years of each other in the mid-1850s, its commercial potential was not fully realized. By 1861 John (1836–1902) and Joseph

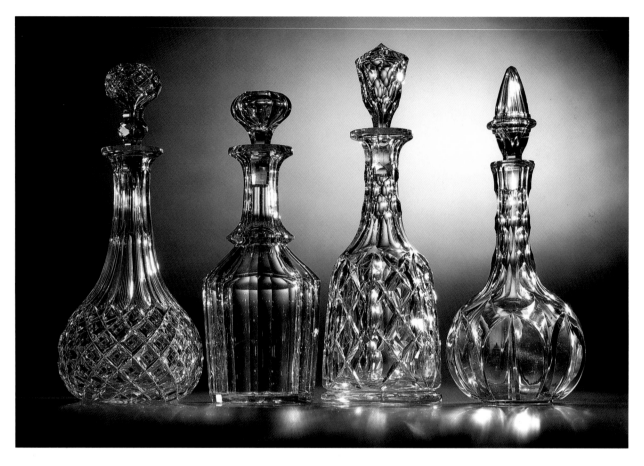

139. *With the perfection of steam-powered cutting mills in the early 19th century came the possibility of producing an endless variety of patterns in the new fashionable heavy style. The sparkling effect of brilliant-cut lead-glass tableware on the candle-lit dinner table was widely appreciated during the mid-19th century.*

(1839–1915) Northwood, two brothers in partnership at Wordsley, who had a highly skilled team, were one of the first major producers to use it extensively. They ensured its commercial success with the invention in 1860–1 of the template etching machine for inscribing the pattern through the resist. With the invention four years later of a gear-driven, geometric etching machine (or guilloche), interlocking patterns such as loops or the ever-popular Greek key border patterns were applied to virtually all table glass, and especially to the new paper-thin glass which appeared in the 1870s (fig. 137). By the end of the nineteenth century, extensive suites of moderately priced, matching, and technically perfect table glass could be purchased for the home.

Despite these technical innovations and major improvements in quality, the use of machinery played only a very marginal role in glass-making. At the heart of it still lay the traditional glass-makers' chair – four highly skilled and perfectly coordinated glass-makers capable of producing, with the most basic of tools, a finished wine glass in less than four minutes. But whereas machine blowing of glass was not possible until the twentieth century, mechanization did become important with the development of the non-blowing technique for pressing glass.

Pressed Glass

The perfection in the United States in the early 1820s of the hand-operated machine for press-moulding glass was possibly the most far-reaching technical advance of the nineteenth century. There was a long history to the technique: pressing molten glass into a mould by various means was common in production from 1500 BC. In the eighteenth century the method of using small hand presses, probably in the form of large pliers with a design cut in the faces of the jaws, was used in the production of

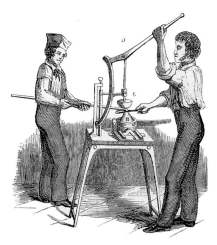

140 (above). *A gather of molten glass, B, is dropped into the mould and cut off from the punty. A lever, A, lowers the metal plunger, C, into the mould.*

141 (right). *Pressed glass was particularly popular for cheap tea services, often imitating more expensive cut wares.*

chandelier parts as well as for decanter stoppers and bases for rummers. The new American method took a team of two men: one to cut a measured gather of hot glass from the punty rod and drop it into a metal mould heated to a certain temperature, and the other to depress a lever, which lowered a metal plunger into the glass forcing it into the patterned mould (fig. 140). By the 1830s this method had spread to Europe and Britain, enabling high quantity output at cheap prices, and revolutionizing the availability of glassware. It made the mid- to late nineteenth century the first period of true mass production,

especially after the invention of the steam-operated press in 1864. Glassworks that introduced this method employed new skills, such as that of the mould-cutter and the engineer, while glass-workers became skilled at managing the machines. However, despite its wide-ranging adoption, automated production remained limited to smaller, relatively unambitious objects. While not suitable for the production of fine tableware, the technique proved invaluable in supplying a growing population with inexpensive, but often highly ornamental tableware in the form of cheap drinking mugs and rummers, milk jugs, sugar basins, cake stands, and a vast assortment of knick-knacks (figs. 141 and 142). The initial disadvantage of a poor surface finish and obvious mould lines, were at first disguised by intricate lacey patterns. Eventually these technical shortcomings were solved in about 1870 by a successful method of fire-polishing. Pressed glass never aspired to the prismatic brilliance and precision of cut lead glass nor the extravagance of coloured 'art glass', but the introduction of opaque, marbled, and heat-sensitive glass into the press-moulded glass repertoire made highly saleable imitations possible.

142. *A group of ornamental press-moulded glass from America and Britain, showing the enormous range of bright colours and design styles that were characteristic of this popular and inexpensive ware.*

Exhibitions

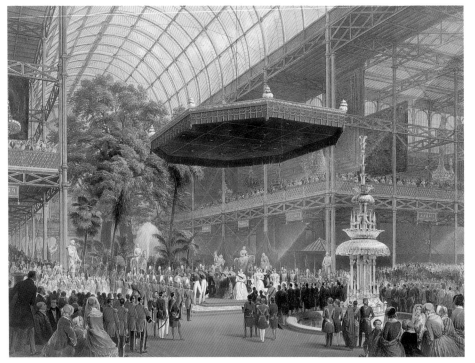

In 1851 the first and most famous of the international exhibitions was held in London. Titled the 'Great Exhibition of the Works of Industry of all Nations, 1851', it was, in effect, a vast international trade fair for all types of manufacturers, where they presented their largest, most elaborate products. It also acted a showcase for nations to display their natural wealth. Between 1851 and 1900 there were 11 more exhibitions of comparable size, held in major cities of the industrially developed world. They were advertised as both educational and as a huge entertainment; visits by the public were numbered in millions, peaking at 48 million to the Paris Exhibition of 1900.

The 1851 exhibition was held in a purpose-built iron and glass structure in Hyde Park, providing 19 acres of displays under glass. Months of disagreement left the design and construction period perilously short, but last minute inspiration saved the day. The 'architect' was Joseph Paxton, estate manager to the Duke of Devonshire, whose only expertise lay in the construction of large-scale hothouses, and who afterwards claimed to have been inspired by the structure of the leaves of the giant water lily Victoria Regia. The statistics associated with the building of the 'Crystal Palace', as it was immediately called by the press and public, are as astonishing as the exhibition itself. The iron structure was the work of the Midlands company Fox & Henderson, while Chance Brothers of Birmingham supplied the glass – 293,665 handmade panes. The entire building was constructed in only 17 weeks. The exhibition attracted 6,039,195 visitors and it made a huge profit of £186,437.

143 (above). Standing at the intersection of the Crystal Palace, the centrepiece of the Great Exhibition was an immense fountain. Made by F. & C. Osler of Birmingham in moulded and clear cut glass, which also hid the plumbing from view, this glittering, shimmering creation towered above the visitors at an unrivalled height of 8 metres (27 feet) and contained almost 4 tons of crystal glass.

144 (below). James Green & Nephew, the London retailer, specialized in clear, cut glass of an entirely traditional British 18th-century type. The glass was either bought in complete from manufacturers, such as Richardson of Dudley, or as blanks which were decorated in Green's own workshops. This stand, at the Centennial Exhibition in Philadelphia in 1876 is typical of the time, with its packed display style. It shows the range of glass goods which such a retailer offered, from tableware to chandeliers and fancy novelties under glass 'shades'.

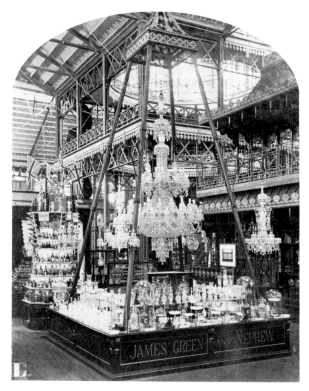

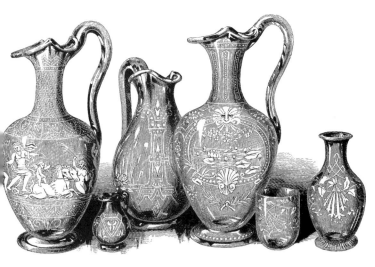

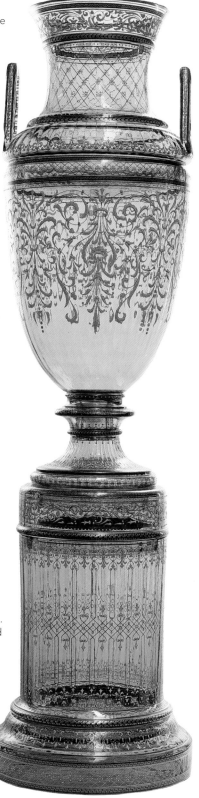

145 (left and below left)). In 1851 the London magazine the *Art Journal* issued a special Great Exhibition edition, with detailed descriptions, reviews, and illustrations of the exhibits. J. G. Green's display was described as 'of the purest crystal, engraved in the most elaborate style … We scarcely ever remember to have seen glass more exquisitely engraved than in these specimens'. The 'Neptune Jug' below was acquired by the Museum of Practical Geology from the exhibition as an example of the use of natural materials, and transferred to the Victoria and Albert Museum in 1901. Possibly it was made by Richardson of Dudley; the engraver is unknown.

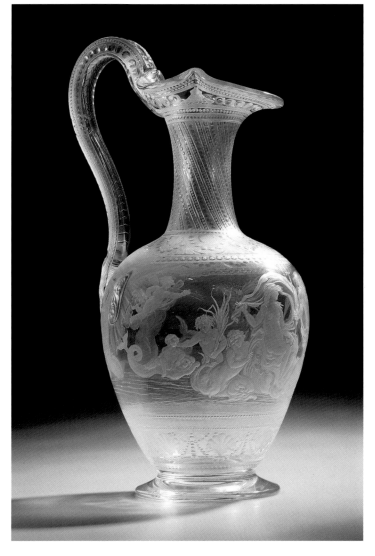

146 (right). The firm of J. & L. Lobmeyr of Vienna produced such Neo-classical vases in different sizes, some small enough for table-settings. This spectacular vase was especially made for the international exhibition held in Paris in 1878, where it was purchased by the South Kensington (now the Victoria and Albert) Museum.

147 (left). *The cameo workshop of George (front row, right) and Thomas (back right) Woodall was the most productive and renowned in Britain. Their famous 'great tazza' is now in the Corning Museum of Glass, New York State.*

148 (opposite). *The shape of 'The Death of Socrates' vase was taken from a Greek ceramic example. It was acid-etched in a fashionable Neo-classical style.*

Dazzling Competition

Glass for the luxury or artistic market was largely hand-crafted – as it is to this day. In the middle of the century, when the local trade fairs of earlier years gave way to massive national and international fairs, glass-making companies vied for attention with the most spectacular works displayed in extravagant style. The firms of F. & C. Osler of Birmingham and Baccarat in France excelled at this kind of brilliant cutting. Both produced enormous sparkling chandeliers and candelabra, and even cut-glass furniture, especially for such fairs and exhibitions. Too grand and elaborate for the bourgeois drawing rooms of Europe, they were particularly favoured by the rulers of Indian royal states, to furnish their sumptuous palaces.

Historicism

The plundering of the past for shapes, decorative motifs, and techniques was a particular feature of the nineteenth century. Now commonly described as Historicism, this movement encompasses various styles, all inspired by the arts of different historic periods, ranging from antiquity to the Renaissance and from the Gothic to Baroque and Rococo.

When new nation states were coming into being and

were in some cases developing imperialist ambitions, their confidence was often demonstrated by an architectural and design style which was patrician, imperial, classical, and readily understood by its audience. In Britain, which regarded itself as the principle world power for much of the second half of the nineteenth century, classicism was regularly thought to be appropriate. It was adopted for glass forms and decoration, and for almost every other material. A vase like that made in about 1865 by Stevens & Williams of Brierley Hill, near Birmingham, more than satisfied the criteria. Its shape was based on a Greek ceramic vase and it was decorated with an equally classical subject, 'The Death of Socrates' (fig. 148). The use of acid-etching was relatively new for luxury items. More restrained than the sparkling effect produced by cutting this technique lent itself particularly well to the Neo-classical style.

The popularity of coloured, cased glass spread to Britain from Central Europe. In Stourbridge glass-makers adapted the Roman technique of cameo-carving, of which the most famous example was the Portland Vase in the British Museum. To achieve real depth in the carving the layers of glass had to be extremely thick, and achieving the essential compatibility between the various colours of glass, each shrinking at a different rate during annealing, took many years. Eventually the glass-blowing

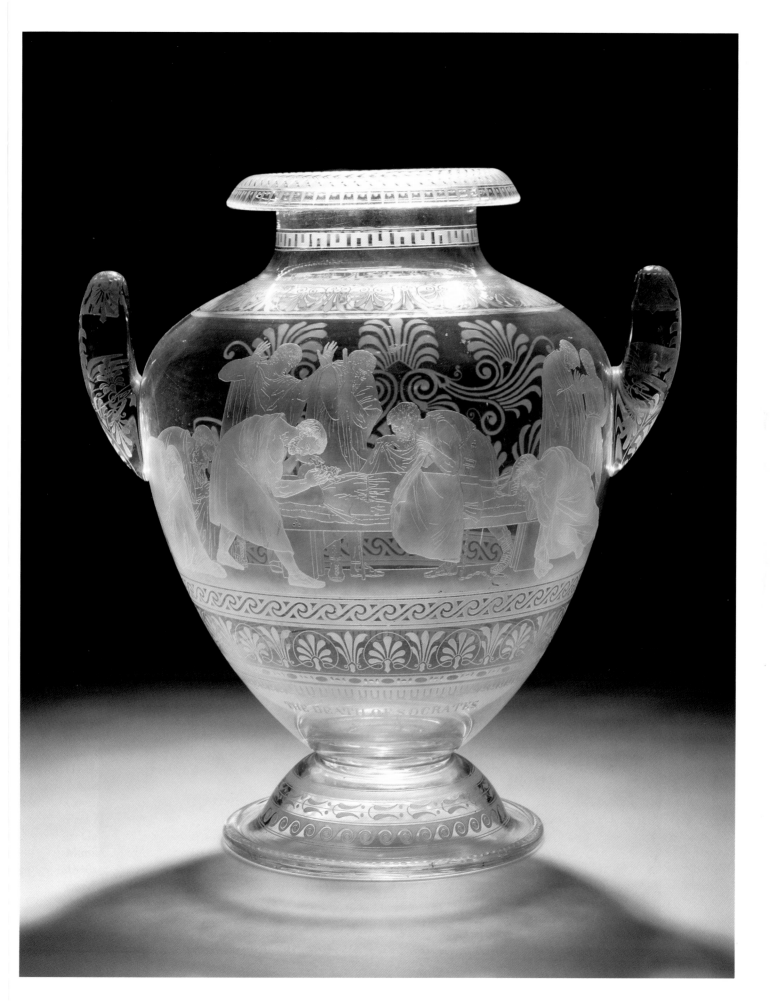

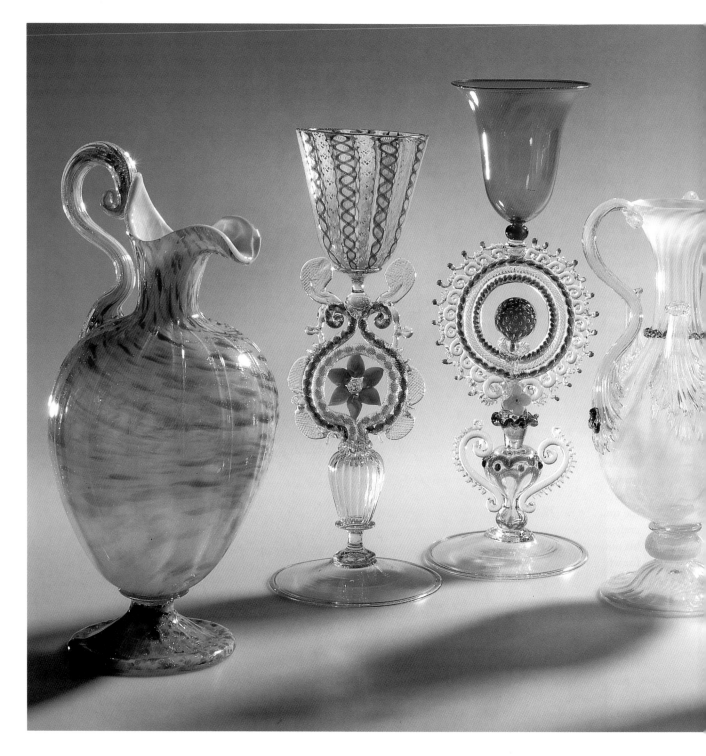

periods in the history of their own lands to lend glory to the present. In Venice, the once famous glass industry was revived after the Austrian occupation ended in 1866. Antonio Salviati (1816–90) played an important role in this revival, bringing together the best craftsmen on Murano with British capital to establish his Venice and Murano Glass Company. He was soon followed by other entrepreneurs. They produced mainly tableware, freely

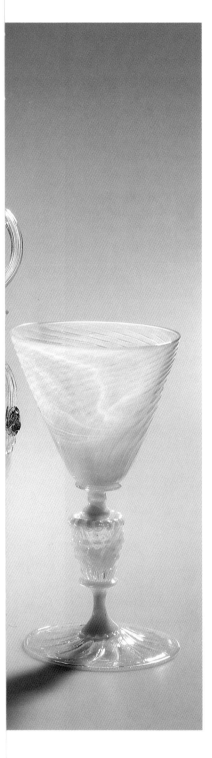

151 (left). *Antonio Salviati, who led the revival of glass-making in Murano, made this colourful ornamental and table glass freely based on Venetian glass of the 16th and 17th centuries.*

152 (above). *The style of press-moulded wares closely followed fashion; the jug shows asymmetrical scrolls in a neo-Rococo style while the goblet is decorated with Gothic arches.*

based on the styles of Venetian glass from the sixteenth and seventeenth centuries, but often much more colourful (fig. 151). This type of glass became especially popular in Britain, France, and the United States. Enamel-decorated Humpen were especially popular in Germany and Austria in the sixteenth and seventeenth centuries (see Chapter IV and fig. 69) and these were imitated and even copied with skill and accuracy by companies such as Ambrosius Egermann of Haida, Bohemia, and Fritz Heckert's Petersdorf glassworks in Silesia, from around 1880.

In the 1880s the French glass-maker Emile Gallé of Nancy (1846–1904), best known for his later Art Nouveau work, began his glass career by designing enamelled and acid-etched glass in a medieval style decorated with fleurs-de-lis, knights and ladies, and Gothic lettering. His style was also taken up by Antonin Daum (1864–1930), one of the most important of the next generation of glass-makers in Nancy.

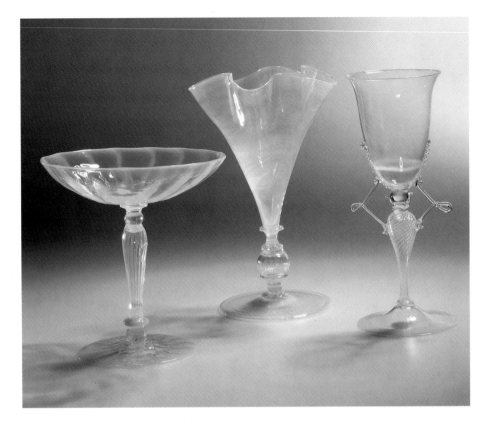

155. *Ultra-thin, free-blown pieces inspired by Venetian glass of the 16th and 17th centuries. Executed in a in a opalescent glass, they were a speciality of the Whitefriars Glassworks under Harry J. Powell.*

parency were all. These beliefs were adopted in the early 1860s by retailers and designers like William Morris (1834–96) and his friend Philip Webb (1831–1915), although their interests also extended to German 'forest glass' and, briefly in 1859–60, to enamelled glass. With the glass-makers James Powell & Sons of Whitefriars, and the architect-designer Thomas G. Jackson (1835–1924), these Ruskin acolytes were responsible for the design and making of some of the most unexpectedly restrained and simple of blown and handworked tableware. Fig. 153 shows some good examples, from the late 1860s.

Ruskin's remarks coincided with the reawakening of interest in Venetian glass of the Renaissance period among the great collectors. The vast majority of the world-renowned collections of Venetian glass in the Victoria and Albert Museum was acquired in the second half of the nineteenth century – the Venetian glass of Salviati also became extremely popular in Britain, and his company was largely funded with British money. James Croft Powell (1847–1914) and his cousin Harry Powell (1853–1922) responded in the 1870s by producing a whole range of 'art' glass and tableware in an old Venetian style, often executed in opalescent glass (fig. 155).

Fancy Colours

One of the most direct ways in which the advances of glass technology can be recognized is in the development of complex colours and surface treatments. Glass-makers in Germany and Central Europe imitated the subtle, sometimes spectacular iridescent sheen found on excavated glass, affected by acids in the soil. The Stourbridge-area companies of Webb and Stevens & Williams and the American firms Libbey's New England Glass Company and Steuben, under Frederick Carder, each made what was called 'fancy' glass in fantastically shaded and brilliant colours with evermore elaborate shapes. Heat-sensitive colours based on uranium, gold, and arsenic were developed and the glass given names to match its exotic appearance – Queen's Burmese, Matsu-no-ke, Peach Satin, Sylveria, Amberina, and Peach Blow.

Naturalism

Neo-classicism aside, probably the most pervasive inspiration for design was the natural world. From Bohemian coloured glass, which emulated semiprecious stones, to

156. *Christopher Dresser combined his interests in Japanese asymmetry and natural forms to produce some of the most surprising designs of the late 19th century, taking full advantage of the ductility of molten glass.*

painted decoration of flowers or drinking glasses and vases in the form of plants, nature was an ever-visited source. Flower painting was done in an opulent manner with an abundance of gilding in many glassworks in Central Europe. The Frenchman Jules Barbe (in Britain 1879–1925) settled in Stourbridge in 1879, working for Thomas Webb & Sons at the Dennis Glassworks. He too used immensely complex gilding to great effect, but with more naturalistically painted flowers, combining translucent and opaque enamels. By the turn of the century many glassworks in Bohemia and eastern Germany, such as that at Theresienthal, were making drinking glasses in the form of flowers so delicately stemmed as to be largely impractical. Perhaps the most influential exponent of this type was the German designer Karl Koepping (1848–1914).

Towards the end of the century naturalism began to take on a more highly charged significance, particularly in France. Literature, painting, and sculpture, as well as the arts of glass, ceramics, textile design, furniture, and metalwork all reflected late nineteenth-century philosophies, which identified certain mystical and symbolic meanings that were locked within the natural world. In addition, the influence of Japanese design was extremely significant. Fashionable in Western Europe in the late eighteenth century, it was taken up again from the 1860s when Japanese prints and artefacts began to appear in exhibitions and shops in Britain and France and elsewhere. Westerners became fascinated with Eastern symbolism which they adopted as the result of either serious study or romantic fancy – according to inclination. One of the few Westerners who actually travelled to Japan was Dr Christopher Dresser (1834–1904), sent by the British government on a fact-finding mission in 1876–7. A designer in many materials and trained in botanical studies, Dresser was interested in Middle and Far Eastern cultures and, uniquely for the time, in South American arts. With this eclectic background he combined accurate understanding of the laws of plant growth with an acute eye for particular features of Japanese patterning. Asymmetry and precise formality were combined in much of his work in pattern design but in glass he was one of the most progressive designers in the Ruskinian school, allowing the behaviour natural to molten glass to dictate its form and decoration. He designed surprisingly freely formed glasses with lightly coloured veiling for the Clutha range of the Perth glassworks, James Couper & Sons (fig. 156).

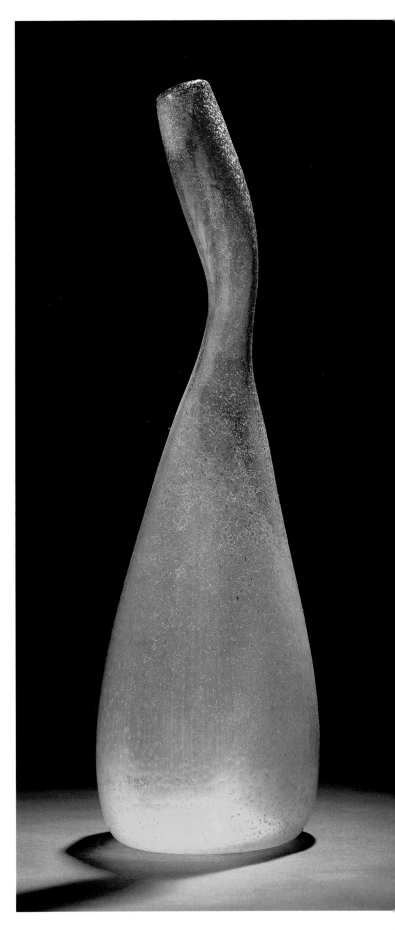

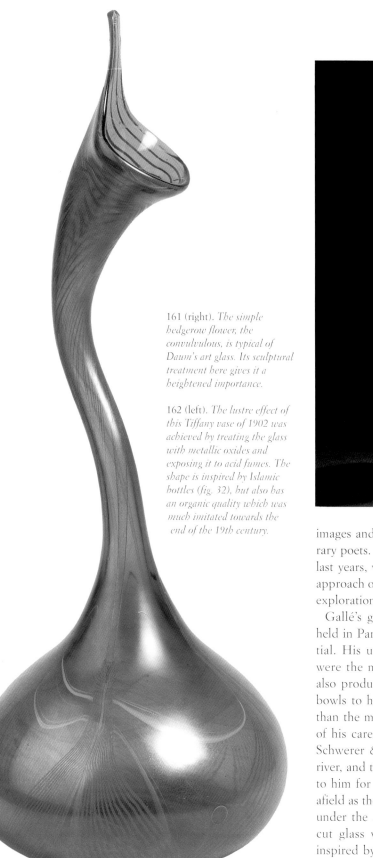

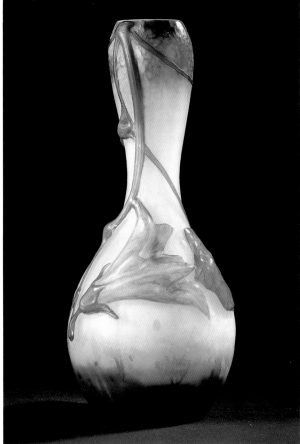

161 (right). *The simple hedgerow flower, the convulvulous, is typical of Daum's art glass. Its sculptural treatment here gives it a heightened importance.*

162 (left). *The lustre effect of this Tiffany vase of 1902 was achieved by treating the glass with metallic oxides and exposing it to acid fumes. The shape is inspired by Islamic bottles (fig. 32), but also has an organic quality which was much imitated towards the end of the 19th century.*

images and engraved lines from his favourite contemporary poets. Gallé died in 1904 at the age of 58, and in his last years, when he was ill and increasingly aware of the approach of death, his glass became an intensely personal exploration of his own preoccupations.

Gallé's glass, shown at the international exhibitions held in Paris in 1889 and 1900, was enormously influential. His unique pieces, which were almost sculpture, were the most highly prized, but the Gallé glassworks also produced a huge number of acid-etched vases and bowls to his designs which satisfied a far wider market than the more costly individual works. At the beginning of his career he had worked in the glassworks Burgun, Schwerer & Co. at Meisenthal in the valley of the Saar river, and this glassworks was one of many which looked to him for inspiration. His influence may be seen as far afield as the Imperial Glassworks in St Petersburg where, under the art director Ivan Murinov, they made cameo-cut glass which, if not mere imitation, was certainly inspired by Gallé's work. In Sweden at the Kosta glass-

works in the 1890s, Gunnar Wennerberg (1863–1914), also a talented watercolourist of flowers and other plants, designed a range of vases made in cameo-cut coloured glass, which is as graceful and decorative as any. In Gallé's own town of Nancy, his most important near contemporaries were the brothers Auguste (1853–1909) and Antonin Daum. The Daum brothers assembled an impressive team including the master decorator, painter and sculptor Henri Bergé (1868–1936) and Amalric Walter (1859–1942), a graduate of the Sèvres school who specialized in pâte-de-verre. Perhaps because they worked with a team of artists, the Daums did not excite the same adulation as that of Gallé – their glass was not so highly charged and personalized. Nevertheless, their ambitious exploration of the limits of decorative glass technology and their use of images taken from history, the East, and the wild flowers of the Lorraine countryside place them centrally and vitally within the various art movements of the late nineteenth and early twentieth centuries (fig. 161).

Pâte-de-verre

For Henry Cros (1840–1907), a fascination with the art and literature of the ancient world led to the development of a new technique. In his art he used images such as classical-style masks or faces. He studied Egyptian casting techniques to develop a new method known as pâte-de-verre – a way of producing works by melting powdered glass in a mould with metallic oxides for colouring. In 1891 he was offered a kiln at the National Manufactory at Sèvres. An extremely private man, who kept his techniques a closely guarded secret, Cros was apparently unaware of the Belgian Georges Despret (1862–1952) who developed much the same technique at his own glassworks, Glaceries de Jeumont, for his part also unaware of Cros.

A rather different technique was being pursued across the Atlantic. In 1881 Louis Comfort Tiffany (1848–1933) had bought a patent for lustred glass. Entering the family business he reformed the furnishing and decorating company several times before deciding to specialize in glass. In 1893, he set up the Stourbridge Glass Co. at the Corona Glassworks in Long Island, N.Y. with Arthur J. Nash (1849–1934), a talented glass-blower from Stourbridge, England. The two worked to perfect the iridescent effects as seen on excavated, Roman glass – much as had been tried some 20 years earlier by various

European manufacturers. Tiffany had seen this technique first in the Central European glass of Lötz and Lobmeyr, as well as some of the English glass-makers. Webb & Sons for instance by 1878 had perfected a particularly strong, dark iridescence called Bronze Ware. Tiffany, however, was immeasurably more successful, producing the most lustrous and vivid iridescence by treating the glass with metallic oxides and exposing it to acid fumes (fig. 162). Iridescent glass was but part of the Favrile range of art vases produced by Tiffany. The range was extensive, varied, and included some of the most rich and sumptuously colourful effects ever seen in glass. Perhaps even more famously, he designed and manufactured windows, lamps, and lights in stained glass with equally innovative colouring and richness. In all his glass, Tiffany, like his contemporaries, was highly influenced by the forms he found in the natural world. He made vessels in the form of flowers, and his designs for stained-glass windows and lamps depicted wisteria, vines, and dragon-flies with an unmatched intensity.

His success attracted imitators of whom, in lustred effects, the most competitive was the glassworks of Johann Lötz-Witwe in Klášterský Mlýn, Bohemia, whose earlier lustred glass had inspired Tiffany in the first place. Under its director Max Ritter von Spaun (d. 1909), appointed in 1879, the glassworks moved into the production of artistic glass in imitation of hard-stones and then lustred glass. It was then relaunched in 1899 in a bid to capitalize on Tiffany's success. Lötz even produced a range of glass of the commercial acid-etched type made by Gallé's glassworks.

The turn of the century was marked by one of the most famous of international exhibitions, held in Paris in 1900, where all the important glass-makers from the major glass-producing countries exhibited together. The Exhibition is usually identified most closely with Art Nouveau, which took its name from the influential Parisian shop owned by Samuel (Siegfried) Bing (1838–1905). There customers could find the latest exotic imports from the East and art wares from many Western countries, including Tiffany's glass. Art Nouveau, also known as the 'Liberty Style' in Britain and Italy and 'Jugendstil' in Germany, was the culmination and final expression of many of the styles that had preceded it. With its intense curvilinearity and insistent, sensual forms, there were aspects of Japonism, Naturalism, and Neo-Rococo within it, as well as, a certain *fin-de-siècle* decadence, which had its roots in Symbolism.

Millefiori Paperweights

The classic paperweight is a dome-shaped object, made of solid colourless glass, incorporating sections of multicoloured canes, which often form a flower or a millefiori pattern. The thick covering layer of clear glass has an optical effect, and both unifies and magnifies the design.

As a decorative device assembled cane sections have a long history, which predates Roman times. Venetian glass-makers of the late fifteenth century, made small glass balls incorporating millefiori patterns. The particular paperweight form, however, came into being and was perfected in the 1840s in France. From there the technique spread to Belgian glassworks, such as Val-Saint-Lambert at Seraing, and across the Atlantic to the United States, where the form has been extraordinarily popular. The size and the direct appeal of these small, smooth objects, with colourful and mysterious insides, have always made them ideal gifts. They remain highly collectable today.

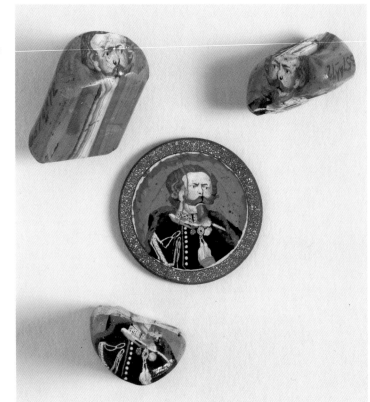

163. Production of the millefiori paperweight depends on prefabricated canes. These are thin rods of glass, made by drawing out a quantity of molten glass. These canes can be monochrome or built up from several colours. Different colours can be gathered successively to form a rod with a bull's-eye cross section or, alternatively, bundles of canes arranged into more complex designs can be fused together. These are then drawn out into long rods of sometimes over 20 metres.

164 (above). A complicated mosaic cane can be made by assembling sections of canes and other bits of glass to form an image, such as a portrait. After fusing this in the kiln, the image is miniaturized by elongating the cane. The firm of Franchini on the Island of Murano, in Venice, specialized in this kind of work from about 1840 onwards.

165. Millefiori paperweights are made by picking small sections of cane arranged in a small metal tray on a solid gather of clear glass. They are then covered with a second gather of clear glass and shaped into a smooth round form.

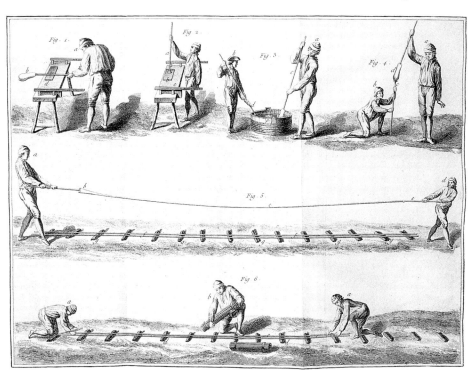

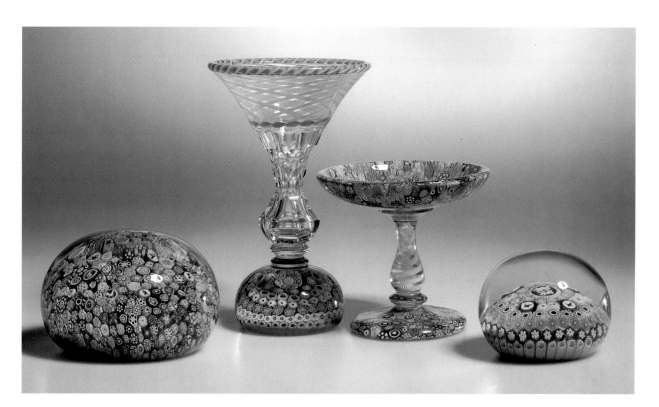

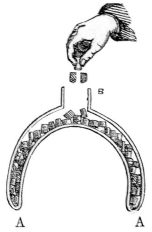

166. Apsley Pellatt described and illustrated an alternative method in 1849: 'The double transparent Glass cone, A, receives the lozenges between the two surfaces. The whole is reheated; a hollow disk, communicating with the blowing-iron, adheres to the neck, B, and the air is exhausted or sucked out of the double case… After being rewarmed, it becomes one homogenous mass, and can be shaped into a tazza, paperweight, &c. at pleasure.'

167 (above). Between 1843 and 1848, the factories at Baccarat, Clichy, and Saint-Louis took the production of millefiori weights to its height, in terms of technical control and richness of colour. The paperweight technique was also adapted to make small dishes and vases. The French factories sometimes marked their products with initials and a date, incorporated into a cane.

168. Britain has had some precedents in paperweight history. From the late 1820s, it produced bubbled green-glass weights known as 'dumps', sometimes decorated internally with floral decorations made up of tiny bubbles. By 1848–9 George Bacchus and Green & Green of Birmingham and Whitefriars Glassworks, London, were making millefiori 'letterweights', while Apsley Pellatt, also of Birmingham, specialized in sulphide decorated weights.

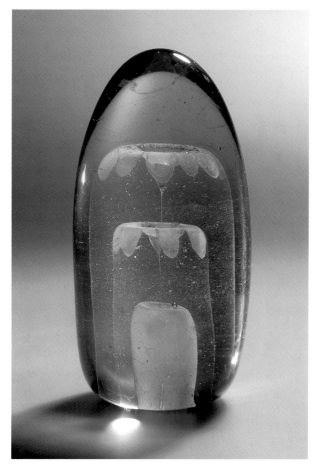

THE TWENTIETH CENTURY: ART AND INDUSTRY

During the twentieth century the polarization of glass-making into the twin roles of art glass and glass-for-use has become complete. Whereas much of the glass made by artists is now like sculpture, sold as art objects in galleries, glass for everyday use has become cheaper and more expendable than ever before. For domestic ware marketing and technology are as integral to the production as the work of the designer.

Modern Beginnings

At the turn of the century, designers from the Vienna Kunstgewerbeschule (decorative arts school) were responsible for some of the most striking glass designs of the period. Professors Josef Hoffmann (1870–1956) and Otto Prutscher (1880–1949) were members of the progressive design workshop called the Wiener Werkstätte, founded in 1903. They worked with the Bohemian glassworks Meyr's Neffe and Lötz. At Meyr's Neffe glassworks specialist skills were employed in traditional cased and wheel-cut glass, while the Lötz glassworks produced lustred glass called *Phänomen*. While Phänomen proved to be the last appearance of the Art Nouveau style, the glass designed for Meyr's Neffe was austere and elegant and heralded a 1920s Modernism (fig. 169).

In France, Art Nouveau lasted barely more than a few years into the new century. Within a year or two its extreme and intense ornamentalism became diluted. This led to a style which was more purely decorative and certainly less demanding of its audiences. After the death of Henry Cros (see Chapter VI, p.127), a number of artists in the studios at Sèvres continued the delicate art of *pâte-de-verre*. Jean Cros (1884–1932) inherited his father's own secret recipes which, in turn, he never divulged. Albert-Louis Dammouse (1848–1926) experimented independently, drawing on his experience as a

ceramicist and developed a fine and glassy paste, known as *pâte d'émail* (fig. 170). François-Emile Décorchemont (1880–1971), using a recipe close to Dammouse's, refined and stretched it to such a degree that some of his pieces emerged lacy-holed or even collapsing from the mould. Joseph-Gabriel Argy-Rousseau (1885–1953) began as a student at the ceramics school at Sèvres, moved to pâte-de-verre and experimented most successfully with a wide variety of subtle colours.

By the 1920s Décorchemont, Argy-Rousseau, and Antonin Daum (see again Chapter VI, p.127) were able to produce substantial vases and bowls on a regular and dependable basis. Décorchemont's production was modest compared to that of Argy-Rousseau and especially the Daum glassworks, which produced considerable amounts through much of the 1930s. At the Daum glassworks Amalric Walter (1870–1959) worked with Henri Bergé designing a commercially successful range of ashtrays and small figures as well as screens and window-

169 (opposite). *In the first decade of this century Joseph Hoffmann and Otto Prutscher designed glasses in simple shapes, sparsely decorated with strictly geometric cutting.*

170 (below). *Albert-Louis Dammouse made this* pâte d'émail *bowl at his studio in Sèvres. It was exhibited at the Paris Salon in 1901.*

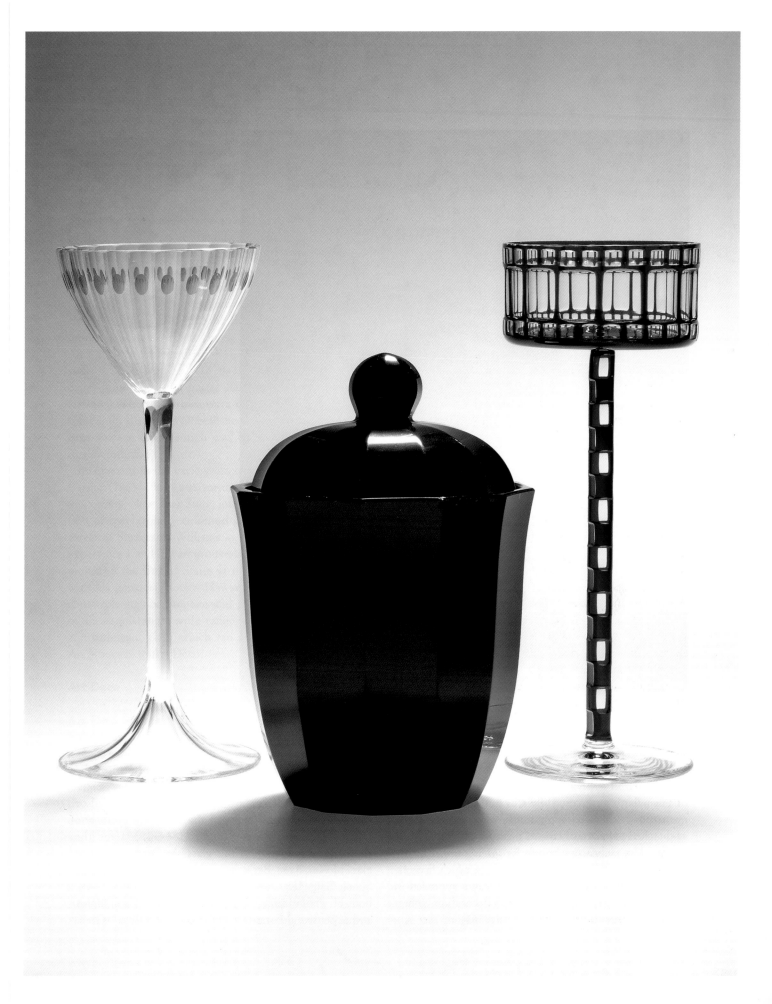

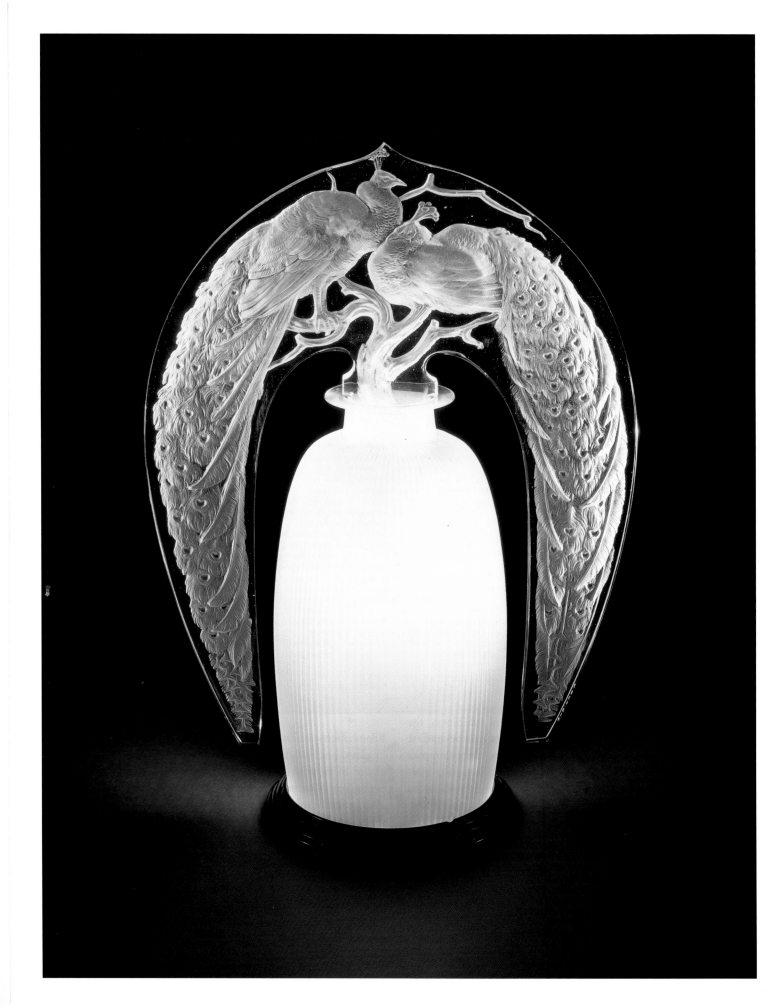

173 (opposite). *René Lalique's lamp 'Deux Paons' (two peacocks), designed in 1920. The press-moulded peacocks are lit from within the glass by a light bulb in the base.*

174 (right). *In about 1930 Maurice Marinot both designed and made these massive sculptural objects, decorated with internal bubbling and colours.*

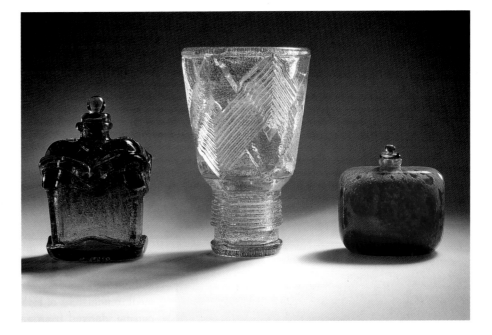

tectural glass and furniture to domestic ornamental glass and tableware. By the mid-1920s he was hugely successful making vast quantities of ornamental glass for the middle-to-higher market and receiving commissions for prestige projects such as the Côte d'Azur railways and luxury ocean liners (fig. 173). He used many colours, but his most distinctive and characteristic range was in a bluish-opalescent colour, which is achieved by the addition of antimony or arsenic and different rates of cooling within the glass. Lalique drew his inspiration from a wide variety of sources and his name is more closely associated with the Art Deco style than that of any other glass-maker.

Maurice Marinot

Maurice Marinot (1882–1960) belonged to *Les Fauves* (the wild beasts), a group of painters using vivid colours and working in an energetic style. In 1911, after visiting a glassworks owned by the Viard brothers at Bar-sur-Seine, Marinot designed some simple bottle shapes, executed by the factory, on which he painted in enamel colours. Two years later his glass was regularly for sale at André Hébrard's Paris gallery, together with work by eminent sculptors such as Auguste Rodin, where it attracted the attention of the art press. By the early 1920s, Marinot had learned to work the hot glass himself and in 1925 he showed his own glass in the international exhibition in Paris where it was greeted with universal praise (fig. 174).

Marinot was different from any glass artist before, in his view of glass as a purely sculptural material and, even more crucially, in acquiring the making skills for himself. No other hand or mind was responsible and it is this apparently unique feature which now places Marinot firmly in the role of father to postwar studio glass.

Marinot worked in glass until 1937. Surprisingly, his by now mythic presence in art glass was founded on only two basic, essentially functional, vessel types: the vase and the stoppered bottle. Within these forms, however, he explored the possibilities of hot and cold-worked glass in ways which were unprecedented. All his works are heavy-walled and intricately decorated with internal gas bubbles and coloured effects, which he magnified with an applied layer of colourless glass or which he subjected to almost brutally deep acid-etching. By these means he created a unique contrast of sombre darkness and sparkling light, of interior life contrasting with exterior profile.

Naturally, Marinot attracted followers of whom the best known are Aristide-Michel Colotte (1885–1959) and Henri Navarre (1885–1971). Navarre specialized in internal decoration and hot-worked applications to his vases but Colotte, a jeweller and glass-engraver who moved to Nancy in 1920, turned to a massively sculptural style. Even more independent, but without the following that Maurice Marinot attracted, was the Spaniard Jean Sala (1895–1976). Sala, who owned antique shops in Paris, worked in pâte-de-verre, but more importantly, he had a

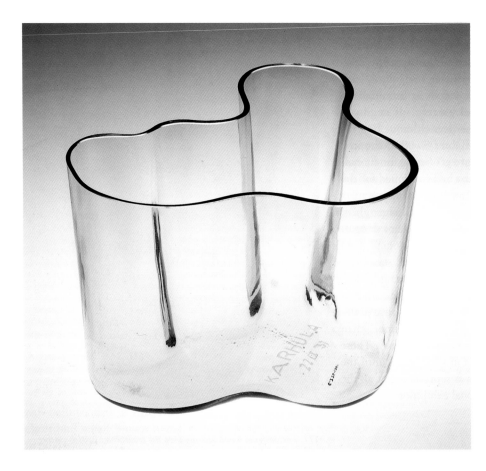

178. *Designed by the Finnish architect Alvar Aalto and his wife Aino in 1937, the 'Savoy' vase is made of cheap, unrefined bottle glass, blown in a wooden mould.*

In fact Aalto's first glass designs were predated by some for tableware by his wife Aino (1894–1949). Her series of practical, press-moulded ringed tableware have become, like most of the Aalto's output, design classics. It is likely that Aino Aalto played an important part in the design for the famous, wavy-shaped, mould-blown 'Savoy' bowl, for which Alvar Aalto is now credited (fig. 178). The vase was, however, designed with a particular organic form which is typical of Aalto's work in architecture and furniture. It was first produced in 1937 and, following the principle of good but inexpensive design, the earlier examples are executed in cheap bottle glass. Manufactured by Iittala glassworks in increasingly expensive glass and colours, the vase has not been out of production since its launch.

During the 1930s Central Europe, especially Czechoslovakia, was one of the European market's chief suppliers of inexpensive blown domestic glassware made to unexacting design standards, inexpensive and popular if unremarkable. Some Czech factories, however, such as the glassworks at Krásná Jizba produced strikingly

modern wares. Ludvika Smrcková (b.1903) designed tableware in strictly geometrical shapes, in a style close to contemporary functionalist architecture.

At Steuben, Frederick Carder continued to produce more and more fancifully coloured ornamental glass, while the neighbouring glassworks, Corning, developed a heat-resistant glass. In 1915, under the brand name Pyrex, they launched a press-moulded range of practical kitchen and tableware. Other countries were soon to follow. Most designs were developed anonymously but a few were the responsibility of named designers. In Britain, for instance, the metalworker and ceramic designer Harold Stabler (1872–1945) worked for Chance Bros at Smethwick, in the West Midlands, and the architect Raymond McGrath (1903–77) at the British Heat Resisting Glass Company. Even Carder himself crossed briefly from Steuben to Corning; he is credited with the design of a teapot and stand of 1922 (fig. 182). Early Pyrex and similar wares for practical use were press-moulded and had a fairly sturdy appearance. Some ranges, however, had cut decorations or later, printed

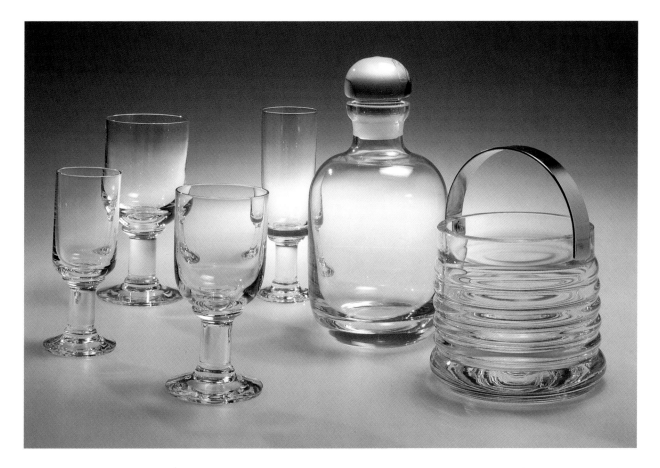

179. *Tableware designed by Frank Thrower for Dartington between 1967 and 1981, illustrating the factory's commitment to functional design executed in high-quality materials.*

patterns. Some were fitted with metal stands and holders, usually of electro-plated nickel silver.

At Schott's Jena glassworks in Germany, far more elegant vessels were produced in heat-resistant glass by blowing, using press-moulding only for stoppers and lids. Drawing on the celebrated Bauhaus school, Schott commissioned designs from Gerhard Marcks (1889–1974) and Wilhelm Wagenfeld (1900–90) for wares that were suitable for coffee, tea and oven-use (figs 180 and 183).

The Second World War inevitably shifted production away from art and towards the functional. Domestic wares were strictly utilitarian. Although the glass industry was generally protected, many factories were seriously run-down by the end of the War or were faced with major changes if they were to survive. The most successful glassworks were those which brought in automation. In 1949, the English United Bottle Glass Company was

the first in Europe to adopt an American invention when they began fully automatic production of drinking glasses. In Germany, many factories were relocated from East to West and obliged to re-equip themselves with machinery and new workforces.

In 1967 the Dartington glassworks was set up at Torrington in Devon. Founded on Swedish principles, with Swedish glass-blowers and with a commitment to good design and a paternal responsibility for the wellbeing of its workforce, the chief designer and guiding conscience of the works was Frank Thrower (1932–87). The new glassworks, from the start, produced practical table and small ornamental wares in colourless lead crystal, sold in elegant, equally well-designed packaging (fig. 179).

Today, contemporary industrial production is the result of many factors. The principles of sound or aesthetically pleasing design have to be balanced against costs and demands. Glass for daily use, from fine goblets and vases to beer bottles and jam jars, is now designed by a team in which the designer occupies a place next to the glass-technician and the marketing expert.

From the Oven to the Table to the Fridge

The pioneering work carried out in the last decades of the previous century in France and Germany on a new type of glass was to have an enormous impact on the industrial and domestic uses of the material in the twentieth century. The German Schott glassworks was the first to make a successful borosilicate glass, which was not only resistant to sudden changes in temperature but was also less prone to breakage and corrosion than any of the earlier types of glass. Schott and the American company Corning jointly developed its scientific application until their collaboration ceased with the First World War. In 1915, Corning was the first to use it for tableware. By the 1930s, wares for the oven and table were being made and marketed by a company which combined Corning, St Gobain in France and, by licence, the Wear Flint Glass Works in Britain, as well as others in Germany and Japan. Meanwhile, in the 1920s, Schott had produced their first tableware. They commissioned distinguished designers to work on their ranges of table glass and ovenware, as did the Lausitzer glassworks for their containers for the new domestic refrigerator. Corning, however, stayed ahead of its rivals and continued to refine the material. During the late 1950s, they introduced Pyroceram, a glass-ceramic mixture. Colours and patterns gave the wares an additional appeal. The more decorative designs were intended to come straight from the oven to the table.

180. A 1930s advertisement photograph taken for Schott, showing ovenware looking elegant enough for table use. The sauce boat and bowls were designed by Wilhelm Wagenfeld.

181 (right). Advertisements like this of 1936 for Pyrex wares combined an explanation of practical virtues with selling smart modernity. Jobling made Pyrex in Britain from 1921.

New!..Sensible!..
...Beautiful!
"Pyrex" streamline casseroles

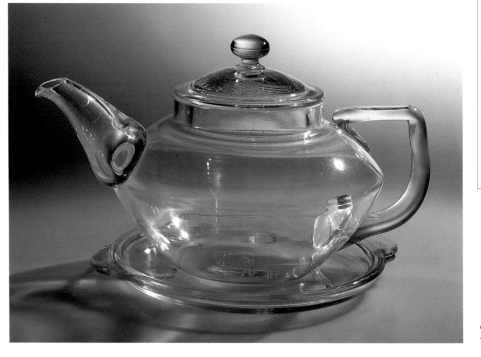

182. Teapot and stand of 1922, said to have been designed by Frederick Carder for the Corning glassworks.

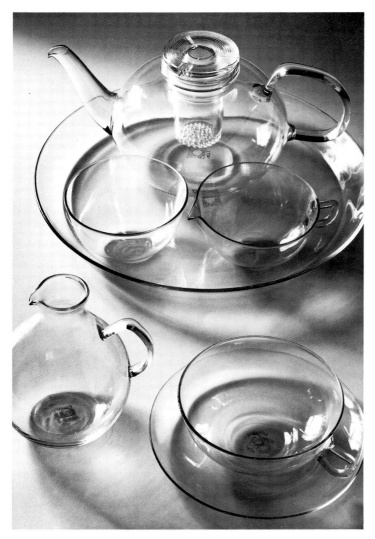

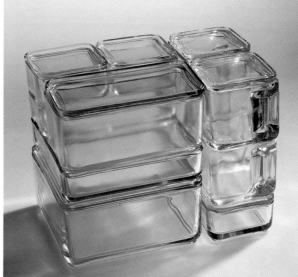

183 (left). Advertisement photograph for teaware by Schott, designed by Wilhelm Wagenfeld around 1930–4.

186. These stackable, space-efficient containers for a refrigerator were made by the Vereinigte Lausitzer glassworks and were designed by Wilhelm Wagenfeld in 1938. The fact that it is very time-consuming to arrange the different containers in the intended way, makes this 'functionalist design classic' rather impractical.

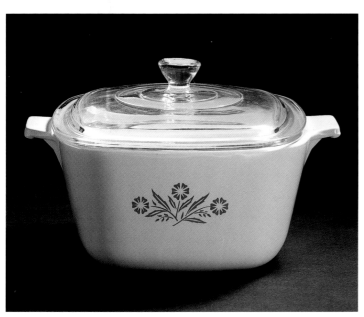

184 (left). Probably the most successful pattern ever was 'Cornflower', introduced in 1958. This saucepan and lid, was made by Corning in Pyroceram.

185 (right). In the 1970s, design for heat-resistant glassware was given a new look by the Swedish company of Boda. This cafétiere, 'Bistro' with polypropylene plastic handles is one of the most familiar coffeewares of the 1980s. It was designed by the Dane Carsten Jørgensen in 1973–4 and made by Peter Bodum (Schweiz) AG.

Art Glass

After the Second World War, art glass production in many countries picked up with unexpected speed and almost immediate success. The foundations for this had often been laid many decades earlier.

In 1921 the Venetian glass production was about to enter a new golden age. In that year the Milanese Paolo Venini (1895–1959) and Giacomo Cappellin (1887–1968) founded Vetri Soffiati Muranesi Cappellin-Venini & C. Their art director Vittorio Zecchin (1878–1947) was inspired by glassware in sixteenth-century paintings. The most famous example is a vase taken from *The Annunciation* (1580) by Paolo Veronese (1528–88), which became a symbol for the Venini glassworks. Throughout the 1930s and into the 1940s Venini's glass-making teams worked closely together with a range of talented designers such as: Napoleone Martinuzzi (1892–1977); Tommas Buzzi (1900–81); Carlo Scarpa (1906–78); Gio Ponti (1891–1979); Fulvio Bianconi (b. 1915) and Paolo Venini himself. Renaissance forms and pale colours came first, then the reworking of classic Venetian techniques and the invention of new ones, in bright colours. Striking shapes and figures, often on a grand scale not attempted anywhere else, became a speciality, which also owed something to an innate Venetian sense of theatricality. Venini was not alone in this. The various glassworks of Seguso, Barovier, Toso and others all made colourful, innovative glass during the 1930s.

The great showplace for design and art was the Milan Triennial. Started in 1923 in Monza, as a biennial, by the 1950s the Milan Triennale was the most important trade exhibition, a status which today is held by the Frankfurt fairs. The first full-scale postwar Triennial was held in 1951 and the star exhibitors were Finnish.

During the 1930s Arttu Brummer (1891–1951), Helena Tynell (b. 1918), Göran Hongell (1902–73) and Gunnel Nyman (1909–48) all contributed to the growth of a national Finnish art style, distinctive for its use of colourless glass (fig. 188). Sometimes bubbled, its forms drew their inspiration from natural sources such as the ice of Finnish winters and the unfolding spring flowers.

Gunnel Nyman died tragically young in 1948, but her glass is generally cited as the immediate precursor to the great classics of the 1940s and 1950s. The Scandinavian model of a studio attached to a commercial glassworks – a model also maintained in Czechoslovakia, Italy, and Holland – more than repaid the investment during this golden period. In the IXth Milan Triennale, 1951, Tapio Wirkkala (1915–85), chief designer at the Iittala glassworks, was awarded a Grand Prize for his design for the Finnish display, for his glass and for wood carving (fig. 187). In 1954 it was the turn of Wirkkala's younger contemporary, Timo Sarpaneva (b.1926) to prove the star attraction. Kaj Franck (1911–89) of the Nuutajärvi glassworks, a designer of the most spare and beautiful table glass, was also responsible for ornamental glass including figures of birds, in an unexpectedly colourful and whimsical range. Finland played a central part in the creation of the design style, embracing all the applied arts, known as Scandinavian Modern. This relaxed, humanistic style was enthusiastically embraced all over Western Europe and America. Glass from the Nordic countries spearheaded the fashion for clean, uncluttered shapes and informal, functional tableware. Wheel-engraving continued to be popular in Sweden. Its style was often graphic and light, amusing, and observant of daily life, particularly in the postwar work at Kosta of Edward Hald's near-contemporary Vicke Lindstrand. At Orrefors, the Graal glass had been complemented in the late 1930s with a new technique, Ariel, in which an engraved design, cased by a layer of colourless glass, becomes visible as images drawn in air bubbles, offset by enclosed colours. During the 1950s Ariel overtook Graal in popularity. In 1957 Nils Landberg (b. 1907) produced the classic Tulpanglas for Orrefors in a subtle range of browns, greys, and pinks. One of the few excursions into stronger colours was the Ravenna series, launched in 1948 by Orrefors and inspired by mosaics seen in the Italian city by Sven Palmqvist (1906–84).

In Italy itself, designers continued the prewar interest in colour, sculpture, and the adaptation of historic techniques, in considerable contrast to the Northern glass. Cut canes, the patchworking of squares of colour and filigree were all used in ways which were entirely new, either in scale or in the palette of rich reds, bright blues, and acidic yellows. The showplace for Italian glass was the Venice Biennial, at which all of the major innovations in Venetian glass were launched. Fulvio Bianconi and Tobia and Carlo Scarpa at Venini were leaders, rivalled by Archimede Seguso (b. 1909), Ercole Barovier (1889–1974) and many others (figs 189 and 190). Their most sculptural work and free-formed blown glass foreshadowed developments in America in the later 1950s. In the 1960s designers from abroad, like Wirkkala, were invited to design for Venini's art range.

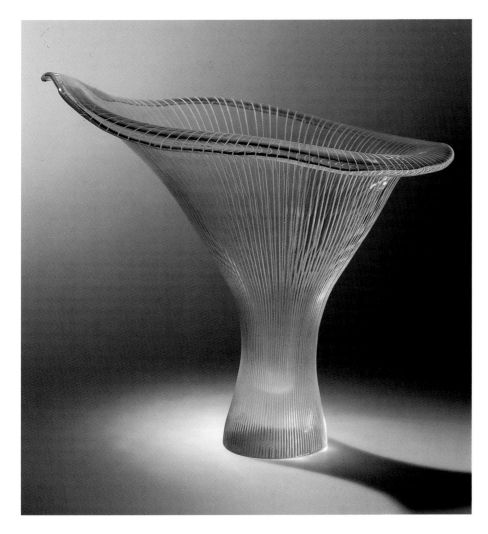

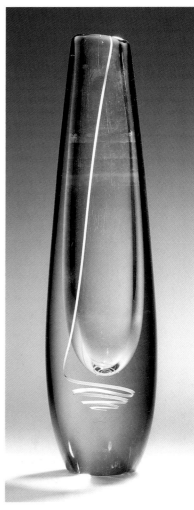

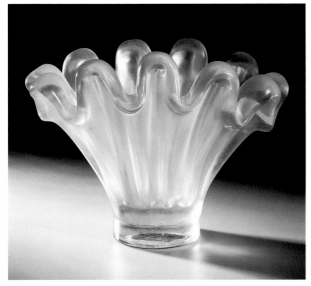

187 (above). 'Kantarelli', a vase designed by Tapio Wirkkala in 1946. Its organic, sculptural form is based on the chanterelle mushroom.

189 (left). Vase, designed by Ercole Barovier in 1942, exemplifying the boldness and flamboyance of Italian glass at this date.

190 (right). Designed by Fulvio Bianconi in 1950, this vase was made at the Venini glassworks using the ancient technique of fusing a patchwork of coloured squares, rolling them into a tube shape and then blowing them to size.

188. Finnish glass artist Gunnel Nyman designed the 'Serpentiini' vase for Nuutajärvi in 1947.

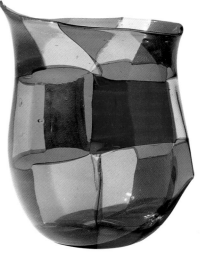

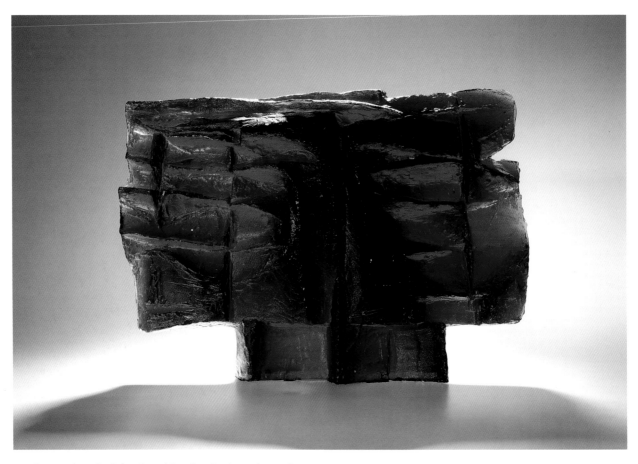

191. *In 1962 Stanislav Libenský and Jaroslava Brychtová designed and made this moulded, sculptural winged head at the Czech Centre for Glass Architecture at železný Brod.*

When production was restarted after the War in Czechoslovakia, companies picked up with what materials they had left – raw glass, enamels and so on. Despite these difficult conditions, however, soon a highly original production was established; painted enamel decoration, rough wheel-cut sculptural panels, and cast glass, all demonstrated a very different aesthetic from that which prevailed elsewhere. In the 1950s and throughout the 1960s Czech glass was more closely tied to painting and sculpture than in any other country. Late Cubism and 1950s Abstract Expressionism played a crucial role. The artists justly most celebrated are the husband and wife team of Stanislav Libenský (b. 1921) and Jaroslava Brychtová (b. 1924) who between them combine the talents of painter, glass decorator, sculptor, technician and, not least, teacher of generations of younger glassmakers. The expectations of a state-owned industry were for monumental, heroic art to represent the nation, and

there were unique opportunities in the access to grand-scale industrial processes. The results were indeed monumental and heroic, and often also adventurous, spectacular, and quite unlike anything made anywhere else (fig. 191). By the 1980s, Czech technical mastery in cast and moulded glass had reached a peak that seemed unassailable, and which was almost entirely due to the pioneering work of the Libenský and Brychtová partnership.

Other Czech artists worked in a variety of alternative techniques, among them were Jirí Harcuba (b. 1928), whose engraved and cut glass of the 1960s was revolutionary in its very direct association with painterly abstract and figurative expressionism; Pavel Hlava (b. 1924), who produced precisely-cut, discreetly coloured, prism-like glass, as well as mould-blown organic forms; and René Roubícek (b. 1922), who made sculpted vases of an unprecedented plasticity, later moving to free-blown decorative sculptures.

In Britain, the emphasis on that British speciality, cut lead crystal, continued. David Queensberry (b. 1929), is

responsible for some of the most successful designs in the medium, in a simple, geometric manner, executed by Webb Corbett. Other new names emerged of which probably the most celebrated now is Geoffrey Baxter (1922–96), who joined Whitefriars in 1954, straight from the Royal College of Art. In his first ten years Baxter concentrated on furnace-worked shapes in discreet colours or sometimes a glowing red. In 1964, William J. Wilson introduced a series of twisted, furnace-worked vases and bowls in streaky coloured glass which attracted attention, not least from Scandinavia and Italy. A few years later, Baxter took Whitefriars into an altogether less subtle mode. In 1967 he introduced a series of vases in aggressively vibrant colours, blown in textured moulds, which abandoned all Whitefriars's previous trademarks of discretion and traditional compromise (fig. 192). No other British glassworks took so courageous a leap into late 1960s popular fashion.

Studio Glass

Before the late 1950s glass which was more decorative than useful was generally termed 'art glass'. Since the late nineteenth century, artists like Gallé, Marinot, Nyman and Barovier, had all occasionally treated glass as a sculptural material. However, in the mid-1950s artists, working entirely independently, either within or outside a factory environment, used glass as a more fully fledged art form. Artists such as Erwin Eisch (b. 1927) at his family glass-works in Frauenau, Germany, and others in the United States, France, and Japan used glass-blowing, lampwork, and kiln-forming techniques such as fusing sheet glass and pâte-de-verre. The notion of glass as sculpture became explicit.

In America, the key to contemporary studio glass was the design and construction of a furnace which might be fired and managed by one artist-maker. The most important figure in this quest was Harvey Littleton (b. 1922), son of the Director for Research at Corning glassworks and, probably as crucial, neighbour to the independently minded Frederick Carder at Steuben. Littleton consulted makers in Europe and with obstinate determination, his ambition became a reality. With the collaboration of Dominick Labino (1910–87) in particular, in 1960 Littleton built his first kiln and learned to mix and melt his own glass. Within a few years he was making multi-coloured, stretched, and bubbled vases which, in appearance, could have been made in any of the studios

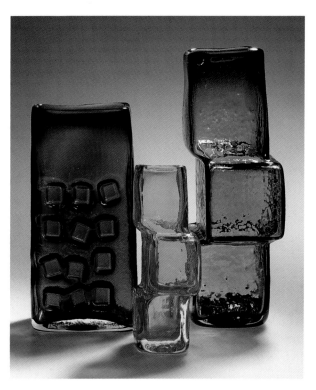

192. *Geoffrey Baxter designed these vases for Whitefriars glassworks in 1966. They appealed to the late 60s taste for unconventional shapes and bright, 'youthful' colours.*

attached to industrial glassworks over the previous fifty years, including those at Tiffany or Steuben. The difference for Littleton and his collaborators was that these relatively primitive vases were his personal concept and were made by him, however inexpertly, at his own furnace. From this stems the term 'studio' or 'craft' glass.

More crucially, Littleton was an effective disseminator of the concept and practice of this 'new' art. Conferences and symposia were held and practical courses were set up for glass artists. Within a short time, this American model had been taken up and spread to other countries. In 1966, Sam Herman (b. 1936), a Littleton student, established a furnace at the Royal College of Art in London and in 1974 he moved to Australia and set up the Jam Factory Workshop in Adelaide. In Europe the term 'studio glass' was adopted by those very glass artists, such as Erwin Eisch in Germany, with whom Littleton had consulted in the 1950s. Today, many universities run glass-making courses.

From the late 1960s and throughout the 1970s, craft or studio glass was largely characterized by the preponderance of blown work. Freely made in organic shapes

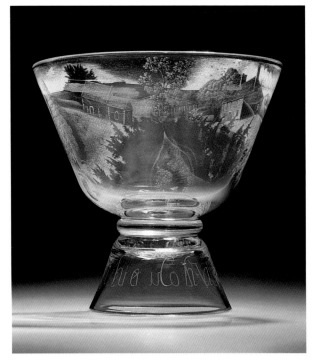

193. *Laurence Whistler is the founding father of modern stipple engraving. The images on the near and far sides of this bowl of 1982 are cleverly designed to come together and form a single scene.*

with hot-worked decoration, this glass expressed the enormous excitement generated among the first generation of students in this new and vibrant art form. Towards the end of the 1970s, however, all the possibilities of cold-working such as sand-blasting, cutting, engraving, polishing, and the use of mixed media were explored, as well as enamelling and different methods of working hot glass. Slumping and sand-casting became especially popular; one of the most celebrated artists working in this technique is Bertil Vallien (b. 1927), at the Kosta glassworks, Sweden. In Britain, the work of the stipple-engraver Laurence Whistler (b. 1921) and wheel-engraver John Hutton (1906–78), who developed the flexible-drive method and whose best-known work is the west window for Coventry Cathedral, influenced a younger generation (fig. 193). The engraver Helen Monro Turner (1901–77) set up the glass department at Edinburgh College of Art and her students, such as Alison Kinnaird (b. 1949) are now among this country's most expert engravers (fig. 196). Pâte-de-verre was reintroduced into the vocabulary by the jeweller Diana Hobson (b. 1943) who, as a student at the Royal College of Art, researched the technique in France where it

survived with the late work of Décorchemont and, after his death in 1971, primarily in the work of his grandson Antoine Leperlier (b. 1953). Hobson's work is now the most sought-after internationally of all British makers (fig. 194). In the early 1960s Harry Seager (b. 1931) pioneered the construction of sculptures from sheets of window glass. Today, sheet glass is used by many artists, such as the American-born Danny Lane (b. 1955). It is often combined with metal or wood as either structural or ornamental elements.

The practice and popularity of studio glass has also been noted by industrial glassworks. For the first time in 1991, Dartington in Britain experimentally presented a range of studio glass by their own designers who were also practising glass-makers in their own right. Nuutajärvi glassworks, in Finland, continues to maintain the liveliest of the long-established studios with the work of Oiva Toikka (b. 1931), Kerttu Nurminen (b. 1943), Markku Salo (b. 1954) (fig. 195) and Heikki Orvola (b. 1943).

Perhaps one of the most distinctive features of the contemporary glass scene is its internationalism. In the 1980s, the effect of the distinctive Post-Modern designs for glass and other materials by the highly influential Italian Memphis Group, under their leader Ettore Sottsass Jnr (b. 1917) was discernible worldwide on an unprecedented scale. Since the early days, discussion and the sharing of ideas and techniques have been integral to the studio glass movement. Today, glass artists travel regularly to other countries not only to teach and take part in conferences, schools, and workshops on the model begun by Littleton, but also simply to exhibit and sell their work.

In Britain, America, and Australia there are specialist makers in virtually every technique. In other countries a more limited range of techniques are practised. In the Czech Republic monumental cast glass remains the most typical and is still made by Libenský and Brychtová. Marian Karel (b. 1944) and Dana Zámecniková (b. 1945) represent opposite ends of the spectrum in terms of using sheet glass. One works in an austere, illusionistic, architectural manner, and the other in a pictorial and theatrical form with cut-out shapes and graphic, painted images, sometimes combined with other materials (fig. 198). In France, Antoine and Etienne Leperlier (b. 1953 and 1952), Décorchemont's grandsons, continue the pâte-de-verre tradition, using it for sculptural work, often with graphic or calligraphic images in colour.

The Art Glass movement of the nineteenth century has

194 (above). *Diana Hobson combines* pâte-de-verre *with bronze and stone in her 'Fragment of a Circle' of 1996.*

195 (right). *The Finnish glass-artist Markku Salo began his career as a designer of electrical products. He often combines glass with metal mesh or wire. Interested in movement and change, wheels and motorized vibration play an important part in his innovative sculptures.*

196 (below). *Alison Kinnaird is interested in Celtic myths and folklore. The imagery in the triptych, which she engraved in 1992, is based on the symbolism of 'three' – past, present, future; man, woman, child.*

moved beyond the imaginings of Gallé, and even of Marinot in the twentieth century. We now refer to contemporary glass *art*. Today the material is used in ways bearing little resemblance to the studio glass of thirty years ago and most glass artists now aspire to sculptural forms even if their starting point is still the vessel. An exhibition of contemporary glass may include works that are constructed more of other materials than of glass. Many pieces are made on a scale which can only be housed in wide public or corporate spaces (fig. 197).

In industry, the mass production of glassware for domestic use takes place on a larger scale and is more competitive than ever before. Manufacturers all over the world, using highest quality lead crystal or cheap recycled glass, feed an insatiable international market.

A rich diversity of artistry and design, combined with the complexities of modern manufacturing and marketing, as well as centuries of skill and knowledge, are behind today's glass-making, whether it is the unique work of art or the inexpensive tumbler.

198. *The Czech artist Dana Záměníková uses mixed media, including vividly painted laminated sheet glass. Her works present aspects of contemporary or historic life as collages or, overlapping, three-dimensional scenes.*

197 (opposite). *The British artist Peter Aldridge (b. 1947) is one of the most precise and cerebral of contemporary glass artists. For his installation 'Portals of Illusion' at the Corning Incorporated headquarters building he used a highly reflective, prismatic glass.*

199 (below). *Dale Chihuly (b. 1941) is America's best known and most flamboyant glass artist. His inter-nesting shapes are based on colourful shells and sea anemones and are a perfect illustration of bravura glass-making skills.*

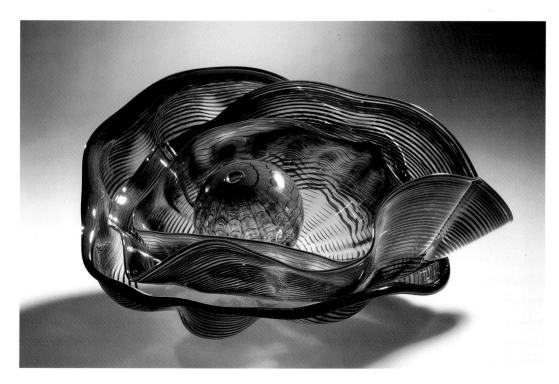

GLOSSARY

Annealing: the process by which a completed object is gradually cooled so as to avoid internal stresses caused by different parts of the glass cooling more quickly than others, which often leads to breakage. Annealing takes place in a separate furnace, or in a separate part of the main furnace, called either the annealing furnace or lehr.

Batch: the mixture of raw materials that is melted in a pot to make glass.

Broad glass (muff process): window glass made from a blown cylinder. After cutting the cylinder lengthwise, it is reheated and opened flat to form a square sheet of glass.

Cameo: a method of cutting cased glass, in which the outer layer of a contrasting colour is partly cut or engraved away, so that the remaining part stands in relief against the background.

Cane: a thin glass rod, made by stretching out a quantity of molten glass. Canes can be monochrome or built up from different colours in such a way as to form a design visible in cross section.

Cased glass: glass made up of differently coloured layers. This can be made by blowing a gather of glass (see below) inside a prepared cup of a different colour, or by covering a gather by dipping it into molten glass of a contrasting colour.

Chair: the glass-blower's bench, which is provided with extended arms on which the blowpipe or pontil can be easily rolled with one hand, while the hot glass is being worked with the other. The word is also used for a team of glass-makers working at the furnace.

Core-forming: the method of shaping glass around a core, usually made of clay and animal dung, fixed at the end of a metal rod. After the object is finished and has cooled, the core can be scraped out to produce a hollow vessel.

Cristallo (Italian: crystal): a fine colourless glass resembling rock crystal.

Crizzling (glass disease): chemical instability of glass caused by an imbalance in the basic ingredients; usually a surplus of alkali or a deficiency of stabilizers. Although the terms disease or sickness are often used, this phenomenon is by no means infectious and it cannot be cured. The first signs are a misty surface, sometimes combined with the presence of water drops. Later a network of small surface cracks appears and, if the glass is not carefully stored at a constant temperature and humidity, it can eventually disintegrate.

Crown glass: window glass made by blowing a large glass bubble, cutting it open at the end opposite the blowpipe, and subsequently spinning it very quickly. The centrifugal force causes the glass to open out into a large flat disc which can, after annealing, be cut up into panes.

Crucible: a fireproof clay container in which the batch is melted. It is also simply called the 'pot'.

Cullet: glass intended for glass-making. This can either be in the form of recycled fragments, or especially prepared from raw materials in the furnace and broken into chunks.

Cutting: a technique for decorating glass in which a rotating wheel of stone, wood, or metal, fed with an abrasive, is used to grind away part of the glass surface, usually to form abstract patterns.

Diamond-point engraving: a technique in which glass is decorated by scratching a pattern into its surface with a sharp instrument, often a small diamond chip.

Dip mould: a conical one-piece mould, which is open at the top so that the gather can easily be pushed in and withdrawn from it, leaving a pattern which can be further shaped by blowing or tooling.

Enamel: a type of coloured glass, opaque, or transparent, which fuses at a relatively low temperature. It is mostly used in a powdered form, suspended in an oily substance like gum arabic. This can be painted on a glass (or metal) surface and fired in a kiln to fuse with its support.

Façon de Venise (French, in the Venetian manner): glass made outside Venice, but in the Venetian style, using a Venetian-type of material.

Filigree glass: blown colourless glass incorporating canes of contrasting colours.

Fire-polishing: a finish given to an object with a dull

surface. The object is introduced into the glory hole (see below), the heat of which causes the surface to become shiny. This was often used to improve the quality of pressed glass.

Flint glass: see lead crystal.

Flux: a raw material, either soda, potash, or lead, used in the glass batch to lower the melting temperature of its main silica component.

Furnace: the construction in which glass is melted. It is used for melting the batch, but also for keeping glass at working temperature in pots. The glass-maker can reach these through the glory hole.

Fusing: the process of melting separate pieces of glass together.

Gather: a quantity of molten glass gathered by the glass-maker at the end of the blowpipe or the pontil.

Glory hole: opening in the furnace wall through which the glass-maker can gather the molten glass from the pot. It is also used for reheating the glass during the working process.

Intaglio (Italian: engraving): a method of engraving a decoration into the glass, thus forming a 'negative' relief below the main glass surface.

Kick: a concavity at the base of a vessel, pushed in during manufacture by the pontil or another tool. Underneath the apex there is often a rough patch or pontil mark, where the pontil is detached from the object. The kick improves stability and the strength of the object, but reduces its capacity.

Kiln: an oven for heating glass at a lower temperature than that of the furnace, used for fusing enamels or separate pieces of glass together or for slumping.

Lampwork: the technique by which objects are shaped from prefabricated rods and tubes of glass, which are tooled and fused in the open flame of a lamp or torch.

Lead crystal (lead glass, flint glass): a clear colourless glass made with at least 20 per cent lead oxide.

Lustred glass: a glass whose surface is decorated with metallic pigments, usually silver and copper, to produce a shiny coloured stain. Lustre is fired in reducing conditions.

Marver: a smooth flat slab of stone or metal on which the gather is rolled to smooth it and give it the desired shape prior to blowing. It can also be used to pick up surface embellishments, such as gold leaf or small pieces of coloured glass.

Mould-blowing: the process of blowing glass into a mould, which defines both shape and surface decoration of the object. Hinged, two-part moulds with a smooth interior are used for mould-blowing simple enclosed shapes, such as bowls for goblets. These are closed around the gather, which is subsequently blown to shape, while being constantly rotated. These moulds are usually made of pear wood, and are kept wet during use. The moisture creates a layer of steam during blowing; this prevents direct contact between mould and glass, which could cause surface blemishes. See also dip mould.

Mould-pressing: see press-moulding.

Mosaic glass: glass formed by fusing pieces of differently coloured glass together.

Muff process: see broad glass.

Pâte-de-verre (French: glass paste): glass made by melting powdered glass into a mould.

Pincering: shaping or decorating glass with the aid of pincers.

Pontil (punty): metal rod used during glass-making. Tipped with a small quantity of glass, it is usually attached to the base of an object when the blowpipe has to be removed in order to shape the upper part or the rim. The pontil can also be used to gather glass which does not have to be blown, for instance, the stem or the foot of a goblet or the handle of a jug.

Pot: see crucible.

Potash: potassium carbonate, derived from plant ashes, which is used as a flux.

Press-moulding: the process of pressing a quantity of molten glass into a mould to form an object. It developed into a highly developed industry in the nineteenth century.

Prunt: a decorative pad of glass, applied to the vessel.

Sand-blasting: technique of decorating glass or giving it a matt finish by bombarding its surface with fine sand particles propelled by compressed air. Patterns can be formed by partly covering the surface with a resist.

Slumping: the process of shaping glass by allowing it to sag, through its own weight, into or over a form during heating.

Trailing: a process of decorating by laying on or winding a strand of molten glass drawn out from a gather.

Wheel-engraving: the technique of decorating glass in which small rotating wheels of different size, usually made of copper and fed with an abrasive, are used to grind away parts of the surface to create a decoration. Wheel-engraving produces much finer work than cutting.

75. Pair of flasks by Ignaz Preissler: enamelled, Bohemia, probably 1720s. H: 7.5 cm. (C.337, 338-1936)

76. A glass-engraver's table and tools: engraving, detail from Johan Georg Kruenitz, *Oeconomische Encyclopädie*, Berlin, 1779. 14.2 x 7.9 cm. (NAL)

77. The Glass-engraver: engraving attributed to Christoph Weigel, Germany (Nuremberg), *c.* 1680. 8.5 x 7.5 cm. The Corning Museum of Glass, Corning, N.Y.

78. 'Perseus and Andromeda' by Caspar Lehmann: engraved panel, Bohemia (Prague) or Germany (Dresden), 1607–11. 23 x 19.7 cm. (6940-1860)

79. Goblet and cover signed by Georg Friedrich Killinger: engraved, Nuremberg, late 17th century. H: 41 cm. (C.353&A-1936)

80. Beaker and cover, engraved by Martin Winter or Gottfried Spiller: cut and engraved and with enamelled gold knop by Peter Boy, Germany (made at Potsdam, engraved in Berlin, enamelled at Trier), *c.* 1701. H: 17.2 cm. (3-1871)

81. Goblet and cover engraved by Friedrich Winter: engraved and carved in relief, Silesia (made at Schreiberhau, engraved at Hermsdorf), *c.* 1700–5. H: 36.1 cm. (C.63&A-1954)

82. Goblet and cover: cut and engraved, Silesia, *c.* 1730. H: 23 cm. (C.371&A-1936)

83. Mug, bottle, cup and saucer, bowl: ruby glass with gilt-metal mounts, South Germany, *c.* 1680–1725. H: (bottle): 27.5 cm. (5321-1901; C.393-1936; C.395&A-1936; 8872-1855)

84. Frontispiece to J. Kunkel, *Ars vitraria experimentalis…* : engraving. Edition published in Amsterdam and Danzig (Gdansk), 1679. 17.3 x 12.2 cm. (NAL)

85. Goblet: with ruby and aventurine threads, cut, Bohemia, *c.* 1720–30. H: 34 cm. (C.638&A-1936)

86. Design for a goblet: pen and ink and watercolour, Dresden, *c.* 1710–20. 27.7 x 10.9 cm. (PDP, E.1143-1911).

87. Beaker: *Zwischengoldglas*. ? Dresden, *c.* 1720–30. H: 6 cm. (C.401-1936)

88. *Façon de Venise* goblet: diamond-point engraved, Northern Netherlands, inscribed, 'De Liefde siet geen Leidt. Te ver gheifs' (Love sees no grief. In vain), 1660–70. H: 17.5 cm. (C.418-1936)

89. Two confinement cups decorated by Jacob Sang: wheel-engraved, Northern Netherlands (decorated in Amsterdam), signed and dated 1762. H: 21.6 cm (C.466&A,465&A-1936)

90. Stipple-engraved goblet by Frans Greenwood: the glass probably Britain, the engraving Northern Netherlands (Dordrecht), signed and dated 1728. H: 21 cm. (C.435-1936)

91. Wheel-engraved plaque by Bominik Biemann: Bohemia (? Prague or Franzensbad), signed 'D. Biman.F', *c.* 1839–44. D: 9.6 cm. (C.5-1978)

92. Goblet and cover: ruby glass, cut and engraved, Bohemia, 1840–50. H: 43.5 cm. (4467&A-1901)

93. A beaker painted by Anton Kothgasser with a view of St Stephen's Cathedral, Vienna: cut, stained, enamelled, and gilt, Austria (Vienna), *c.* 1830. H: 11.2 cm. (C.155-1939)

94. Jug: red lithyalin, Bohemia (probably Blottendorf), possibly made in Egermann's facory, *c.* 1830. H: 21.6 cm. (C.139-1916)

CHINESE GLASS

95. 'Eyebead': the eyes were pressed in the blue glass while hot, China, 4th–3rd centuries BC. D: 2.1 cm. (C.19N-1947)

96. Three bottles: with wheel-engraved marks on the bottoms, China. From the following reign periods (left to right): Kangxi (1662–1722), Qianlong (1736–95) and Xianfeng (1851–61). H. (highest): 22.2 cm. (C.174-1938; C.332-1918; C.171-1956)

97. Bowl: China, 18th century. H: 7.1 cm. (413-1880)

98. Jar: wheel-engraved, China, mark and reign period of Qianlong (1736–95). H: 18.7 cm. (C.677–1936)

99. Two snuff bottles: cased with multi-coloured overlays and wheel-engraved, China, 1750–1895. H. (highest): 7.1 cm. (C.1683-1910; C.1537–1910)

100. Vase: cased, China, reign mark of Qianlong (1736–95), but 19th century. H: 17.5 cm. (C.1525-1910)

V: British Supremacy

101. Goblet made by Giacomo Verzelini: mould-blown stem, gilt, trailed decoration, engraved with diamond-point by Anthony de Lysle, England (London), 1586. H: 16.8 cm (C.226-1983)

102. Decanter jug and wine glass: mould-blown ribbing, England, *c.* 1685. H. (highest): 21.9 cm. (C.144-1928; Circ.224-1965)

103. Group of black wine bottles: England, mostly with dates and names or initials on seal. As follows (left to right): unsealed bottle, datable toc. 1660–70; I*I, 1693; T. Ridge, 1720; Ann Pate, 1738; WR, 1752; and Jas Oakes Bury, 1788. H. (highest): 26.6 cm. (C.382-1993; C.383-1993; C.113-1945; C.36-1994; c.384-1993; C.6-1967)

104. Bottle seal, inscribed 'JOHN SMART': England or Scotland, *c.* 1800. L: 5.6 cm. (C.29-1995)

105. Bottle, inkwell, and jug made of bottle glass with white flecks or trailed threads: bottle, Scotland, dated 1827; and the others England, early 19th century. H. (highest):

29.5 cm. (920-1898; 5277-1901; 573-1854)

106. Bottle mould, foot-operated: from Apsley Pellatt, *Curiosities of Glass Making*, London, 1849, p. 103

107. 'A Mechanically Bottle-Blowing Machine in operation': from Arnolf Flemming, *Scottish and Jabobite Glass*, Glasgow, 1938. 14.5 x 10.2 cm.

108. Roemer made by George Ravenscroft: mould-blown with applied prunts, marked with raven's head seal, England (London), *c.* 1676–7. H: 16.5 cm. (C.530-1936)

109. Ewer and basin made by George Ravenscroft: with mould-blown ribbing, England (London), *c.* 1676–7; the basin is marked with raven's head seal. H (jug): 27.6 cm. (C.163-1993; C.528-1936)

110. Goblet and cover (possibly used as a chalice): blown glass, diamond-point engraved, 'St Simon Boosington', England, *c.* 1700. H: 37.4 cm. (C.55-1969)

111. Beer and ale glasses and decanter: cut and engraved, England, 1700–1800; the decanter *c.* 1765. H. (highest): 29.5 cm. (C.599-1936; 63-1906; C.206-1913; C.361(1,2)-1993)

112. Drinking glasses: engraved with political and Masonic inscriptons, England, *c.* 1755–65. H. (highest): 19.7. (C.323-1931; C.189-1925; C.175-1925; C.506-1925; C.180-1925)

113. 'A Midnight Modern Conversation' by Hogarth: etching and engraving, England, 1733. 34.5 x 47.1 cm. (PDP, Dyce 2724)

114. 'Voluptuary under the Horrors of Digestion' by James Gilray: coloured etching, England, dated 1792. 28.0 x 34.3 cm. (PDP, 23476)

115. Trade card for John Jacob: engraved, England, *c.* 1765. 16.2 x 13.0 cm. (PDP, E.1641–1907)

116. Four-branch candelabrum: England, *c.* 1720. H: 34.3 cm. (Circ.521-1931)

117. Chandelier at Uppark, West Sussex: cut, England, *c.* 1770–4. National Trust Photographic Library/Nadia MacKenzie

118. Candelabrum: cut glass, on base of gilt-blue glass, mounted in ormolu, England, *c.* 1780. H: 67.3 cm. (C.8-1936)

119. 'Messrs Pellatt & Green': coloured engraving from Ackermann's *Repository of Arts*, May 1809. 11.8 x 19.6 cm. Photo courtesy of John Smith

120. Trade card for the glass-dealer Colebron Hancock of Charing Cross: engraving, designed by Hancock, engraved by Morrison, England, mid-18th century. 23.1 x 17.8 cm. (PDP, 16575)

121. Decanter and two glasses decorated by the Beilby family: enamelled in Newcastle upon Tyne, England, *c.* 1760–70; decanter signed by William Beilby, dated 1762. H. (highest): 23.5 cm. (C.623-1936; C.620-1936; C.628-1936)

122. Decanter and stopper decorated by James Giles: opaque-white glass with gilt decoration, England (London), c. 1770–4. H: 29.2 cm. (C.17 &A-1978)

123. Part of a suite of table glass: cut and engraved, England, c. 1790. H. (highest): 27.3 cm. (Circ.167-1922 etc.)

124. 'Turnover' bowl: blown and cut, with press-moulded foot, Ireland, c. 1790–1800. H: 21.9 cm. (C.720-1936)

125. Cruet stand: silver, with cut-glass bottles, England, c. 1780–90. H: 27.9 cm. (C.748 to M-1936)

126. Osler's Gallery at Oxford Street, London, by Owen Jones: pen, ink, and watercolour on paper, England, 1858–60. 147.3 x 102.0 cm. (PDP, P.29-1976)

127. Trade card for the steam-powered cutting mills of W. Wilson, Blackfriars Road, London, c. 1807. 12 x 8 cm. The Corning Museum of Glass, Corning, N.Y.

128. Decanter and two glasses made for the Prince Regent, later George IV, by Perrin, Geddes: cut, England (Warrington), 1806–8. H. (highest): 34.3 cm. (C.179-1980; C.56 &A-1976; C.57-1976)

129. Jug made by Apsley Pellatt: enclosed ceramic 'sulphide' plaque, emblematic of Geography, England (London), c. 1820. H: 18.4 cm. (C.16-1978)

130. Model of a ship: lampworked, England, c. 1800. H: 15.2 cm. (C.563-1925)

GLASS IN MUGHAL INDIA

131. Hookah base: with trailed decoration and gilt, India (Mughal), first half of 18th century. H: 16.2 cm. (IM.91-1948)

132. Detail of a miniature, 'Mir Qasim Smoking a Hookah': opaque watercolour on paper, India (Murshidabad), 1760–3. 28.3 x 21.7 cm. (D.1178-1903)

133. Bottle, two cups, and a saucer: enamelled and gilt, India (Mughal), early 18th century. H. (highest): 18 cm. (C.141&142/140/143-1936)

134. Bottle: enamelled and gilt with silver mount, western India or Deccan, 18th century. H: 13.8 cm. (14-1867)

135. Rosewater sprinkler (gulabpash): mould-blown, probably Britain, first half of 18th century. H: 28.2 cm. (13-1893)

VI: Nineteenth-Century Eclecticism

136. View of Wordsley: photograph from a postcard, c. 1900. Coll. H. J. Haden. H. J. Haden and Broadfield House Glass Museum.

137. Page 97 from Silber & Fleming trade catalogue: Britain, 1880s. 36.9 x 26.8 cm. (NAL)

138. Luncheon (Déjeuner) by Gustave Caillebotte: oil on canvas, signed and dated, 1876. 52 x 75 cm. Private collection. © Photo RMN/D. Arnaudet.

139. Four decanters made by W. H. B. & J. Richardson and Davenport (right): cut, Britain (possibly Stourbridge and Longport, right), 1840–1855. H. (highest): 35.3 cm. (Circ.502/501-1970; C.54-1970; C.145-1985)

140. 'Pressing Glass': from Apsley Pellatt, Curiosities of Glass Making, London, 1949. 10 x 10 cm. (NAL)

141. Tableware produced by Edward Moore & Co, including sugar basin, cake stand, footed bowl, bowl, and dish and cover: press-moulded, made at the Tyne Flint glassworks, Britain (South Shields), 1886–9. H. (highest): 14.1 (C.65/70-1983)

142. Group of pressed glassware: press-moulded, Britain and America (the basket and the candlestick), 1830–1920. H. (highest): 25.2 cm. (C.262-1987; Circ.381-1966; C.26-1992; Circ.508-1970; C.271-1987)

143. 'The State Opening of the Great Exhibition of all Nations, May 1st, 1851' by Louis Hague: lithograph, published by Ackerman & Co., London. 49.2 x 67.5 cm. (PDP. 19606)

144. James Green and Nephew of London's exhibition stand at the Philadelphia Centennial Exhibition of 1876: a stereopti-con card. H: 11 cm. The Corning Museum of Glass, Corning, N.Y.

145. J. G. Green's display at the Great Exhibition: from the Art Journal's illus-trated catalogue, London, 1851, p. 91. (NAL). The 'Neptune Jug', or ewer, made by J. G. Green: engraved, Britain, 1851. H: 33.7 cm.(4453-1901)

146. Vase and pedestal made for the Vienna glass retailers Joseph & Ludwig Lobmeyr: enamelled (the shape was probably designed by Professor Josef Ritter von Storck), Austria; it was shown at the International Exhibition, Paris, 1878. H: 117 cm. (411-1878)

147. The cameo workshop of the Woodall Brothers: photograph, Britain (Stourbridge), c.1895. Broadfield House Glass Museum.

148. 'The Death of Socrates' vase made by Stevens & Williams: etched, Britain (Stourbridge), c. 1865. H: 30cm. (C.48-1972)

149. Vase designed and engraved by Paul Oppitz after Jean Bérain: wheel-engraved, ornament arranged to fit the vase by 'J Jones', made for W. J. Copeland & Sons, Britain (London); shown in the International Exhibition, Vienna, 1879, c. 1872–3. H: 28.5 cm. (Circ.15-1961)

150. Goblet (in two parts) designed and engraved by Franz Paul Zach: cased and engraved, probably made by Wilhelm Steigerwald, Schachtenbach Glassworks,

for his brother, the Munich retailer Franz Steigerwald, Germany (Zwiesel); shown at the International Exhibition, Paris, 1855. H: 32.5 cm. (2672&A-1856)

151. Group of tableware and vase made by Salviati & Co: various techniques including aventurine, opalescent, ruby, and filigree glass, Italy (Venice, Murano), 1868–9. H. (highest): 33.5 cm. (891-1868; 79-1870; 882-1868; 75-1870; 887-1868)

152. Goblet and jug: press-moulded, France (probably Saint-Louis glassworks), c. 1855. H. (highest): 14.4 cm. (C.94&95-1994)

153. Tableware designed by Philip Webb: made by James Powell & Sons, Whitefriars glassworks, Britain (London), c.1859–74. H. (highest): 12.7 cm. (C.79A-1939; C.260/262/264/261-1926)

154. Water jug and carafe: jug, enamelled, made by W. H. B. & J. Richardson, Dudley, Britain (Stourbridge), 1848; 'Well Spring' carafe designed by Richard Redgrave, enamelled and gilt, made by A. J. F. Christy, Stangate Glassworks, Britain (London), 1847. H. (highest): 26 cm. (Circ. 167-1964; 4503-1901)

155. 'Venetian' tazza, vase, and goblet designed by Harry James Powell: opalescent glass, made by James Powell & Sons, Whitefriars glassworks, Britain (London), 1876. H. (highest): 22.8 cm. (542/537/544-1877)

156. 'Clutha' range vase designed by Christopher Dresser: with metallic inclusions, made by James Couper & Sons, Britain (Glasgow), c. 1885. H: 49 cm. (C.52-1972)

157. Emile Gallé by Victor Prouvé: oil on canvas, 1892. 158 x 96 cm. Musée de l'Ecole de Nancy, photo Claude Phillipot.

158. Vase designed by Ernest-Baptiste Leveillé: wheel-cut with gold inclusions, probably made by Appert Frères, Clichy, France (Paris), 1880–90. H: 16 cm. (C.417-1922)

159. Vase designed by Emile Gallé: cased, wheel-cut, and acid-etched, made at the Gallé glassworks, France (Nancy), 1904. H: 37.5 cm. (C.53-1992)

160. 'Sol-fleur' vase designed by Emile Gallé: cased, wheel-cut, and acid etched, made at the Gallé glassworks, France (Nancy), c. 1902. H: 32 cm. (C.57-1972)

161. 'Vase des liserons' (convulvulous) designed possibly by Henri Bergé or Ernest Bussière: cased, mould-blown, and cut, made by Daum Bros, France (Nancy), 1907–10. H: 23.5 cm. (C.55-1992)

162. 'Favrile' bottle designed by Louis Comfort Tiffany: iridescent glass, made at the Corona glassworks, America (Long Island, N.Y.), 1896. H: 40 cm. (512–1896)

163. Illustration of cane-making: engraving from Diderot et D'Alembert, *Encyclopédie des Arts et Métiers*, Paris, 1772, vol. X, pl. XXI. 35.5 x 44.5 cm. (NAL)

164. Sections of cane, one as a plaque, with the portrait of King Vittorio Emanuele II of Italy made by Giacomo Franchini: fused and miniaturized composite canes, (Murano, Venice), *c.* 1860. D. (Plaque): 2.5 cm. (357R; AA; FF; HH-1872)

165. Tray for making paperweights: iron, with sections of composite cane, France, 1850–1900. D: 8.3 cm. (4476–1901)

166. 'Mille-fiorie': engraving from Apsley Pellatt, *Curiosities of Glass Making*, London, 1849, p. 110. 4 x 4 cm. (NAL, 89.J.40)

167. Tazza, vase, and two paperweights with enclosed sections of cane: tazza and paperweight (left), made by Baccarat, marked on a cane 'B' and '1846' and '1847', respectively; the paperweight (right), made by Saint-Louis, marked on a cane 'SL', and the vase probably by Saint-Louis, both 1840–1860. H. (highest): 16 cm. (4474/4451/4450/4474A-1901)

168. Weight or 'dump': with enclosed gas bubbles, Britain (possibly Sunderland), after 1829. H: 12.8 cm. (C.165-1917)

VII: The Twentieth Century: Art and Industry

169. Wine glasses designed by Otto Prutscher and a jar and cover designed by Josef Hoffmann: all cut, the wine glasses also cased (red) and stained (yellow), probably made by Meyr's Neffe, Adolfshütte glassworks, for the retailers E. Bakalowits & Söhne, Austria (Vienna), designed *c.* 1917–18 and 1907, respectively. H. (highest): 21 cm. (Circ. 391-1976; C.602&A-1966; C.4-1979)

170. Bowl made by Albert-Louis Dammouse: *pâte d'émail*, France (Sèvres), 1900. D. 11 cm. (961-1901)

171. *Graal* (grail) tazza designed by Simon Gate: etched and cased, engraved by Heinrich Wollman, made in Orrefors glassworks by Knut Bergvist, Sweden (Småland), 1918. H: 26.4 cm. (C.363-1993)

172. Vase designed by Marcel Goupy for Maison Rouard, Paris: mould-blown, enamelled and gilt, France, *c.* 1925. H: 16.2 cm. (C.12-1979)

173. 'Deux Paons' (Two peacocks) lamp designed by René Lalique and made at the Lalique glassworks: press-moulded and mould-blown, France (Wingen-sur-Moder), 1920. H: 45.1 cm. (C.73-1972)

174. Two bottles and a vase designed and made by Maurice Marinot: enclosed metallic oxides and gas bubbles, acid-etched, Viard Frères glassworks, France (Bar-sur-Seine), 1929–32. H. (highest): 26.3 cm. (C.9&A/13/20&A-1964)

175. 'Fireworks' (*Fyrverkeriskålen*) vase and stand designed by Edward Hald: mould-blown and wheel-engraved, made by Orrefors glassworks, Sweden (Småland), 1921. H: 27 cm. (Circ.52-1931)

176. 'Acrobats' giant goblet with engraving designed by Pavel Tchelitchew: partly mould-blown and wheel-engraved, made at Steuben glassworks, America (Corning), 1939. H: 31.6 cm. (Circ.86-1952)

177. Vase designed by Keith Murray: mould-blown and cut, made by Stevens & Williams, Brierley Hill, Britain (Stourbridge), *c.* 1936. H: 28 cm. (Circ.16-1938)

178. 'Savoy' vase designed by Alvar Aalto: mould-blown, made at the Karhula glassworks, Finland (Karhula), designed 1936 and made 1937. W: 21 cm. (C.226 -1987)

179. 'Victoria' wine glasses, 'Devon' decanter, and 'Art Deco' ice bucket designed by Frank Thrower: mould-blown and metal handle on ice bucket, made by Dartington glassworks, Britain (Torrington), 1967–81. H. (decanter): 22 cm. (C.174&A/176&A/178-1987)

180. Advertisement photograph for oven and tablewares designed by Wilhelm Wagenfeld: made by Schott, Germany (Jena), 1930–40

181. Advertisement for Pyrex wares designed by Harold Stabler: produced by J. A. Jobling, Britain (Sunderland); illustrated in *Good Housekeeping*, 1936.

182. Teapot and stand said to have been designed by Frederick Carder: blown lid and stand, press-moulded pot, made by the Corning glassworks, USA (Corning, N.Y.), 1922. H: 13.7 cm. (C.47-1995)

183. Advertisement photograph for teaware designed by Wilhelm Wagenfeld: made by Schott, Germany (Jena), 1930–40

184. Saucepan and lid 'Cornflower pattern': pyroceram and press-moulded, made by the Corning glassworks, USA (Corning, N.Y.), introduced in 1958. H: 14 cm. (C.53-1995)

185. Stackable containers 'Kubus-Geschirr' designed by Wilhelm Wagenfeld: press-moulded, made by the Vereinigte Lausitzer Glaswerke, Germany (Weisswasser), 1938. H: 21.5 cm. (C.154-1980)

186. Cafetière 'Bistro' designed by Carsten Jørgensen: machine-blown boro-silicate glass, with polypropylene plastic, stainless steel, and cork, made by Peter Bodum (Schweiz) AG, Switzerland, designed in 1973–4. This example was made in 1989. H: 20.3 cm. (C.23-1990)

187. 'Kantarelli' (Chanterelle) vase designed by Tapio Wirkkala: wheel-engraved, made by the Iittala glassworks, Finland (Iittala), 1946. H: 19.5 cm. (Circ.457-1954)

188. 'Serpentiini' vase designed by Gunnel Nyman: mould-blown, with opaque-white thread, made at the Nuutajärvi glassworks, Finland (Nuutajärvi), designed 1947 and made 1952. H: 39 cm. (C.164-1987)

189. Vase designed by Ercole Barovier: part mould-blown, hot-worked, and iridised, Italy (Venice), made at Barovier and Toso & C. glassworks, 1942. H: 26.8 cm. (C.137-1991)

190. 'Pezzato' (patchwork) vase designed by Fulvio Bianconi: fused squares and blown, Italy (Venice), made by Venini & C., 1950. H: 19 cm. (C.150-1991)

191. 'Winged Head' made by Stanislav Libenský and Jaroslava Brychtová: mould-melted, made at the Centre for Glass Architecture, Czechoslovakia (Zelezny Brod), 1962. H: 49 cm. (C.19-1996)

192. Vases designed by Geoffrey P. Baxter: mould-blown, made by James Powell & Sons, Whitefriars glassworks, Britain (Wealdstone), designed in 1966, in production from 1967. H. (highest): 33.5 cm. (C.241-1991; C.175-1996; 240-1991)

193. 'Flourish the Chalk' bowl engraved by Laurence Whistler: diamond-point and wheel-engraved on a purchased blank, Britain (Alton Barnes), 1982. H: 22.2 cm. (C.350-1983)

194. 'Fragment of a Circle' made by Diana Hobson: *pâte-de-verre*, stone, and bronze, London, 1990. L: 25.5 cm. (C.78-1996)

195. 'Journey to Troy', part of a series, by Markku Salo: blown into a metal mesh form with metal mounts, made with the Nuutajärvi glassworks' team, Finland (Nuutajärvi), 1995.

196. 'Triptych' designed and engraved by Alison Kinnaird: optical glass, wheel-engraved, Britain (Shillinghill), 1992. H: 25 cm. (C.335-1993)

197. 'Portals of Illusion' by Peter Aldridge: dichroic-coated Starphire Glass, multi-laminated/etched mirror, steel, and aluminium structure, America (Corning), 1992–3. Commissioned by Corning for their headquarters. Photograph courtesy of Corning Incorporated.

198. 'Old Woman' by Dana Zámečníková: hand-cut laminated-sheet glass, enamel painted, metal, and wire, Czechoslovakia (Prague), 1990. W: 167 cm. (C.117-1992)

199. 'Sea Form' by Dale Chihuly and his team at the Pilchuck School: hand-blown, America (Seattle), 1985. W: 34.5 cm. (C.203-1985)

SELECTED FURTHER READING

General Works

Charleston, R. J., *Masterpieces of Glass: A World History from the Corning Museum of Glass*, New York, 1980
Honey, W. B., Glass: *A Handbook and a Guide to the Museum Collections*, Victoria and Albert Museum, London, 1946
Klein, D. and W. Lloyd, *The History of Glass*, London, 1984
Klesse, B. and A. von Saldern, *500 Jahre Glaskunst Sammlung Biemann*, Zürich, 1978
Polak, A., *Glass, its Makers and its Public*, London, 1975
Schack von Wittenau, C., *Die Glaskunst,* Munich, 1976
Tait, H. (ed.), *Five Thousand Years of Glass*, London, 1991
Weiss, G., *Ullstein Gläserbuch*, Berlin, Frankfurt, and Vienna, 1966

I: The Ancient World

Barag, D., *Catalogue of Western Asiatic Glass in the British Museum*, vol. I, London, 1985
Cool, H. E. M. and J. Price, *Roman Vessel Glass from Excavations in Colchester, 1971-85*, Colchester Archaeological Reports 8, Colchester, 1995
Grose, D. F., *Early Ancient Glass in the Toledo Museum of Art*, New York, 1989
Harden, D. B., 'Ancient Glass', I, II and III, *Archaeological Journal*, 1969, 1970, and 1971
Harden, D. B., *Catalogue of Greek and Roman Glass in the British Museum I*, London, 1981.
Harden, D. B. et al., *Glass of the Caesars* (exh. cat.), Corning (Corning Museum of Glass), London (British Museum), and Cologne (Römisch-Germanisches Museum), 1987
Hayes, J. W., *Roman and Pre-Roman Glass in the Royal Ontario Museum*, Toronto, 1975
Kunina, N., *Ancient Glass in the Hermitage Collection*, St Petersburg, 1997
Newby, M. and K. Painter (eds), 'Roman glass: two centuries of art and invention', *Society of Antiquaries of London Occasional Paper*, no. XIII, London, 1991
Stern, E. M., *The Toledo Museum of Art: Roman Mold-Blown Glass*, Rome, 1995
Stern, E. M. and B. Schlick-Nolte, *Early Glass of the Ancient World*, Ernesto Wolf Collection, Ostfildern, 1994
Tait, H. (ed.), *Five Thousand Years of Glass*, London, 1991 (rev. ed. London, 1995)

II: Glass from the Islamic World

Arts Council, 'Glass', *The Arts of Islam*, Hayward Gallery, London, 1976
Jenkins, M., 'Islamic Glass, A Brief History', *Bulletin of the Metropolitan Museum of Art*, New York, Fall 1986
Kröger, J., *Nishapur: Glass of the Early Islamic Period*, Metropolitan Museum of Art, New York,1995
Von Folsach, K., 'Glass', *The David Collection: Islamic Art*, Copenhagen, 1990

Ward, R. (ed.), *Roman Glass in the Corning Museum of Glass*, vol. 1, Corning, N.Y., 1997

III: Tradition and Innovation:

MEDIEVAL TRADITIONS
Baumgartner, E., and I. Krueger, *Phönix aus Sand und Asche: Glas des Mittelalters* (exh. cat.), Munich, 1988
Foy, D. and G. Sennequier (eds), *À Travers le Verre du Moyen L'Âge à la Renaissance* (exh. cat.), Le Musée des Antiquités de Seine-Maritime, Rouen, 1989
Glück und Glas zur Kulturgeschichte des Spessartglases, Munich, 1984
Henkes, H., 'Glas zonder Glans', *Rotterdam Papers*, no. 9, Rotterdam, 1994
Polak, A., *Glass, its Makers and its Public*, London, 1975
Theuerkauff-Liederwald, A.-E., 'Der Römer, Studien zu Einer Glasform', *Journal of Glass Studies*, vol. X, Corning Museum of Glass, Corning, N.Y., 1968

VENICE AND THE VENETIAN STYLE
Barovier Mentasti, R., *Il Vetro Veneziano*, Milan, 1982
Corning Museum of Glass, *Three Great Centuries of Venetian Glass* (exhibition catalogue), Corning, N.Y., 1958
Dreier, F. A., *Venezianische Gläser und 'Façon de Venise'*, Kunstgewerbemuseum, Berlin, 1989
Gasparetto, A., *Il Vetri di Murano dalle Origine ad Oggi*, Venice, 1958
Heikamp, D., *Studien zur Mediceischen Glaskunst*, Florence, 1986
Tait, H., *The Golden Age of Venetian Glass*, London, 1979
Tait, H. (ed.), *Five Thousand Years of Glass*, London, 1991
Theuerkauff-Liederwald, A.-E., *Venezianisches Glas der Veste Coburg*, Coburg/Lingen, 1994
Zecchin, L., *Vetro e Vetrai di Murano*, vols I–III, Venice, 1987, 1989, and 1990

IV: European Splendour

Amic, Y., *L'Opaline Française au XIXe Siècle*, Paris, 1952
Baumgartner, S., *Sächsisches Glas: Die Glashütten und ihre Erzeugnisse*, Wiesbaden, 1977
Blunt, A. (ed.), *The James A. de Rothschild Collection at Waddesdon Manor: Glass and Enamels*, London, Fribourg, 1977
Bosch, H., *Die Nürnberger Hausmaler*, Munich, 1984
Buckley, W., *European Glass*, London, 1926
Buckley, W., *The Art of Glass*, London, 1939
Charleston, R. J., Masterpieces of Glass: *A World History from the Corning Museum of Glass*, Corning, N.Y., 1980
Drahotovà, O., *European Glass*, New York, 1983
Klesse, B. and H. Mayr, *European Glass from 1500-1800: The Ernesto Wolf Collection*, Vienna, 1987
Meyer-Heisig, E., Der Nürnberger Glasschnitt des 17. Jahrhunderts, Nuremburg, 1962
Palmer, A., *Glass in early America: Selections from the Henry*

Francis du Pont Winterthur Museum, Winterthur, Delaware, 1993
Petrova, S. and J.-L. Olivié (eds), *Bohemian Glass*, Paris, 1990
Polak, A., *Glass, its Makers and its Public*, London, 1975
Ritsema van Eck, P.C., *Glass in the Rijkmuseum*, vol. II, Zwolle, 1995
Rückert, R., *Die Glassammlung des Bayerischen Nationalmuseums München*, vols I and II, Munich, 1982
Saldern, A. von, *German Enameled Glass: The Edwin J. Beinecke Collection and Related Pieces*, Corning, N.Y., 1965
Schmidt, R., *Brandenburgische Gläser*, Berlin, 1914

CHINESE GLASS
Brill, R. and J. Martin (eds), 'Scientific Research in Early Chinese Glass', *Proceedings of The Archaeometry of Glass Sessions of the 1984 International Symposium on Glass, Beijing*, Corning Museum of Glass, Corning, N.Y.,1991

V: British Supremacy

Bickerton, L., *Eighteenth Century Drinking Glasses*, Woodbridge, 1987
Charleston, R. J., *English Glass and the Glass used in England, c. 400-1940*, London, 1984
Dumbrell, R., *Understanding Antique Wine Bottles*, Woodbridge, 1983
Hajdamach, C., *British Glass 1800-1914*, Woodbridge, 1991
Kenyon, G., *The Glass Industry of the Weald*, Leicester, 1967
Rush, J., *A Beilby Odyssey*, Olney, 1987
Seddon, G. B., *The Jacobites and their Drinking Glasses*, Woodbridge, 1995
Thorpe, W., *English Glass*, third edition, London, 1961
Truman, C., *An Introduction to English Glassware to 1900*, Victoria and Albert Museum, London, 1984
Warren, P., Irish Glass: *The Age of Exuberance*, London, 1970
Witt, C., C. Weeden and A. Palmer Schwind, *Bristol Glass*, Bristol, 1984

GLASS IN MUGHAL INDIA
Digby, S., 'A Corpus of "Mughal" Glass', *Bulletin of the School of Oriental and African Studies*, vol. XXXVI, I: 1973, pp. 80-96.
Dikshit, M. G., *History of Indian Glass*, University of Bombay, Bombay, 1969.
Markel, S., 'Western Imports and the Nature of Later Indian Glassware', *Asian Art*, vol. VI, 1993: 4, pp. 35–53.
Qaisar, A. J., *The Indian Response to European Technology and Culture (A.D. 1498-1707)*, Oxford University Press, Delhi, 1982.
Victoria and Albert Museum, *The Indian Heritage: Court Life and Arts under Mughal Rule*, London, 1982.

VI: Nineteenth-Century Eclecticism

Amic, Y., *L'Opaline Française au XIXe Siècle*, Paris, 1952
Arwas, V., *Glass: Art Nouveau to Art Deco*, 2nd edition, New York, 1987
Arwas, V., *Art Nouveau to Art Deco: The Art of Glass*, Windsor, 1996
Bloch-Dermant, J., G. *Argy-Rousseau Glassware as Art*, London, 1990
Gallé (exh. cat.), Musée de Luxembourg, Paris, 1985
Garner, P., *Gallé*, London, 1976
Hajdamach, C., *British Glass 1800-1914*, Woodbridge, 1991

Hannes, A., *Glas aus dem Bayerischeswald*, Grafenau, 1975
Morris, B., *Victorian Table Glass and Ornaments*, London, 1978
Olivié, J.-L. and S. Petrová, *Bohemian Glass*, Paris, 1990
Olivié, J.-L., 'The Discovery of an Unknown Collection of Emile Gallé Glass', *Royal Glass* (exhibition catalogue), Christiansborg Palace, Copenhagen, 1995
Polak, A., *Glass, its Makers and its Public*, London, 1975
Ricke, H. (ed.), *Lötz: Böhmisches Glas 1880–1940*, vols I–II, Munich, 1989
Spillman, J., *American and European Pressed Glass in the Corning Museum of Glass*, Corning, N.Y., 1981
Spillman, J., *Glass from World's Fairs*, Corning Museum of Glass, Corning, N.Y., 1986
Truman, C., *An Introduction to English Glassware to 1900*, Victoria and Albert Museum, London, 1984
Wakefield, H., *Nineteenth Century British Glass*, London, 1982
Warmus, W., *Emile Gallé, Dreams into Glass*, Corning Museum of Glass, Corning, N.Y., 1984

VII: The Twentieth Century: Art and Industry

Arwas, V., *The Art of Glass*, Sunderland, 1996
Barovier-Mentasti, R., *Venetian Glass 1890-1990*, Verona, 1992
Bloch-Dermant, J., G. *Argy-Rousseau Glassware as Art*, Paris, 1990
Corning Museum of Glass, *World Glass Now*, Corning, N.Y., 1979
Corning Museum of Glass, *New Glass: A World Survey*, Corning, N.Y., 1982
Daum, N., *Daum: Mastery of Glass*, Lausanne, 1985
Dodsworth, R. *British Glass between the Wars*, Broadfield House Glass Museum, Kingswinford, 1987
Dorigato, A. and D. Klein, (eds), *International New Glass/Venezia Aperto Vetro*, Venice, 1996
Evans, W., C. Ross, and A. Werner, *Whitefriars Glass: James Powell and Sons of London*, Museum of London, London, 1995
Frantz, S., *Contemporary Glass, A Worldwide Survey from the Corning Museum of Glass*, New York, 1989
Frantz, S. (ed.), *Stanislav Libensky/Jaroslava Brychtová*, Corning Museum of Glass, Corning, N.Y., 1994
Garner, P., 'Glass between the Wars', ed. D. Klein and W. Lloyd, *The History of Glass*, London, 1984
Huldt, A. (ed.), *Svenskt Glas*, Växjö, 1991
Jackson, L., *Whitefriars Glass: The Art of James Powell and Sons*, Manchester City Art Galleries, Manchester, 1996
Klein, D., *Glass: A Contemporary Art*, London, 1989
Koivisto, K., *European Glass in Use*, Finnish Glass Museum, Riihimäki, 1974
Kuspit, D., *Chihuly*, second edition, Seattle, 1998
Marcilhac, F., *René Lalique*, Paris, 1989
Olivié, J.-L. and S. Petrová, *Bohemian Glass*, Paris, 1990
Opie, J., *Scandinavian Ceramics & Glass in the 20th Century*, Victoria and Albert Museum, London, 1989
Polak, A., *Modern Glass*, London, 1962
Reynolds, E., *The Glass of John Walsh Walsh 1850–1951*, Shepton Beauchamp, 1999
Stennett-Willson, R., *Modern Glass*, London, 1975
Sunderland Museum and Art Gallery, *Pyrex: 60 years of Design*, Sunderland, 1983
Wickman, K. (ed.), *Orrefors: A century of Swedish Glassmaking*, Orrefors, 1998

INDEX